W9-BDL-032

Barry Faulkner

Barry Faulkner

Sketches from an Artist's Life

1973

William L. Bauhan Publisher
Dublin, New Hampshire

Library of Congress Catalog Card No. 70-162875
ISBN: 87233-023-0

MANUFACTURED IN THE UNITED STATES OF AMERICA

Contents

List of Illustrations

Publisher's Note

During his long lifetime, Barry Faulkner became one of this country's most celebrated muralists, his decorative painting to be found in many of our prominent public buildings and large private residences. It is not the purpose of this brief note to assess his work or its place in American art, but shortly after his death, the American Academy in Rome recorded this tribute in its Minutes, providing us with an insight into his life and career:

Barry Faulkner was born in Keene, New Hampshire, July 12, 1881 and died there on October 27, 1966. From early youth he was exposed to the influence of able, powerful artists; first Abbott Thayer and George de Forest Brush in Dublin, then Augustus Saint-Gaudens in whose Cornish studio he found "a world of collaboration in the arts, exhilarating and dreamed of." It was this combination of architecture painting and reading that absorbed him all his life.

In 1907 while he was studying and working in New York he was given the first award in painting to the American Academy in Rome. Except during the interruption of the First World War when he served courageously in the Camouflage Corps, Barry Faulkner painted murals. Outstanding architects employed him continuously because of the distinction of his work and his understanding of their mutual problems. . . . The list of his work is long and impressive.

Barry Faulkner shared his wide interests with friends of all ages. He woke them to new aspects of the visual world. He saw the good and pointed out the fine and creative. He saw without

prejudice the difference between one artist and another and one
time and another. He was a delightful companion, a cultivated
and civilized man, a wise critic, a distinguished artist. All his life
he worked at his painting and worked for the arts.

Barry Faulkner also found an avocation in writing—
especially during the last two decades of his life, when he
could no longer "scramble up ladders and paint murals."
Among the boxes of papers found after his death were
biographical sketches of his mentors Thayer and Brush,
his friends Paul Manship, James Earle Fraser and others; a
lively correspondence with other friends, such as the poet
Witter Bynner and the sculptor Frances Grimes; vignettes
of local history; chapters from a projected book on artists of
the Connecticut River Valley. And of course the manu-
script which became the basis of this book.

He did not sit down and plan out his "memoirs" as one
would write a formal autobiography. The book grew in-
stead out of a series of sketches, jotted down as the spirit
moved, recalling memorable episodes or characters from the
rich tapestry of his life. Some of the pieces were written
for his own amusement or to entertain his friends, others
as tributes to fellow artists or as scripts for talks and
lectures. Only when he was very old—and at the urging of
such friends as Anne Gugler, Isabel Manship and Corinna
Lindon Smith—did he begin to assemble these recollections
into a chronological narrative.

The result is a lively, entertaining, and often graphically
immediate picture of the times he lived in, peopled by a
remarkable range of interesting personalities and memo-
rable characters, who, as it so happens, make up a virtual
Who's Who of American painters, sculptors and architects of
the period. Oddly enough he speaks little of his own work,
perhaps due to his own innate modesty or because of the
enormous expenditure of creative energy which it demanded
at the time. Contrary to the impression he leaves, he was a
prodigious worker, and between the lines we are able to
glean a portrait of the man himself, his far reaching interests
and his broad humanity.

It remained after Barry Faulkner's death to continue the editing and arranging he had begun and to assemble as many illustrations as possible—tasks completed in collaboration with his niece Jocelyn Faulkner Bolle. We drew upon some of his other writings to "fill gaps" and give the narrative greater continuity; some elucidatons were necessary to identify and clarify references to important artists he knew. But scrupulous regard was paid to the author's own words and, it is hoped, his intentions.

Many hands have helped in the preparation of this book since the author's death, and to all of them profound thanks are due, whether their names are mentioned here or not. Berkeley Rice and Edith Milton read the manuscript and offered valuable criticisms, and Professor William Morgan of Princeton verified data concerning various American artists. Special credit goes to Grace Pierce Forbes, grand-daughter of Barry Faulkner's mentor George de Forest Brush, for her skilled assistance in editing and arranging the book, and for her research into the background of many painters and architects who figure in the narrative.

Friends of Barry Faulkner generously offered help and material as the work progressed: Eric Gugler, architect of his studio, and his wife Anne; William and Margaret Platt of New York and Cornish; his cousin Ellen Faulkner of Keene; Kay Fox of the Keene Public Library; Peggy Colony; Hal Close; and Mrs. Harold Bowditch (the Nancy Brush of this book) of Peterborough, New Hampshire.

Others who kindly lent photographs include: John Manship, son of Barry Faulkner's closest friend Paul Manship; Donald Fenn; T. Handasyd Cabot; the late Mrs. Ruth Faulkner Hayward; Eloise Segal of the American Academy of Arts and Letters; John Dryfhout of the Saint-Gaudens National Historic Site. Permission to use illustrations was also given by the Metropolitan Museum of Art, the Thorne Art Gallery, Keene State College, the Keene National Bank, and the Oregon State Highway Division.

Stephen T. Whitney photographed many of the original paintings, and the archives of Peter A. Juley and Sons were also an invaluable source.

Thanks go to Rosamond Putnam, not only for her encouragement but her generosity in making possible the color reproductions which appear in these pages. And for their cooperation in making possible the use of the black and white illustrations, credit is due members of Barry Faulkner's family: his sister-in-law, Katherine Kingsbury Faulkner; and his nephews and nieces, Anne Faulkner Jacobs, Martha Louise Jones, Helen M. Rogers, Francis F. Faulkner, Philip H. Faulkner, Jr., Harry Mowbray and James Mowbray.

Jocelyn Faulkner Bolle first put her Uncle Barry's manuscript on my desk, and it was in large measure because of her determination, enthusiasm and unflagging interest that it came to fruition.

William L. Bauhan

Dublin, New Hampshire
July 1973

I

Memories of Keene

The Faulkner family have been sturdy walkers for three generations, except for my father who did not share this taste and preferred to drive his white horse, Roland. But my brother and sisters, my cousins, and I knew the hills of Keene, New Hampshire well and the spine and pinnacles of Mount Monadnock. We loved to explore the Ashuelot Valley and its hills; to tread forgotten roads, to come across an aged hawthorn in bloom, an unexpected waterfall or an ancient cellar hole; to feel the wind in our faces, the sweat on our backs, a bright arch of sky over us and sharp rock or springy turf under foot. My first incentive for walking was a love of landscape and the search for places to sketch and paint. Later my brother Philip shared with me this liking for long tramps.

Our town of Keene lies between ranges of hills; Beech Hill to the east, West Hill where it should be, and to the north the broad back of Surry Mountain and the pastures of the Walpole uplands. From any of these hills, what charm our little city held for the eye! The prospect from Beech Hill was one of the best; the neat white houses stowed away under great elms, the spires and cupolas piercing the heavy foliage, giving elegance and distinction to the scene. To the east is the pleasing view of Mount Monadnock; to the south the modest eminences of Mount Huggins and Mount Caesar and the prosperous farms of the three Swanzeys.

1

Seen from any angle, Keene's cluster of spires and well-kept houses, its factories and mills had a prosperous and inviting look. Today, the plan of the center of town is the same as in my boyhood. Five streets radiate from Central Square, and the handsome tower of the First Church, rising over the Soldiers' Monument and the circle of elms on the Common, dominates the length and breadth of Main Street. The First Church remains, and the Court House remains, but their imposing companion, the mammoth Cheshire House, is gone. It stood on the corner of Main and Roxbury Streets on the site of two previous taverns, both destroyed by fire. The Cheshire House I knew, built in 1837, was three stories high with two ranges of attics in its gable, topped by a cupola as big as a house. Its frontage was seventy-five feet and behind it were large stables.

It was a famous hostelry and the *New Yorker* magazine once declared it had the longest breakfast menu in the world. The menu offered, besides standard breakfasts, such dainties as tripe, pie and Bubble and Squeak, venison, pickled pigs' feet and Bombay Duck. The spry elderly waitresses wore white collars and cuffs and aprons so over-starched that as the women flew about, their aprons crackled like tiny pistol shots. The parlors on the second floor were ample and handsomely furnished with heavy lace curtains, bright flowered carpets, fantastic chandeliers and plush covered chairs, sofas, ottomans and love seats. In an annex were a ballroom and a banquet hall. These splendors made the hotel seem to me a miniature Saratoga.

A row of one-storied shops have replaced the Cheshire House and most of the three and four-storied buildings around the Square have been scalped of their upper stories. Now the old buildings have not even the charm of familiarity.

Today's flow of cars, endless and monotonous, circling Central Square, replaces the curiously varied traffic of my early memories—the bicycles, the lumbering yokes of oxen dragging huge logs to the sawmill, the farmer's big hay wagons, the drays and dump carts of all sizes and forms, the buggies, surreys and carry-alls. The strangest of these vehicles was a little shanty on wheels which passed through

Central Square, Keene. Pencil study of a mural for the Elliott Community Hospital by Barry Faulkner

the Square morning and evening. Smoke came from a tin
pipe in the shanty's roof and inside, by a stove, sat Welcome,
the lunatic brother of Robert Leonard who drove the con-
veyance. Robert was desperately poor and could not afford
to hire someone to watch his brother while he himself
worked away from home; but he loved his brother too well
to put him in an asylum, so out of his love and poverty he
contrived for him this strange rolling retreat.

South of the Common, a row of musty hacks used to
wait to waft my Grandmother Faulkner and her elderly
friends to church or to a tea-drinking. Where the flag-staff
now stands stood a solitary elm, known as the Auction Tree;
near it a bandstand and a large, circular iron watering
trough for horses. The trough had low and smaller basins
for thirsty dogs. Near the Elm and in the shadow of the
Cheshire House the weekly market spread its offering to
the sky; offerings ranging from live-stock, harrows and
plows, old clothes, and brass bedsteads to upright pianos
and delicate flower vases. Abiel Jones, the auctioneer, was
a racy chap, and once when a lady questioned the goodness
of the springs of a bed he had put up for sale, Abiel threw
himself on the bed and bounced up and down. When the
dame still was unconvinced he invited her to join him on
the mattress for a real tryout.

Years later I painted these early memories of Keene in
murals in the entrance hall of the Elliot Community Hospi-
tal. I also painted a mural for the Cheshire County Savings
Bank of a scene which was perhaps the most important
commercial event in Keene's history—the first railway
train to cross Main Street. The painting shows the train
entering the station; the huge bell of the engine's stack is
spewing smoke, and seated upon the improvised benches of
the decorated flat-cars are distinguished, cinder-covered
visitors from Boston, including Mayor Quincy. The visitors
banqueted in the brand-new covered station, then as fresh
and clean, as afterwards it was black and grimy.

The railway brought prosperity to Keene and Keene be-
came a small rail center with roundhouse and repair shops.
Very pleasant it was at night, in the soft darkness, to hear

the whistles at distant crossings and the tinkle of an engine bell at the station.

From early times, Keene and its neighbors to the west, Walpole and Brattleboro, had each a small, gifted and intelligent society. The boys went to Chesterfield Academy, to Exeter and Andover, to Harvard, Amherst and Dartmouth; and the girls to Female Seminaries. One of the best known of these Seminaries was opened in Keene by Miss Katharine Fiske in 1814. Most branches of polite learning were taught there, with emphasis on Deportment. Her pupils came not only from Keene and nearby towns, but from "most of the states of the Union," and varied in number from eighty to a hundred young women. Miss Fiske furnished for their use the first piano seen in Keene. She was an efficient and successful teacher and her school flourished until her death thirty years after its founding.

The women of Keene were a force in our local culture. They competed in household skills, worked for their churches and charities and founded our excellent Invalids' Home. They gave few formal parties, but entertained visiting relatives for a night or a month. At the frequent tea-drinkings and picnics, they planned whist and Shakespeare clubs, a Choral Society and excellent amateur performances of *Pinafore* and *The Mikado*. They read Emerson, Dickens, and Thackeray, and sampled the newer novelists like Meredith and Thomas Hardy.

We had no movies, no television, no supervised play. Men, women and children supplied their own amusements and exercised their initiative and invention. The men hunted, camped and fished, formed debating societies. In winter they raced one another in their sleighs down Main Street. In the evenings they sang with the women around the piano, read aloud, and acted dumb-crambo and charades. These homely diversions cost next to nothing.

Transportation was by horse, and a fine one cost in hundreds what we now pay in thousands for a car. Hay and oats cost pennies. The care of a horse was a daily chore and not a light one, but the constant responsibility for the welfare of a horse was good for the human animal. The

swift river of the years has washed away many outward forms of the older days, but who really regrets the passing of the ancient earth closet, the kerosene lamp so difficult to clean, the leaky icebox in the woodshed, the freezing bedrooms in winter or even the horse and buggy? The outward forms change in substance, the subsoil of life, rich and generous, remains.

II

Boyhood, School Street

My entrance into this world took place on July 12, 1881, and the first home of my boyhood was on School Street. My parents named me Francis Barrett—a well-meant compromise to appease both sides of the family. Francis was my father's name and his father's before him, and my mother had been born Martha Barrett Ripley. But my parents had reckoned without Grandmother Faulkner. She had just read Thackeray's novel *Barry Lindon,* and the name pleased her. She stepped in and said, "There are enough Franks in the family already. Let us shorten the Barrett and call the child 'Barry'." I am glad the name has stuck.

I recall bright vignettes of those early days. My brother, Philip, with golden curls and red jacket standing beside our tall, white horse, Roland. The gaiety of spring cleaning, near the little fringe tree by the kitchen door; the household furniture and rugs on the new grass, looking marvellously pretty and cheerful in the sunlight—Beezie, the nurse-maid, singing at the top of her lungs, as she brushed and sunbathed them. Father called her "Our Irish Thrush." It was a sparkling out-of-doors drawing room then. Another memory of the exact same place was after the Blizzard of '88, when the fringe tree disappeared under drifts of snow, and to my seven-year old eyes, the path to the kitchen door was a deep crevasse between Alpine summits.

Sitting on the steps of my great-aunt Handerson's house

7

on Washington Street, I remember watching a procession
of middle-aged men in faded blue, with brass band and fly-
ing flags. Why are they marching, and why is it Memorial
Day? I had heard of Waterloo and the Wars of the Roses,
but no word of our Civil War, which had ended little more
than twenty years before. Why was my family silent? Were
the memories too painful to recall? I never knew.

There were dressmaking days at Grandmother Ripley's
when Miss Mattie Skroll arrived with her scissors, scrap
bag, and cornucopia of gossip. There were more elegant
dressmakers in town than Miss Mattie, but Grandmother
was content with Buttrick's patterns and Miss Mattie's
sheaf of scandal. My handsome grandmother and my two
aunts, Mary and Hattie, listened demurely, with ears away,
to the misdeeds and crotchets of their friends and neigh-
bors. The sitting-room and bay window were a riot of dress
material and in the sea of cloth, like Atropos with her shears,
stood Miss Mattie, lank, bleak, indomitable. Once when fit-
ting Aunt Hattie, who fidgeted, she shouted, "Stand still,
or I pin it onto your hide!"

The laboratory-museum at Cousin Bill Faulkner's was a
source of unending fascination for little boys. I remember
us bending in gloating horror over a dead rattlesnake, as
Cousin Bill skinned and mounted it for his collection of
rarities—for rattlesnakes are rare in Cheshire County. Bill
and his brother, Rob, met and killed this reptile as they
were walking up Chesterfield Hill on their way to Lake Spof-
ford. Our glee as we watched the operation is confused with
Sunday School memories of an unfortunate incident in Eden.

Our Sunday dinners with the inevitable roast of beef
were long. But once they were over, Father took Philip,
little Katharine and me on the long Sunday afternoon walk.
One route led to the semi-circular roundhouse of the Bos-
ton and Maine Railroad with its many engines, clouds of
steam and enormous turn-table. From there it was only a
step to the Keene Gas Works in which Father owned a con-
siderable interest. Phil and I took proper pride in this fact,
but secretly preferred the great engines and turn-table.

The second route led to Woodlawn Cemetery and the

county jail. The cemetery was a pretty, well-shaded place, packed with glimmering obelisks and figures of Grief and Hope, whose up-turned eyes searched in vain the mute heavens. The lot of my great-grandfather Phineas Hander-son, within its iron fence, bulged sociably with great-aunts, uncles and second cousins.

And then the jail!—a jolly place to us because of our friend, Sheriff Tuttle. Bill Tuttle was a large ample man, as good humored and jovial as a ray of sunshine, popular all over Cheshire County. The sheriff told us tales of arresting thieves and murderers, and of his youth in Stoddard in a farm house in front of which stood the five Medicinal Trees, and in whose kitchen on Saturday nights, one after the other, the family soaped and luxuriated in the same big bar-rel of hot water.

The sheriff lived in a part of the jail, and at four o'clock he would leave Father to a skillfully mixed rum punch and take us children into the jail proper while he locked up his prisoners for the night. On one of these trips my sister Katharine, who was then four or five, met an old acquain-tance—our fish man. Well pleased, she thrust her little hand through the bars with a cordial "How-do-you-do, Mr. Bab-cock?"

Sheriff Tuttle loved my father, as did many people in town—how many I never realized until his death. Father was even-tempered, solid and benevolent, warm and com-passionate, a wise lawyer. At Harvard he was a co-founder and editor of the *Magenta,* the forerunner of the *Harvard Crimson.* He wrote verses for Hasty Pudding plays and acted in them. He formed durable friendships at Harvard but the only name I recall of his friends is that of Edward Simmons, the painter, who was sympathetic to my budding artistic aspirations. Father's law practice and civic interests gave him little time for reading, but on wet Sunday afternoons he read me *Lamb's Tales from Shakespeare, The Lady of the Lake,* and *Hamlet.*

His close friends in Keene that I remember best, apart from the sheriff, are Mr. William Elliot and Judge Ward Holmes. Mr. Elliot, red as a fox, was a genial man, able and

easy-going. He had a summer place about ten miles away
in Nelson, north of Silver Lake. The house was remodelled
from the old County Poor Farm, and near it was the pit of
an ancient lead mine, filled with dark green water. Mrs.
Elliot had turned the surrounding slag heaps and small pits
into a wild garden, filled the tiny ponds with pink water-
lilies and the woods with laurel and rhododendron. Our
cottage was on the east side of the lake and each Sunday
morning Phil and I paddled Father up the lake, past Trout
Rock to meet Mr. Elliot at his boathouse on Sandy Beach.
After a swim and a bask on the sand, we climbed to Lead
Mine Farm and while Mr. Elliot and Father drank their
whiskey, we boys absorbed soft drinks with Mrs. Elliot and
her daughter, Rosamond.

Judge Holmes was tall and thin, a man of wit and humor.
His irony stung. Once when he was sentencing a culprit,
the man's counsel, Joe Madden, interrupted: "But, your
Honor, this man's wife is about to be confined."

"So is he," said the Judge, "thirty days!"

Most evenings, his smoke-filled office in the Courthouse
was a club for the Keene lawyers, and Father was a steady
member. Judge Holmes' son Robert and I went to Sunday
School in the gallery of the First Church and, when our
teacher wasn't looking, brightened the sessions by knock-
ing hymnals off the gallery rail onto the heads of the classes
underneath.

Our little Ashuelot River is associated in my mind with
many pleasures and excitements. It is a beautiful stream
winding past meadows, thick woods, high sand-banks and
little islands, a paradise for water birds and picnickers. I
swam in it, canoed and skated on it when a boy, and in later
years painted it. To be allowed to swim with the bigger
boys at the Double Elm swimming hole was almost a cer-
tificate of manhood, and we youngsters revelled in escap-
ing and jumping into the river before our larger and
stronger friends could catch us and toss us in.

One glorious Christmas vacation the river froze hard
and glare, free from snow for ten days. In weather heady

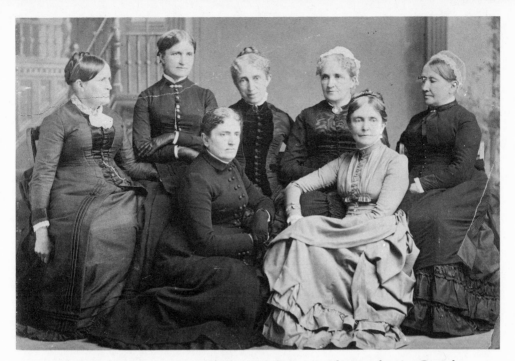

The Seven Handerson Sisters of Keene. The author's Grand-
mother Faulkner is at left, and the others, from left to right, are
Maria Hatch, Mary Ela, Esther Handerson, Harriet Abbott, Annie
Handerson and at right Ellen Thayer, mother of Abbott H. Thayer

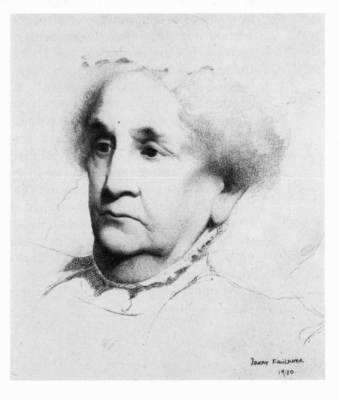

Grandmother Ripley.
Pencil sketch by
Barry Faulkner, 1910

as wine, we skimmed over that incomparable ice from the
Mill Pond (now defunct) to the Stone Bridge on Court
Street. Above the bridge the ice became uneven. Returning,
we rested on an island near the Bullet Bank, where the
Keene Light Guards practiced marksmanship. The boys
lit a fire and the girls roasted sausages whose goodness I
can still taste.

In March, I used to go with Gerry Whitcomb and brother
Phil to sugaring-off at Batchelder's farm in Surry. It was
fine sugaring weather, cold at night, hints of spring at mid-
day, snow on the ground, reddish twigs on the trees. Under
the shed of the sugar house, the great sap pans bubbled and
thickened. Horses and sleds, loaded with buckets of fresh
sap, kept the pans working. And the syrup spread on gobs
of snow was mighty good.

Elbridge Gerry Whitcomb was a character. His bright eyes
and intelligent expression redeemed the impish plainess of
his face, for as an out-spoken relative said, "That child will
never be killed for his beauty." He was a comedian, with a
hawk's eye for the sham and false in people, which he de-
veloped into a rollicking and sometimes ruthless sense of
humor. Humor, however, unlocked the hearts of men to
him and gave him power to influence them. He grew up to
become a successful engineer, manager of a large munitions
factory in Canada during the first World War. Later he
turned to farming in Richmond, New Hampshire, where he
became the friend and confidant of Alexander James, the
painter.

Gerry and I were friends of long standing. When our
fathers first allowed us to stay out as late as we wished on
Fourth of July eve, we were jubilant. Up to midnight we
overturned the stepping blocks in front of the houses of
people we disliked, danced around the flaming bonfire in the
middle of Main Street, and escaped from the sexton of the
First Church when he caught us sneaking up the belfry
stairs to ring the big church bell. Our final tribute to this
night of Independence was to help the bigger boys decorate
Main Street by stringing a garland of chamber pots across
it. At one o'clock we collapsed gloomily on the steps of Bul-

lard and Shedd's drugstore, very, very sleepy but ashamed
to go home. The leaden minutes dragged along for half an
hour, then by mutual impulse, no word spoken, we slunk
away to bed.

Gerry and I never missed the summer mornings when the
circus came to town. No matter how early the hour, we
greeted the long trains as they rumbled heavily across Main
Street. One sizzling July dawn, a large, bare female rump
sticking out of an open sleeping-car window startled us and
stirred our imaginations. From Main Street we went to the
circus grounds to watch the great tents rise. One morning
the hubbub and confusion there was tremendous, for Al-
bert, Barnum and Bailey's finest elephant, had gone mad,
escaped and thundered off, trumpeting, toward the river.
Gerry and I tore after him but were stopped and turned
back. Terror gripped the town; mothers cowered with their
young in the houses, and fathers walked with caution along
the streets. At last in a meadow by the Ashuelot, noble Al-
bert was captured and chained—the Keene Light Guards
had marched in and after their first nervous volleys the huge
beast simply toppled over.

Grandmother Faulkner's house on School Street was
separated from our house by a lawn and vegetable garden.
Grandmother's name had been Caroline Handerson, and
she was the fourth of seven sisters, all women of energy
and character. When I was nine or ten, I haunted Grand-
mother's house, where she and her sister-in-law, Aunt
Lizzie Faulkner, lived together. The house was of brick and
was more spacious than it looked from the street. The front
hall and easy staircase were ample, and beside them were
double parlors; then the house widened and had space for
a large library and dining room. Behind these were the kitch-
en, pantries and china closets, various woodsheds and a
workshop, near which stood one of the oldest and tallest
elm trees in Cheshire County.

The double parlors were large and well-proportioned,
with their sliding doors always open. Each room had a fire-
place and steam radiators disguised by handsome cases of

scrolled ironwork embossed in white and gilt. Each room
had an alcove opposite its fireplace; the one in the back par-
lor held a bookcase and that in the front parlor a Rogers
group of a girl and a soldier gossiping over the village pump.
The walls of both rooms were hung with engravings after
the Italian Masters, spoils of Aunt Lizzie's trips to Europe.
Alongside Raphael's Madonnas and Guido's *Aurora* were
paintings by Grandmother's nephew, Abbott Handerson
Thayer, notably a large *Hunter and Dog* and a small most
attractive *Sleeping Cat.* On the center table in the front room,
Darwin's *Origin of Species* and Renan's *Life of Jesus* lay beside
The Country of the Pointed Firs and the stories of Miss Mary Wil-
kins.

Aunt Lizzie was thin and alert as a grass-hopper, Grand-
mother slow, calm and capacious. Grandmother was going
blind and Aunt Lizzie read to her while she shelled the peas,
prepared the string beans or played solitaire. Both women
were quietly forceful characters, twin pillars of the Uni-
tarian Church, whose conferences they seldom missed and
whose visiting ministers they entertained.

Aunt Lizzie read aloud to Grandmother through the long
afternoons and after school I would drop in and listen with
equal interest to *Looking Backward, The Cloister and the Hearth,*
and even *Beauchamp's Career.* When I asked to hear some of
the older novelists, Aunt Lizzie obliged with a lot of Scott
and a bit of Thackeray. She tried *Persuasion,* Grandmother's
favorite Jane Austen, but I missed out on its subtle flavor. I
heard nothing of Mrs. Proudie and Barchester, nor of *Oliver
Twist,* and *The Tale of Two Cities,* but my mother read me
David Copperfield and I devoured the rest of Dickens by myself.

In the 1870's and '80's Aunt Lizzie had travelled widely
with her cousin Mrs. Rebecca Green of Boston. She knew
Rome, Paris, London, Moscow and St. Petersburg, and had
ascended the Nile to Abu Simbel and the Second Cataract.
From Egypt she returned with braided fly-whisks and long-
handled back-scratchers ending in delicate hands carved in
ivory; from Scotland she brought a portrait of Mary Queen
of Scots painted on a cobweb, which I demolished one day
with a too enthusiastic forefinger. But best of all her trophies

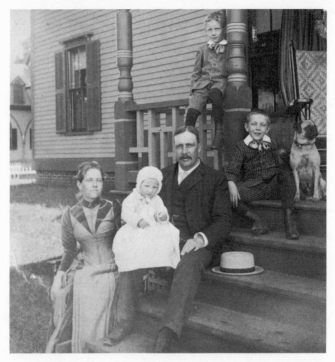

Mr. and Mrs. Francis Faulkner with Katharine,
Philip and Barry, about 1890

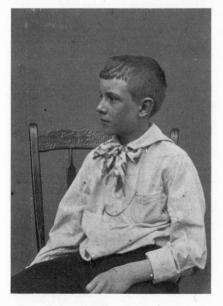

Barry Faulkner as a boy,
about 1892

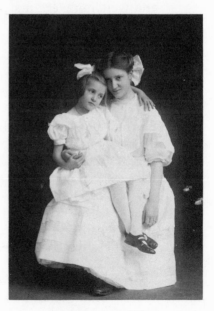

Katharine and Dora,
Christmas 1905

were the stereoscopic views whose magic perspectives let me stand in the Place de la Concorde or by the Kremlin's wall, and which made me long to know a larger world.

At a time when I still read with difficulty and before Aunt Lizzie introduced me to the British novelists, I took great interest in Shakespeare's plays, an interest not literary but pictorial. Early in their married life, my parents subscribed to a lavishly illustrated, folio edition of the plays. They came in monthly installments, and having heard Lamb's *Tales* read aloud, I was keen to know the looks of such lovely creatures as Titania and Juliet. The illustrations were large, with minimum light and shade, and ached for color to complete their beauty.

A friend and confederate appeared in the person of little Pearl Richardson, who was a few years older than myself. She had dark eyes and a soft rippling voice; was a gay little wren of a thing, brimming over with cheer and helpfulness, qualities she retained to the end of her life. Pearl was the daughter of our Congregational minister and lived in a house next to Grandmother Ripley's on Summer Street. She had a girlish crush on Mother, and Mother's engagement and wedding were matters of intense interest to her. Pearl centered her affection on Mother, but she loved all our family indiscriminately and we all loved her. This happy family friendship continued for many years, sustained by an annual Christmas reunion in Wellesley Hills, where my younger sister, Dora Mowbray, and Pearl both lived.

Pearl was much with us in the early School Street days. She had a box of watercolors and taught me to tint the paper dolls she drew and cut out. Then came a stroke of luck; my parents tired of the folio Shakespeare, which I now suspect they seldom read, and stopped their subscription. They had already received copies of most of the plays and allowed Pearl and me to color the illustrations. It was a first step toward painting, and I thrilled with happiness as I dashed bold, heraldic color over those graceful women and lusty men.

Bit by bit I read the snatches of dialogue below the pictures. "Kill Claudio!" I understood and relished, with no

notion why he deserved to die. When I read more freely, I translated "a canal in Venice" or "the courtyard of Glamis Castle" into miniature reality with the red, white and blue of the Anchor Stone Building Blocks. And after a time, with the help of Aunt Lizzie over the hard words, I read enough of the text to increase the scope and enjoyment of my hobby.

When I was ten or twelve, Father bought Grandmother Ripley's house, for after Katharine's birth, the little house on School Street became too cramped for comfort. There, in an unused bedroom on the marble top of a large commode, I developed my Shakespeare Festival Theatre. I supplemented the Anchor Stone towers and street with backdrops of smiling meadows and blasted heaths, and either drew the characters myself or snipped them out of magazines. I didn't fuss as to whether the figures matched in size; they seldom did. But standing erect, tinted and mounted on cardboard, they looked fine and jaunty.

My comprehension of the text limped along, and I preferred the historical plays to those filled with more glorious poetry, for their frequent changes of scene were a respite from my battle with the text. In the next two or three years I mounted most, if not all, the plays. I think my absorption in this hobby was due to its combination of architecture, painting and reading, interests that have filled my life and which led step by step to the profession of mural painter.

Another influence that led me, consciously or unconsciously, toward painting were Grandmother Faulkner's stories of her nephew, Abbott Thayer, a figure bathed in the romantic glow of her memories. Cousin Abbott, born in 1849, was the son of her sister Ellen and Dr. William Henry Thayer, who had lived and practiced in Keene for some years. Grandmother loved Abbott like a son and asserted that he made his first painting, a freshly caught trout, lying belly-flat on her dining-room floor. Grandmother's story of painting the trout typifies Thayer, for throughout life his absorbing passions were painting and study of animals, birds and all wild life.

III

Abbott H. Thayer

My first vivid memory of Abbott Thayer recalls him crouching in the dust of School Street, demonstrating to Mrs. Weeks, our teacher of drawing in the public schools, his newly evolved theory of Obliterative Gradation, or Protective Coloration—the foundation of his discovery of why birds and animals are difficult to see against their natural background.

The demonstration consisted of two small wooden ducks, mounted on wires, both painted the color of the dirt on which they stood, representing for the moment a natural background. One duck stood out solid and rotund, but the other Thayer had painted darker on its back and lighter on its belly until it had no more solidity than a cobweb. Suddenly a frightened cat bounded between Thayer's legs, avoided the ungraded duck and dashed into and knocked over the duck it couldn't see. Cousin Abbott was as happy as a child at the cat's vindication of his theory. Mrs. Weeks was entertained, if not enlightened.

Thayer had arrived at this part of his theory of protective coloration by his observation that birds and animals average darker on the back and lighter on the belly. The light from the sky lessens the darkness of their backs and throws the lighter tint of the belly into shadow, thus lessening their appearance of solidity.

A fascinating addition to this theory was Thayer's per-

18

ception that many birds and some animals carry on their plumage and hides a stylized picture of their most frequent habitats. Thayer's book *Concealing Coloration in the Animal Kingdom* contains a striking illustration of this part of his theory. It is the painting of a copperhead snake. The entire picture, except for the snake, is covered by a stencil cutout, showing the snake complete and emphatic. Lift the stencil— and the reptile is almost invisible against a background of dead and withered leaves.

Only the eye of a painter and the accurate observation of a naturalist could have made these discoveries. Thayer developed his twin faculties from childhood, as Grandmother Faulkner's story of the fish testifies.

Years after the happy demonstration on School Street, when Cousin Abbott wished to revisit the scenes of his Keene boyhood, I canoed him up the Ashuelot River, where he had hunted and trapped with his father or with my Uncle Finn Faulkner forty years before. At each fresh turn of the river he recalled some youthful exploit; here he had shot a heron or a hawk, here he had trapped his first muskrat and at the Bullet Bank had struggled successfully with a snapping turtle, huge and ancient. The back yard of his home on Washington Street became a menagerie of pets; many varieties of owl, a bird of which he was particularly fond, porcupines, squirrels, turtles and snakes. He often mounted specimens he had killed, and became an excellent taxidermist through his inborn sense of form and gesture. He told me that the only book he willingly read was Audubon's *Birds of America*.

When I first knew Thayer, he was in his middle forties, a handsome man with chiseled features and dark speaking eyes. He was of medium height, strong and well made. As a young man, to judge from early photographs, he looked every inch a Puritan Adonis. Winter and summer he wore Jaeger underwear, a flannel shirt, a Norfolk jacket, golf trousers descending into high Norwegian boots and a battered felt hat; which at funerals he exchanged for a brown derby and in winter for a knitted toque with a long tassel. He preferred that I should call him "Uncle Abbott" rather

than "Cousin," perhaps because his army of relatives had
"cousined" him more than he could bear.

When I was fifteen, Thayer and his family lived in Dublin,
New Hampshire, a village and summer resort, twelve miles
from Keene and about six from our summer place at Silver
Lake. My father, troubled by my desire to be a painter,
asked his cousin to test my abilities during a summer vaca-
tion. Thayer consented, and every weekday that summer
of 1897 I rode my bicycle back and forth between Silver Lake
and Dublin Pond. The road was hilly; every morning as I
pushed my bicycle up the steeper hills, I cheered myself
with the thought of how I would go whizzing down them
in the afternoons. The way was narrow and unfrequented,
but one morning as I pedalled along a level stretch beside
a swampy meadow, I suddenly came face on with young
Raphael Pumpelly and his Uncle John, driving in a buggy.
I had a large canvas strapped to my back and their lively
horse, taking me for a winged demon, jumped the ditch into
the meadow and there the Pumpellys rested, mired to the
hubs. I wished to help them, but they waved me coldly away
and extricated the buggy and horse by themselves.

Thayer's house and studio lay to the south of Dublin Pond,
facing Mount Monadnock whose granite bulk towered over
them. The house was a thin summer cottage, unsheathed,
unplastered, with neither cellar nor plumbing, except a
hand pump in the kitchen. There were two fireplaces down-
stairs and two in bedrooms above. The illumination was by
kerosene lamps and candles.

The family slept out of doors, winter and summer, under
Adirondack shacks concealed behind bushes. The windows
of the house stood open at all seasons except in blizzard or
driving rain storm. In winter ice formed around the vege-
tables on the table, unless they were carefully drained. All-
out exposure to fresh air, Uncle Abbott believed, was neces-
sary for the health of his three children, Gerald, Mary and
Gladys, whom he feared were subject to tuberculosis. This
simple life was sustained by Edward, the hired man, who
never spoke; and by three pretty Irish maids, the Price sis-

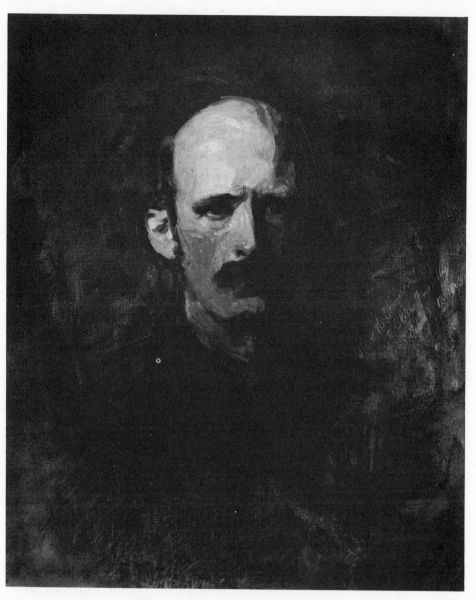

Abbott H. Thayer, self-portrait, 1893

ters; Bessie, the prettiest of the girls, Uncle Abbott often painted.

Between the house and Thayer's studio was a bed of brilliant Iceland poppies; and further off was the privy and a stable where Edward the Silent cared for a riding horse and sometimes a pony. Around the house were wire cages containing porcupines and monkeys. The monkeys were expert in escaping from their cages. One morning Mrs. Thayer awoke in her Adirondack shelter to see one of them sedately brushing his teeth with her own tooth brush.

At the Thayers', I drew in the long living room which was painted in a fantasy of bird colors, pale gray, delicate pink and dove. On the walls were a beautiful small portrait by George de Forest Brush of his wife, Mittie, a drawing by Thayer of his son, Gerald, and another of Baby Mary asleep beside a dog. Most remarkable of all was a snow landscape, made by Thayer, of blue-jay feathers against a background of white cotton, showing how the strong markings of the jay protected against a winter landscape.

On the bookshelves were Audubon's *Birds of America*, in quarto edition, the well-worn set that Thayer had read as a boy. Next came Emerson, Browning, *Thus Spake Zarathustra* and Robert Louis Stevenson. In these surroundings I drew from plaster casts of the antique, the heads of Michaelangelo's Slave, the Venus de Medici and the figure of Victory tying her sandal. Often at eleven o'clock Uncle Abbott appeared with a glass of milk in his hand and, as he sipped, he gave me a criticism on my morning's work. One day a divinely blond girl, also with a glass of milk, came with him, and I saw for the first time, the beautiful Elise Pumpelly, sister of Raphael of the swamp episode, who was posing for Thayer's current picture.

Thayer's instruction excited me and opened my eyes. It was rich in fundamental and revealing ideas, many of which were too advanced for me to grasp completely. But if ill-understood, his teaching was inspiring, for he steeped his austere standard of performance in the glow of a brilliant imagination, whose surface sparkled with simile and metaphor. He liked to compare the relation of the darks and

lights in a drawing or picture to the tuning of a piano. The picture might range from black to white or be run through a delicate scale of values, but each note must have its proper relation to the others. It was amazing how with a few practised touches he turned a pupil's mediocre study into something coherent and presentable.

Artists, young and old, are troubled by their inability, after notable improvement in their work, to follow up at once their advancement in perception and skill. Thayer compared these fallow periods in my development, to a mountain brook running gaily down hill until it strikes a deep hollow and there remains quietly until it fills the hollow, overflows and proceeds on its appointed way.

The studio in which Thayer himself painted was Spartan, with a large north light and a fireplace in a corner. After his winter in Italy the skins of two huge eagle vultures, the lammergaier, which he had shot in Sardinia, hung from the ceiling.

I believe that Thayer was the most powerful figure painter of his generation, a generation which produced many excellent portrait and figure painters. His painting was simple, direct and powerful, with no detail that detracted from the expression of the face which was always notable for strength, serenity and tenderness. He limited his compositions to a single figure or to arrangements of three figures, for which his children were usually the models. He would fly at a canvas and paint furiously for three days. Then he believed that his inspiration exhausted itself and the canvas might become a battle ground whose outcome was doubtful for months and sometimes for years. He believed that he had destroyed many of his finest beginnings by painting on them after the three bright days were over. In my opinion some of these "starts" were essentially finished, even if the canvas was not entirely covered.

Thayer shaped his life and the life of his family on Emerson, Audubon and Monadnock. Monadnock was their totem, their fetish, the object of their adoration. They surrendered themselves to the sorcery of its primitive being.

Gerald and his father prowled its peaks and precipices, its naked spine, and knew well the mysteries of the mountain brook and its groves of spruce and hemlock. Thayer fought successfully to defend his mountain against commercial vandals, and through his efforts much of Monadnock is now a state preserve.

Gerald, Thayer's only son, was his father's constant companion and from childhood knew wild nature. He became a well-trained ornithologist. Under his father's supervision he painted birds and fishes with exquisite skill, but he had little creative impulse. His late mother, Kate Bloede, had come from a distinguished German family of poets and scholars, and Gerald longed vaguely to emulate them but lacked the talent and drive to do so. He was a noble-looking boy with a fine muscular figure and with a nature generous, open-hearted and appealing.

Mary, Gerald's older sister, was the most Germanic of the three children. She was self-centered and withdrawn. In a moment of irritation her father compared her to an animal peeping from its burrow, seeing nothing on either side, only what was directly before it. Marriage was her goal, but she had few opportunities of meeting suitable young bachelors. Once on an ocean voyage she engaged herself to a ship's steward. Her horrified father quashed the match, with a guilty feeling of responsibility for the way he had reared her. Mary and the other children went to no schools, public or private. They studied with tutors or with their stepmother. Uncle Abbott had a morbid fear of the germs they might pick up at school, and moreover loved Gerald and Gladys too passionately to have them for long out of his sight. Lack of regular schooling did not hurt them intellectually, for daily contact with their father's brilliant mind and those of his friends who visited them gave them mental stimulus. They had young friends among the Brush and Pumpelly families and a few among the other summer residents. In the winter, the family occasionally made bird-collecting trips to Europe or the West Indies and from these forays brought back to Dublin the monkeys and

macaws, specimens galore for their collection of bird skins; also skis and heavy Norwegian boots, at that time great novelties in this country. The children lived beneath the shelter of their father's reputation and charm, which did not give them sufficient opportunity to rub against the world and to test out a normal variety of friends and enemies, and they paid for this lack in later life.

Gladys, the youngest of the children, was the least affected by the family regime. She was a charming young girl with the ancestral dark hair and speaking eyes. Like Gerald, she was amiable and affectionate. She had a true gift for painting, a gift which her father fostered with loving care and delight.

The children called one another by their baby names, "Yea Yea," for Mary and "Gra," and "Galla" for Gerald and Gladys. They called their stepmother "Addie," but Uncle Abbott addressed her as Emma, or Emmeline. Emma had been one of her husband's pupils before their marriage in 1891. She was a tiny sprite of a woman, cheerful, devoted, self-effacing, who added to the family resources common sense and a comfortable income of her own. Her father was Moses Beach, one of the organizers of the trip described in *The Innocents Abroad*, and the Thayers were proud of the tradition that on that memorable voyage Mark Twain proposed marriage to her.

I see "Addie" under her halo of bright hair, bending over a mountain of sewing, mending the children's clothes, or making over for herself the handsome, slightly-worn dresses her sisters sent her. "Barry," she said to me one day, "now I have enough clothes to last me the rest of my life!"

And Uncle Abbott himself? He cloaked his fundamental egotism with a grace and charm that disarmed most adverse criticism. In compensation for this flaw he flung open to his friends the door to a sublime and noble vision. In later years when his pupils discussed his faults and virtues, they ended by agreeing that Thayer's influence and teaching were the most inspiring experience of their artistic lives. Thayer's personal peculiarities and way of living amused and mystified his older artist friends, but they admired and respected

him. Among the friends whose liking and admiration he
reciprocated were the sculptor, Augustus Saint-Gaudens,
and the painters George de Forest Brush, Thomas W. Dew-
ing and Dwight Tryon.

Thayer left Monadnock seldom, except to demonstrate
the principles of Protective Coloration. He had little difficul-
ty in convincing the top ornithologists in America and Eng-
land of the validity of his theories, but the rank and file of
the less perceptive scientists were harder to convince, for
Thayer's demonstrations were not always as tidy as they
might have been. He suffered unduly from their skepticism,
not realizing that the publicity given to their dissents inter-
ested the public in his theories and in the event did him less
harm than good. Uncle Abbott's nature was too sensitive
and self-centered to endure in a normal way the rough-and-
tumble of these casual gatherings and he returned from
them either over-elated or irritated and exhausted, thank-
ful to sink back into the uncritical cotton-batting of his
family and of his admiring students.

With the Thayers I lived in a brave new world and felt
something of the happiness and delight which ravished the
young essayist William Hazlitt on his first meeting with
Coleridge and Wordsworth. Uncle Abbott was unfailingly
kind and helpful; the few times he chastened me, I richly
deserved it. I loved all the Thayers and soon merged into the
family routine—the long walks, the camping trips on Mo-
nadnock and the discussions on protective coloration, fas-
cinated by Uncle Abbott's eloquence and the ingenious
beauty of his ideas. At first I had noon dinner with the
family and then rode back to Silver Lake, but as our inti-
macy grew, I made longer stays and sometimes visited them
in the winter.

A typical Dublin day began early. Everyone except Mary
painted or drew until the milk break at eleven, and then
worked until dinner at one. After dinner Uncle Abbott
stretched out on a couch in the living room and listened
with the ears of memory to the music which his first wife,
young Kate, had played to him. There were no record play-

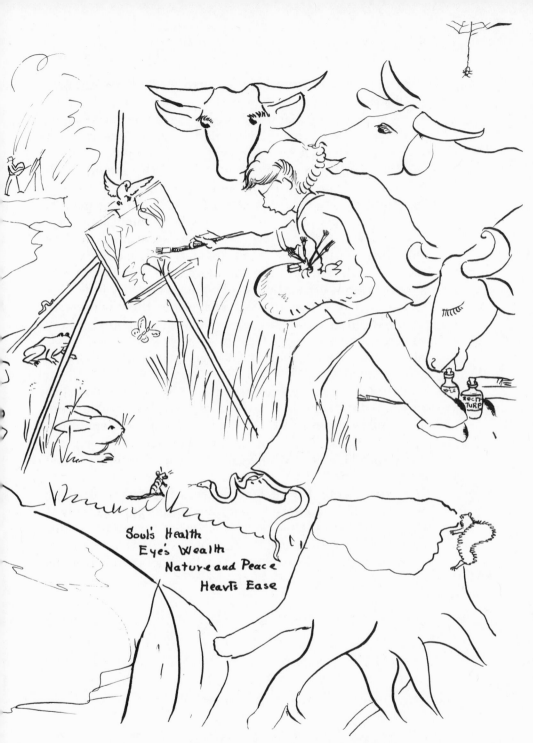

Soul's Health
Eye's Wealth
Nature and Peace
Hearts Ease

B. F. as the youthful artist. Cartoon by Margaret Platt

ers at the time, but my halting performances of Schubert
and Beethoven were to him better than nothing. I played
on the small upright piano that the Bloede family had brought
with them from Germany, when they came to America with
the great German-American lawyer Carl Schurz.

After a half-hour of music we climbed the mountain or
took a five or six mile tramp along the roads, while Uncle
Abbott showed us how the caterpillar, the praying mantis,
and other insects protected themselves by mimicking their
surroundings. After supper we sat or lay around the fire
while one of the family read aloud *Harry Richmond* or an
Icelandic saga. At nine the family, except for Gerald and
myself, trooped off to their sleeping bags and airy huts.

I like best to remember the Thayers in their winter re-
galia, Jaeger underwear, high Norwegian boots, heavy
woolen garments, topped by huge sheepskin coats—stal-
wart and handsome they looked against the heaped snow-
drifts.

The passions for painting and for the world of nature
were equally strong in Thayer, and were inseparable from
his eminence as an artist. During his lifetime his reputation
as an artist was high and honored; he strove to express
what Edith Hamilton would call "a beauty absolute, simple
and everlasting."

Today the number of his admirers has fallen off. The
look of gentle innocence in his female figures, especially if
winged, are derided by critics and museum curators. But
the strength of their dislike may indicate that in a future
upheaval of taste Thayer may regain at least much of his
former prominence.

IV

Schools and Sculpture

When I was sixteen I went to Phillips Exeter Academy, the preparatory school to which my father and grandfather had preceded me. The sudden change from the exotic life of Dublin and the warmth of the family nest was a stinging shower of cold water on my spirits. I was confused, frightened and homesick. When father left me on the station platform the morning after our arrival, I stood alone facing an alien jungle of whose hidden pitfalls I was ignorant. I was not a good mixer and was timid and slow at making friends. My adjustment to school life was painful, yet to a degree I made it and became more self-reliant. For the first months at Exeter, during the fall of 1897, I was acutely homesick. When Mother and Aunt Mary paid me a surprise visit, they were in my eyes a radiant vision of solace and joy. They were, in fact, both exceptionally pretty women and I treasure the memory of their affection and sympathy, their beauty and elegance.

Mother was a "private person" living in and for her family, gentle and serene on the surface, underneath firm and courageous. Her lovely ways made us children a happy and united family. She had few intellectual interests yet she seconded my lofty ambitions with unquestioning faith; her interest in the arts was founded on her affection for me. My sisters Katharine and Dora inherited Mother's beauty of character and feature. Dora brought up her own family with Mother's gentle firmness, and Katharine, in the years we lived together, indulged my whims and idiosyncracies.

29

Dora was seventeen years younger than I and was born in 1898 during my first summer vacation from Exeter. She became the joy of the family, especially of Father who loved her deeply. During this important event I was sent from underfoot to my father's cousins at the Whiting Farm near Berkshire, a small village in the Berkshire Hills of western Massachusetts. On the farm were two capacious houses about a hundred yards apart, occupied by the large families of Abbott Thayer's sisters, Mrs. Edward M. Whiting (Cousin Sue), and Mrs. Edward T. Fisher (Cousin Nelly). The outdoor life and the example of Uncle Abbott led two of the boys into careers as naturalists: Dick Fisher founded the Forestry School at Harvard, and Ted Whiting, with whom I was to room at Harvard, became a landscape architect and a partner of the younger Frederick Law Olmsted. I boarded in the Fisher household. But my memory of this summer is hazy, except for three vivid recollections: the grace and equanimity of Cousin Nelly; a small painting by A. P. Ryder owned by the Whitings, typical of his dramas of moonlight, sea and cloud; and my own first attempt at landscape painting, a pastel of a mist-filled valley, delicate and non-committal.

My second year at Exeter was agreeable enough but when I graduated I begged Father to let me go to art school. He was distressed, but kind and understanding, and on the advice of Uncle Abbott, finally agreed that if I went to Harvard for my Freshman year and did not wish to continue, I might then study art. Father had such happy memories of Harvard, the *Crimson* and the Hasty Pudding; his life there had been so rich in durable friendships that he could not conceive that anyone, after tasting its attractions, would willingly forego them.

I went to Cambridge for the entrance examinations and across the aisle from me sat a tall, dark young fellow, distinguished and excitable looking. As we passed in our papers we chatted together about our ordeal, and I dropped a word about returning to Keene that evening. He was bound for Windsor, Vermont, by the same train, so we had an early supper at the Parker House and rode the Boston and Maine

until I got off at Keene. My new acquaintance was Homer Saint-Gaudens, the only son of the sculptor Augustus Saint-Gaudens who was then at the height of his fame. I knew the name well for Thayer often spoke of him with warmest admiration and respect.

I entered Harvard in September 1899, and during the following year Homer and I were much together. It was the beginning of our long and troubled association. He had rooms on Brattle Street, and I roomed on the top of Gray's Hall with Edward Clark Whiting, my Cousin Ted from Berkshire. Our room was heated by a coal-grate, when the fire didn't go out, and down three flights of stairs were the toilets and shower baths. However, Ted and I didn't mind for we had known some of these inconveniences before, he on the farm and I in Dublin. I have been grateful many times to the Spartan life of Dublin for later it conditioned me to take in my stride hardships in remote places in France and Italy and also in the first World War.

At Harvard I was a lax student. I took a course on art appreciation from an aged professor at the Fogg Museum and learned nothing. I enjoyed a course in writing under Professor Barrett Wendell, a glorious teacher, and another course on world history with Professor Coolidge. The rest of my time I spent studying the pictures in the Museum of Fine Arts and at the Public Library under the magnificent murals of John Singer Sargent and Puvis de Chavannes, for even at this time I aspired to be a mural painter.

Homer and I shared an insatiable appetite for the theatre. Seats were inexpensive and we went from burlesque at the Old Howard to Verdi's *Otello* at the Opera. We saw Henry Irving and Ellen Terry in their classical repertoire, and also contemporary plays: *The Second Mrs. Tanqueray*, Julia Marlowe in *Barbara Fritchie* and the young unforgettably charming Ethel Barrymore in *Captain Jenks of the Horse Marines*. We tested our youthful capacity for hard liquor at the Reynolds House and sharpened our liking for wines and good food at the Hotel Touraine. In fall and spring we canoed in parties on Charles River and one one of these expeditions I met a future friend, Witter Bynner.

During the first months of our freshman year, Homer's
parents were living in Paris where his father was finishing
his statue of General Sherman, the statue for which he re-
ceived the Grand Medal of Honor at the Salon of that year.
Then Saint-Gaudens' doctor found that his patient had
cancer, and in the spring of 1900 he returned to this country
for an operation in Boston.

On his recovery, his Boston doctors forbade his living in
the city and he made his summer place, "Aspet," in Cornish,
New Hampshire, his permanent headquarters. It was a true
"G.H.Q." of art, for Saint-Gaudens was not only a distin-
guished sculptor but an artist whose sound judgment and
ready tact were in constant demand by the various art com-
missions in the country. The isolation of Cornish made his
good nature less vulnerable to these demands than a resi-
dence in New York would have been.

Homer spent the summer of 1900 at Aspet with his father
and mother, and in August I visited him there. The land-
scape of Cornish was a revelation of delight: the down-
pouring of the hills into rich meadows by the Connecticut
River, the domination of Mount Ascutney, towering over
land and river; the size and density of oak, maple and birch,
nourished by heavy river fogs and the grand bulk of the
giant white pine, all these filled me with wonder. Aspet it-
self was rich in white pine, which often grew in protected
gullies, and in one of these ravines, near the house, were a
brook and icy swimming pool. There, as I splashed in it, the
pines seemed to touch the sky.

The house and grounds of Aspet amazed and delighted
me as much as the Cornish landscape. It was the first house
I had seen whose grounds had been treated with an attempt
at formality. The formality was loose and easy but to my
eye, bred to the lawns and picket-fences of Keene and the
forest recesses of Dublin, Aspet looked as formal as Aunt
Lizzie's photographs of Versailles. The sharply clipped hed-
ges of white pine impressed me indelibly and now, sixty
years later, I still clip away at the hemlock and privet hedges
on my own summer place in Keene.

At Aspet the hedges barred the house and lawns from the

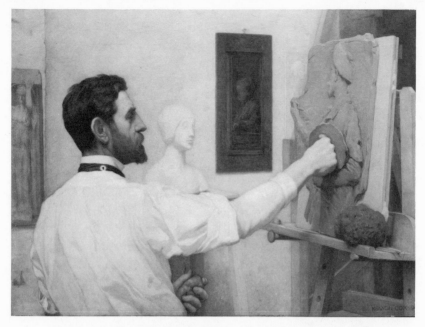

Augustus Saint-Gaudens. Portrait by Kenyon Cox, 1908

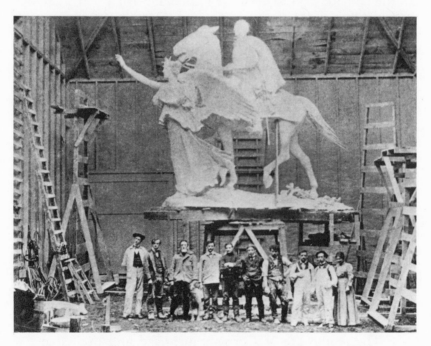

Saint-Gaudens studio, Cornish, 1901. Left to right beneath the Sherman statue: unknown, James Earle Fraser, Saint-Gaudens, Harry Thrasher, Henry Hering, unknown, Antonio (studio boy), two unknown helpers, and Elsie Ward

main road. More hedges concealed the kitchen and stable from the main part of the house which had been an old-time tavern of red brick, known as "Huggins' Folly." A stately thorn acacia grew beside it. The old house was now surrounded by an artificial terrace and balustrade, and to its western end had been added a wide veranda with Doric columns commanding a sweeping view of Ascutney and the Vermont hills. Near the house was Mr. Saint-Gaudens' private studio, a converted stable which he had used since he had first come to Cornish; and at a distance a big studio newly built, where his assistants worked.

Homer met me at Windsor and as we reached the veranda my hostess approached with long, graceful strides. Mrs. Saint-Gaudens, born Augusta Homer, was of good height and figure, but in repose the expression of her wrinkled face was grim, for she was deaf, pitifully deaf. She greeted me politely, and presently Mr. Saint-Gaudens came from his studio and joined us. If Mrs. Saint-Gaudens suggested the climate of northern New England, Mr. Saint-Gaudens himself radiated the warmth of the Mediterranean. He had a large head and a long straight nose, which made one line with the slope of his forehead. His beard and heavy rumpled crest of hair were reddish. He looked like nobody I have seen before or since, except perhaps the head of Zeus on a worn Greek coin. The power and warmth of his personality created spontaneous liking and respect and at once captured my loyalty and affection.

His kindness toward me never failed. Later he often had me at Aspet when Homer was absent. His older friends, except Jimmy Finn [the painter and architect, James Wall Finn], seldom visited him, for Mrs. Saint-Gaudens was not cordial to them. Once he said to me, "Barry, don't mind what Gussie says, *I* want you here." My green and boyish enthusiasms must have entertained him for in his Cornish exile he longed for diversion, gaiety, bright colors and blazing fires, anything to distract him from his recent collision with death.

The studio life at Cornish surprised and excited me as

Frances Grimes and Augustus Saint-Gaudens. Cartoon by Saint-Gaudens

much as had the way of life in Dublin. Here was a world of
collaboration in the arts, exhilarating and undreamed of.
Saint-Gaudens modelled his portraits, reliefs and busts him-
self, and made the small scale models for his monumental
work. These were enlarged, by means of a huge and ingeni-
ous mechanism called a "pointer", to the required size, and
completed by the assistants under the Master's direction,
for he could no longer climb ladders to work on scaffolds.
"The Saint", as his assistants called him, came to the Big
Studio once or twice a day and directed his helpers by draw-
ings and careful verbal instruction.

The Big Studio was a lively, sociable place and I was al-
lowed and even encouraged to visit it. There began my life
long friendships with the sculptors Frances Grimes and
James Earle Fraser. Frances was a beautiful woman of thirty
with a lovely speaking voice. She moved with languid grace.
The languor was deceptive for her character was alert and

vigorous, her mind clear and searching. She was wise and discreet and she became Saint-Gaudens' confidante, and stayed with him until his death. After he died, she joined her group of friends in MacDougall Alley in New York.

In the long list of Saint-Gaudens's pupils and assistants, Fraser was perhaps his favorite. Fraser was a vigorous athlete, a good-looking young man of twenty-two or so, who usually could do with a hair-cut. He was good at any game, and he initiated Saint-Gaudens into the excitements of skating and hockey and the pleasures and exasperations of golf. "The Saint," in his New York youth, had had no time for fun except street fighting; and with returning health he delighted in any new diversion. He understood better than his wife the difficulty of inducing vigorous young men of talent to give up city life and maroon themselves beside the Connecticut. Her face grew dark when he took a couple of assistants away from work for an afternoon of golf. She economized in petty ways to offset her husband's lusty extravagance, who when he could not find a hammer or pencil under his hand, ordered them by the barrel from New York.

At the time of my first visit to Cornish, Fraser lived in the house with his "patron" and ate with the family. One day at luncheon I unwittingly committed a first rate blunder. Grace, the waitress, brought in a handsome custard pie and Madam said to Fraser, "You don't wany any custard pie, do you?" He murmured that he did not. After this glacial beginning others refused the pie too, but when my turn came, I piped up, cheerfully, "Why yes, Mrs. Saint-Gaudens, I'd love some pie." A hush fell over the luncheon table broken by Saint-Gaudens clapping his hands and exclaiming, "Good for you, Barry!" Do not fear that Fraser went hungry, for at night in his bureau drawer he would find half a chicken and the remains of the pie smuggled in by the cook, that fine understanding woman, Nellie Bryant.

Saint-Gaudens and his assistants took an interest in my landscape sketches and in the fact that I was Thayer's pupil. The solidity and simplicity of Thayer's painting, his bold assertion of form, appealed to them as sculptors; they felt

it more akin to their own work than the delicate impression-
ism of many contemporary painters. My new friends also
took an interest in my prospect of going to Italy with Thayer
for the winter, for Father, true to his word, had agreed that
I should leave Harvard. So I departed from Cornish in a
rosy cloud of excitement and best wishes, and my own fer-
vent hope that I might return there the next summer.

V

Italian Winter

with the Thayers

New York harbor, December 1900. The dingy iron pier vibrated with clamor and bustle. The last of the cargo was being hoisted into the hold and the tiny freighter was getting up steam. One of its two stewards was hunting for a missing trunk, and a small group of relatives who had made their farewells aboard ship, moved along the pier waving hands and handkerchiefs.

Up the gangway we walked: a file of six people, at our head a strong, vigorous boy carrying a shotgun in its case. He wore no hat and his tousled hair was dark. He had the "speaking eyes" of a poet and walked as one accustomed to having mountains underfoot; but a weak mouth and chin marred the splendor of his appearance. This was Gerald Thayer.

His two sisters followed him, both dark and both remarkable for the beauty of their eyes. Their woolen garments were heavy protective coverings rather than dresses, suggesting the costumes of Esquimo ladies. On their feet were heavy Norwegian boots. Their brother wore the same footgear.

Next came Uncle Abbott, a handsome man, alert and moving with quick assurance. He, too, carried a gun, and had the same eloquent eyes as his children. Behind him came two young men, one slender and tall with ivory white skin, smooth and unaccented; the other ruddy, short, and broad-

bottomed. He was short-sighted and wore a pince-nez and was so eager and clumsy in his movements that he was continually stumbling and falling down. As he hurried up the gangplank he stumbled and all but fell with the package he carried. Luckily he recovered himself without dropping the package which held the fragile and very expensive water-filter, which was to protect the party from the typhoid germs of Europe. The three men wore knickerbockers and Norfolk jackets. The two latter were George Ferdinand Of and myself.

In that order we boarded the freighter *Tartar Prince*, prepared to spend a winter in Italy.

I had met "G.G.", as Of was called, in the summer of 1900 when he was painting landscapes and copying one of Thayer's pictures. He was a gifted artist and came from a family of famous framemakers. This was the first ocean trip for both of us, and the Thayers, who were immune to seasickness, watched us sharply for any sign of weakness. I did well until the day when the ship's steering gear broke and the *Tartar Prince* wallowed horridly from side to side. I sat forlornly on deck and did not join our party at lunch; then at one fearful lurch, I rushed to the rail and threw up. I made it in time did the job neatly and the Thayers never knew for sure the extent of my disgrace.

The four other passengers besides ourselves were pleasant and friendly and we soon made friends with the ship's officers. Uncle Abbott drew the portraits of the purser and of the boat's splendid cat "Menelik." His biggest hits were the drawings he made on the walls of the deck. The *Tartar Prince* was not spotlessly clean, and the deck walls were coated with a thin layer of coal dust. On their surfaces, Thayer with his thumb, made huge drawings of leaping tigers, mermaids on rocks, cats chasing birds in flight, and schooners under full sail. The drawings surprised and delighted all of us, especially the officers and crew.

The first sight of land after days at sea, to one who is new to the ocean, brings an unforgettable thrill which cannot

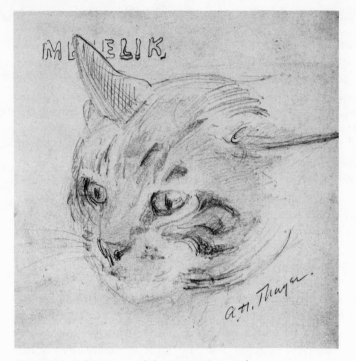

"Menelik," ship's cat of the *Tartar Prince*, drawn
by Abbott Thayer, en route to Italy, 1901

quite be repeated on later travels. I had that thrill early one
morning when I stuck my head out the porthole and saw the
wharves and houses of Ponta de Garda in the Azores: the
throbbing life of the wharves, the unfamiliar costumes of
the natives and the gay rowboats coming to the steamer
laden with knick-knacks and luscious tropical fruits. We
had a day's stopover there. I rushed ashore, where I was met
by a Mr. Nichols, a friend of my Ripley aunts who had spent
two years in Ponta de Garda. My aunts had written him
that I would be on the *Tartar Prince*, and he showed me the
town, gay and pretty, white and pink, shaded by palm and
eucalyptus. The experience was like a dream, which con-
tinued when at sunset the *Tartar Prince* passed Mount Pico,
pink and immeasurably tall as it rose sheer from the ocean
floor.

Early on the trip I noticed that Mary Thayer spent more
time sitting with G.G. as he painted, holding his paints and

generally ministering to him. Presently, to her father's dismay, she announced their engagement. Uncle Abbott had no objection to G.G. as a son-in-law, but remembering the effect of sea air on Mary's temperament he thought it unfair to the young man. His displeasure was not lessened when Mary dropped and broke in fragments our famous water-filter. (We survived its loss without mishap.)

Thayer's prime interest in coming to Italy was to collect bird skins for his already large collection and to gather further data for his projected book *Concealing Coloration in the Animal Kingdom*. So his first business in Naples was to procure gun-licenses for himself and Gerald. In late December Cousin Emma joined us in Naples. Since she was a poor sailor, she had taken a fast boat from New York to Le Havre, and came from there by rail.

In spite of its spectacular beauty, Naples did not please the Thayers. They were distressed by the cruelty of the peasants, who brought to market live kids and chickens swaying upside down from the axles of their carts; by the dirty ways of the market women, who washed their lettuces in the public urinals, and finally by a stalwart matron with heavy panniers who with legs astraddle the rails, stopped our street car, while she placidly relieved herself, to the encouraging hoots of the by-standers.

We climbed Vesuvius, looked fearfully into the seething crater, and slid back down the slope through the soft ashes. From Sorrento we climbed on foot to a *pensione* at Sant' Agata on the height of the Sorrento peninsula. It was a small and primitive place. The *padrona* had not expected us, and for supper could only offer cheese, bread, wine and an omelette; not bad for hungry people, excepting Uncle Abbott, who for years had believed that eggs poisoned him. Luckily, his hunger overcame his fear, and he ate heartily of them with no dire results, proving to himself that he had outgrown his former weakness.

Sant' Agata was a lovely place with splendid views up and down the coast and of nearby Capri. Gerald and I explored rough trails which led down to the sea and to mysterious caves and tiny beaches, handy spots for smugglers

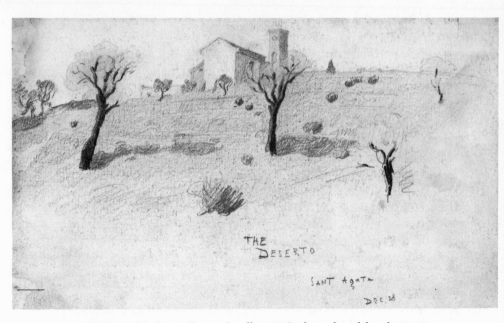

Sant' Agata. From Barry Faulkner's Italian sketchbook, 1901

not so long ago. We sketched and tramped for a week until the beauty of Capri drew us away. We sailed there in a small boat; the sea was lively and I thought that even the Thayers looked slightly green. My innards were in turmoil but I managed to keep myself to myself, and landed without mishap.

Is there any place as tiny as Capri whose landscape holds such variety and drama? Monte Solaro towers over the brightly colored little town, sitting in the saddle of the Island between its two harbors; to the north was the promontory of the Timberio down whose legendary precipices Tiberius chucked his friends and enemies. Then the delight of the rural peace of Anacapri, away from the noisy town; the delight of stretching out among the yellow broom of Monte Solaro's cup-like top, or walking through the olive groves to the lighthouse at the island's southern ·tip; of watching the infinitely varied colors of the sea, the sea birds flashing past the cliffs, whose crannies are studded with flowers of the most intense blue I have ever seen.

We came to Capri for a day and stayed nearly three months. The place suited everybody, the bird collectors and the artists. I rented a studio, at four dollars a month, a high vaulted room in an old palace and, for the first time, drew from the nude. The studio was fiercely cold but my models minded the cold less than I did. My drawings were crude, but Uncle Abbott watched my efforts with interest and was seldom too busy to give a criticism. In the afternoons I painted landscape or explored the island with Gerald and his father. On our comings and goings, we sometimes met a tall, lank figure in a long monkish robe, wearing immense goggle-eyed spectacles and on his flowing hair a cowboy hat. He was a German artist living in a high-walled villa, in whose seclusion he and his family went naked, according to the peasants' report. True or not, the souvenir shops in Capri town were full of his playful silhouette designs of naked children leaping, dancing and jumping through hoops. They sold famously.

In our hotel I shared a bedroom with Uncle Abbott and at dawn he was out on the balcony working on his picture of Monte Solaro and the town of Capri, lit by the rays of the rising sun. I watched him from my slothful bed but was too sleepy to reap full benefit from this rare privilege.

In January, 1901, Queen Victoria died. The flag of the English Tennis Club was at half-mast and the sorrow of the English residents and tourists was heartfelt. The Thayers could not share their regrets, for they were heart and soul pro-Boer.

In March we left for Rome.

In Rome the bird collecting became intense. The Italian pot-hunters shoot any birds from wren to raven, and early each morning Uncle Abbott went to market and returned with many kinds of pretty little song-birds and sometimes with a rare species of hawk or quail. The birds had to be skinned immediately; the stress of work became too great for Gerald and his father, so they instructed me in the delicate art of enlarging a bird's rectum sufficiently to roll its skin tenderly back from its carcass. I then cut the carcass away from the skull and wings, put on rubber gloves and

rubbed the hide with powdered arsenic, rolled the skin back in place and stuffed the body with cotton. We labelled them carefully and stowed them away in boxes lined with cotton.

It was fun working with Gerald and Uncle Abbott, but my real interest was studying the frescoes in the Vatican. The hours I spent in the Stanze, the Borgia Apartments, and the Sistine Chapel were endlessly exciting. Thayer on two previous brief trips to Italy had seen only the picture galleries and was unaware of the beauties of the wall paintings. Gradually my enthusiasm for the frescoes infected him, and on days when the bird skinning was not too pressing he went with me to the Vatican. The colors of the Borgia Apartments delighted him and he compared them to the beauty of feathered birds.

One day in the Stanze we met a young American painter who was copying at full size Raphael's *School of Athens.* His name was George Breck, and he was the first painter chosen to go to the newly founded American Academy in Rome. I had never heard of the Academy, but Thayer knew its Director, and that afternoon we called on him at Villa Aurora, high on the Pincian Hill. I had no notion that a few years later I should spend my first winter in Rome as a student in the Academy.

We also visited Thayer's friend Elihu Vedder in his vast studios, which had once been those of Fortuny, close outside Porta del Popolo. Vedder was a majestic figure with his powerful features and walrus mustache, wearing skull-cap and heavy dressing-gown. He was full of zest and anecdote, and although he was at that time one of the most accomplished of American mural painters—I would say he is best remembered for the great *Minerva* in the Library of Congress—he chose to show us the small sketches and paintings he had made in his student days in Paris.

After Rome came Assisi and Perugia. With the exception of Cousin Emma, who rode in a carriage with the suitcases, our party walked from Assisi to Perugia. There Gerald, Gladys and I invented the Walking Game Recipe: begin with any street in an Italian town, keep on to the first turning to

the right, from there take two turnings to the left, repeat
the rhythm and in an hour or two, without a guide book,
you will have discovered much of unexpected interest.

Perugia, perched proud as a falcon among its abrupt hills
and ravines, was ideal for these discoveries. We started from
the Pisani fountain in front of the Cathedral and plunged
down a steep narrow street whose houses were buttressed
against one another by arches high over head. After the
prescribed turns and twists we came abruptly out of the
twilight of the streets to the city's walls with a dazzling view
of olive groves, farm houses, and slowly budding fruit trees.
To one side a finger of the Perugian hills invaded the rural
loveliness, crowned with the battlements, towers and roofs
of the old medieval hornet's nest. Another day we happened
upon the colored facade of the Oratory of San Bernadino,
whose figures, delicate as flowers among their ribbons and
swirling draperies, held an early Renaissance whisper of
the Baroque.

However, the great surprise in Perugia was the Sala del
Cambio whose rooms are decorated by Perugino and by his
youthful pupils, Raphael and Pintoricchio; the parent of the
Borgia Apartments and of the Stanze. Thayer's enthusiasm
for their rich and ordered beauty was so great that our party
made off to Siena and Pintoricchio's Library in the Cathe-
dral; nor were we disappointed in its balanced oppositions
and in the flash of its peacock colors.

Next came Florence, to which Gerald, G.G. and I walked
while the rest of the party went by train. I had expected to
see exciting things on that forty-mile tramp, but I remember
little except an overcast sky, a mournful landscape and a
biting wind. So when at eight o'clock we saw a street-car
marked "Firenze," we climbed stiffly aboard, rode the last
few miles to town, and rejoined the family at Hotel Ber-
chielli.

Among the wealth of fine things in Florence which I
studied closely were the paintings of Botticelli, the statutes
of Donatello, and Benozzo Gozzoli's frescoes in the Ricardi
Palace. Benozzo also became a prime favorite with Uncle
Abbott and on the way to Sardinia we stopped at Pisa and

saw in the Campo Santo his enchanting vintage fresco *The Drunkenness of Noah.*

One incident in Florence tickled my vanity. The Thayers admired William James next to idolatry. Mr. James happened to be in town and they took me with them to call on him. For some reason I had to leave before they did and when they saw me again they asked me in wide-eyed wonder, "What do you think Mr. James asked after you left? 'Who was that unusually intelligent looking boy you had with you?' " Did I gain status in their esteem or did the philosopher go down a peg?

Our party separated at Florence. Galla, Mary and Mrs. Thayer went to Venice, G.G. to Germany to visit relatives, and Uncle Abbott, Gerald and I to collect the skins of seabirds, flamingos and eagle vultures in Sardinia.

At Golfo di Orosei we stepped into the harshness of a primitive world, a brutal contrast to the surface complacence of a tourist's Italy. The people came of an old Mediterranean race; were shorter than the Italians and more taciturn. Men and women wore black and white costumes, handsome and severe, sometimes relieved by a red waistcoat or crimson skirt. The women had kerchiefs and the men black stocking-caps with a long tassel.

All day, our funny little train jolted through a landscape wild, grand and inhospitable. On one side, indigo mountains, the lair of brigands and vultures, stabbed the sky. On the other a dreary plain rolled to infinity. Now and then, far off, we glimpsed the crumbling mounds of prehistoric barrows. At many stations, soldiers were herding onto the train files of pathetic, undersized bandits, handcuffed and chained together.

At dusk we reached Cagliari, the capital of Sardinia. Cagliari has no smile, but frowns from its abrupt outcropping of rock upon sad salt marshes. Our hotel rooms were dirty, and Uncle Abbott washed most of their contents with carbolic acid. Luckily our stay was short for we had a letter to Signore Bonomi, a local taxidermist, who arranged a hunting trip for us near Teulada in the southern part of the island.

We were to leave the day after Easter and Signore Bonomi kindly invited us to share Easter dinner with his family. None of us had been inside an Italian home before, let alone that of a taxidermist, and on entering the *salone,* we were startled to meet a collection of defunct household pets stuffed in attitudes both rampant and couchant. Another surprise was the richness and extent of the Easter dinner. Course followed course, until we Americans were reduced to a feeble pecking at them with hearty exclamations of *"Molto buono!"* Conversation was sketchy, for *"Grazie"* and *"Molto buono"* were almost the limit of our Italian vocabulary, Signore Bonomi's English was hardly more ample, and his family had no English at all. No matter! We had a charming evening, warm and friendly.

We sailed across the Gulf of Cagliari next morning, slightly seedy after the Easter orgy, and rode in an ox-cart, less jolty than our train had been, to a village not far from Teulada. Suddenly Sardinia had burst into spring! Warmth and hosts of wild flowers greeted us, the people were lively and friendly and we were happy and welcome. Could this lovely seacoast be a part of that Sardinia I had thought forbidding and dreary?

Cagliari. From Barry Faulkner's Italian sketchbook, 1901

We lodged with a prosperous farmer named Dessi, of whose pretty daughter, Efissia, Thayer made a drawing and with whom Gerald and I fell in love.

Each morning we went out for birds in the boats of the sardine fishermen, among rocky islets clothed knee-deep in anemones and less familiar wild flowers. The genial fishermen as they drew in their nets ate the sardines alive, an example which I followed with gusto.

The Thayers had good luck with the seabirds and I helped in the skinning. One day they gave me a cormorant, a vile greasy bird. When I finished him I was as greasy and repulsive as the cormorant, and to clean up I stripped and dived into the sparkling water among the sardines. We lunched off bread, wine and cheese and at night returned to Efissia and a hearty meal at the Dessi farmstead.

Spring's glorious outburst warned us that we had only a few weeks left before we took ship for home. We parted at Cagliari. I went to Venice and Gerald and his father to the marsh country of Oristano, where they bought a dead donkey and sat in a blind near it, in wait for eagle-vultures. They shot two fine specimens which afterwards hung from the roof of Thayer's Dublin studio.

I was full-up with new places and pictures, and did little about them in Venice. I "swam in a gondola," sat in the Piazza looking at the glory of Saint Mark's, fed the pigeons, and bathed at the Lido. One day, William Gedney Bunce, an artist friend of Uncle Abbott's, invited us to go with him for a fish dinner at Chioggia, a famous fishing town below Venice. Mr. Bunce, known to his friends as "Kidney Beans," had lived in Venice for years but could not speak the Venetian dialect. At the restaurant, we were at an impasse until a bright young waiter selected the menu for us and we had a spanking meal.

My last memorable experience in Venice was Eleanora Duse in the first performance of D'Annunzio's *La Città Morta*. The play seemed all talk of which I understood little, but I was spell-bound by Duse's lovely voice and matchless grace. At the final curtain Duse and the poet bowed to applause as loud as thunder. Together they were an unfor-

gettable sight—she tall, all dignity and grace, he short, runty and ignoble, smirking and throwing kisses to the audience. Beside her he looked a small pig in evening dress.

Our party left Venice for Genoa and rejoined our *Tartar Prince,* whose officers seemed pleased to see us, for the voyage home. By the first week in June 1901 we had landed in New York.

VI

Apprenticeship, MacDougall Alley

I found recently in a tattered sketch book a drawing of a group of children, dancing on the grass before an old farm house. They are dancing a Virginia Reel and a tall boy is leading one of his little sisters down the center. In the background his tall, slender mother holds a baby in her arms, and his father scrapes merrily on a fiddle. It is my earliest memory of the Brush family at Brush farm in Dublin, New Hampshire.

George de Forest Brush, the American Indian and "Modern Madonna" painter, created a Mozartian world of charm and other-worldliness, a silver echo of *The Magic Flute*, with its gay nonsense and grave mysterious undertones. What a family they were! The seven children greeted life with warmth and gaiety and danced to the cheerful rhythms that Mrs. Mittie and Papa George supplied them. They were beautiful, courageous, light-hearted, bubbling with humor; but when serious matter was in hand, they approached it with the light and tender touch of true reverence.

I met them in Dublin the summer after my Italian sojourn. That summer, too, I made friends with the Pumpelly family. Elise and her brother Raphael (of the swamp episode) both wrote verse, and their sister Daisy was a distinguished painter. Young Raphael was a romantic figure to Gerald and me, for he had seen the domes of Samarkand and with his father had excavated buried cities in Asia. Professor

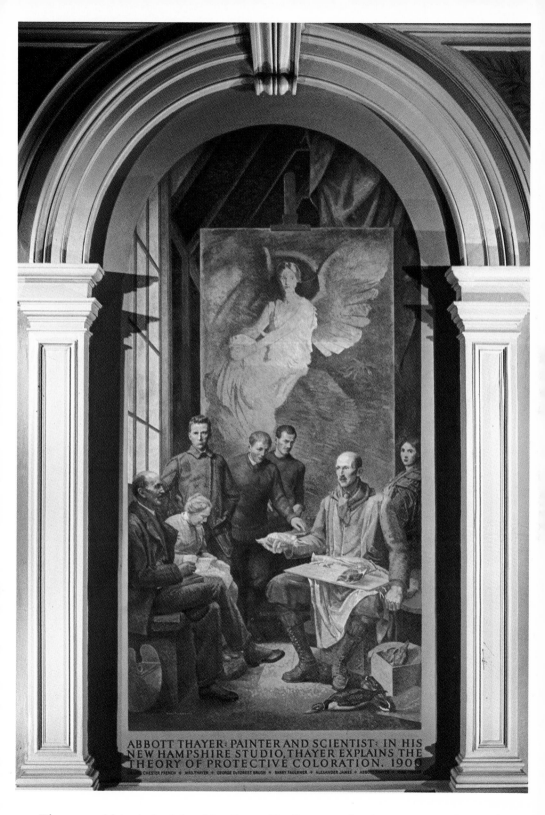

Thayer and his circle. Mural by Barry Faulkner in the State House, Concord, N.H., 1942. Left to right: Daniel Chester French, Mrs. Thayer, George de Forest Brush, Faulkner, Alexander James, Abbott H. Thayer and Mary Thayer.

The Boat. Barry Faulkner's amusing and imaginative fantasy of Homer Saint-Gaudens and his future wife Carlota Dolley at Silver Lake, Nelson, New Hampshire. Tempera painting, about 1905.

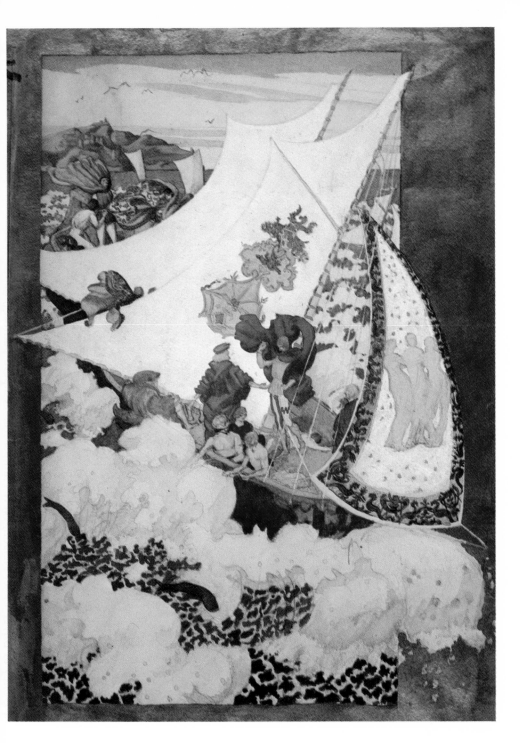

The Tempest. A study in tempera and water color by Barry Faulkner for a mural decoration for Mr. and Mrs. Edwin O. Holter, Mount Kisco, New York. This study was done about 1914.

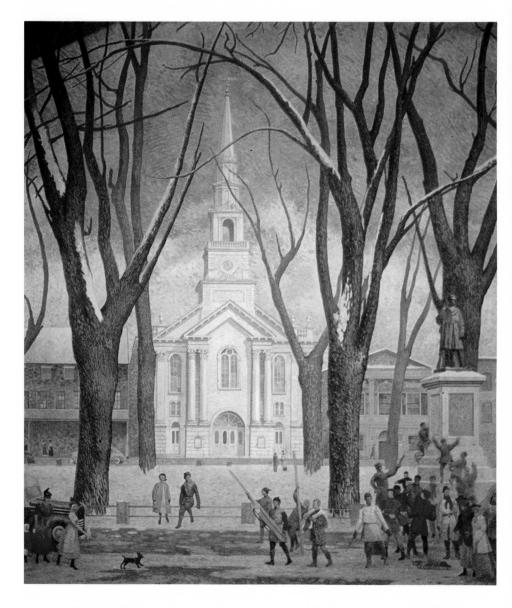

Central Square, Keene. Detail of mural decorations in the Elliot
Community Hospital, Keene, New Hampshire, completed by
Barry Faulkner in 1943. A preliminary sketch for the same murals
will be found on page 3.

Raphael Pumpelly, father of these three, was a celebrated geologist. He wore a long silver beard and, when not exploring for iron and copper deposits around the Great Lakes or surveying the minerals of the Gobi Desert, was a choice companion at the Century Club and in the circle of Henry Adams. His book, *Across America and Asia,* is one of the most absorbing stories of travel and adventure I have ever read. In Dublin, Professor Pumpelly built a spacious Florentine villa overlooking the lake and Mount Monadnock.

The Pumpellys and their cousins the Joseph Lindon Smiths were pivots in Dublin life. Joe, when not in Egypt painting his records of ancient sculpture and bas-relief or scouting Europe for old masters for Mrs. Jack Gardner, was Dublin's "indispensable man." He combined the gifts of an artist with the gaiety of a comedian; he was creator of many festive pageants, in which he himself played the comedian's part. Joe Smith had first come to Dublin in the early 'nineties, and his summer home "Loon Point" on the lake was not far from the Thayers' and in those days was reached by a winding dirt road. He and his wife, Corinna, grand-daughter of the publisher George Palmer Putnam, were married in 1899. She was a woman of energy and intelligence, a glorious brunette with a mind as brilliant as her beauty— a dazzling contrast to her cousin Elise Pumpelly, who was as fair as Corinna was dark. Over the years she was my loyal and inspiring friend, and in our old age I relied much on her wisdom and judgment.

In the fall of 1902 I moved to New York where I had a few friends, James Earle Fraser, Rockwell Kent, who had studied with Thayer, and Witter Bynner, whom I had met at Harvard. Father gave me an allowance of sixty-five dollars a month. This was ample in 1902, and out of it I paid the rent of a hall bedroom, school fees and food. Breakfast, as I remember, cost fifteen cents for two eggs, toast and coffee. Bananas were very cheap, and once in a burst of economy I made my lunches off nothing but bananas and ever since have loathed them.

But even without this unpleasant economy I had enough

left from my allowance for a gallery seat at the theatre and
a Saturday-night extravagance at Mouquin's, the artists'
restaurant, on West 28th Street, where I drank one Martini
and ate the cheapest item on the menu, lamb's fries.

Week-day mornings I drew in Frank Vincent Dumond's
life class at the Art Students' League. I was the poorest
academic draughtsman in the class, unless it was John
Marin, and after Dumond had demolished our efforts, we
walked the streets together in rage and frustration.

Father visited me in the March of the following year. He
met and liked my friends, and we had a happy time together,
for which I have always been grateful. Two weeks later a
telegram came: Father had had a heart attack and was dead.
He was fifty years old.

My father was not a wealthy man, but he left enough for
Mother and my sisters to live in comfort, and for Philip and
myself to finish our educations. I determined to earn my
keep, at least in part, and took back with me to New York
letters of introduction from Thayer to mural painters of
his acquaintance. I also carried with me a series of composi-
tions, reminiscent of the story-telling frescoes I had seen
in Italy. They were gay and informal, and interested Thayer
and Saint-Gaudens; they resembled no student work with
which they were familiar.

Armed with Thayer's letter and my sketches, I went first
to see the muralist Edwin Blashfield, whose marvellous book
Italian Cities I so much admired. His studio was in Carnegie
Hall. I rang the bell and walked straight into a fortune-
teller's parlor, complete with seeress, beads and Oriental
draperies. The lady was primed for business, but I eluded
her and reached Mr. Blashfield through an inner door and
staircase. He turned out to be a tall, rather stiff-looking
man, spectacled, with white mustache, high white circular
collar and white cravat. My sketches interested him, but he
already had two regular assistants and could not take on a
green hand. However, he filled me with joy by buying one
of the sketches.

From Carnegie Hall I went to the Tenth Street Studios
of John LaFarge, whose masterpiece is of course the decora-

tion of the Church of the Ascension in New York. His assistant, Ivan Olinsky, took Thayer's letter and my compositions into him, and after a while he returned and said Mr. LaFarge would see me. I was unprepared for the appearance of this famous scholar and distinguished mural painter. Before me sat a wrinkled Oriental sage, huddled on a couch, staring at me through owlish double-lensed spectacles. He asked a few questions which I answered confusedly, and when he realized how thoroughly inexperienced I was, with a wave of a hand he motioned Olinsky to take me away.

Mr. Robert Blum was my last hope. Blum, then a man in his mid-forties, had leapt with ease from easel painting to murals, and had earned a reputation as a brilliant technician. He looked over my compositions, and to my astonishment engaged me to make the design for a stained glass window. Although I had rarely seen a stained glass window except in the Episcopal Church in Keene, I carried away the blueprints and set to work.

Mr. Blum died within the week, so all my hopes were totally dashed.

During the next four years, I studied now and then at the Art Students' League and the Chase School, the latter presided over by the mustachioed and indefatigable William M. Chase, painter, lecturer and teacher. Chase, a contemporary of Thayer, probably influenced as many younger painters as any other man of his generation. Between schools, there were short-lived jobs as a mural assistant, illustrations for the *Century* and other magazines, and I copied a Pompeiian fresco for Mr. Saint-Gaudens. Summers were spent with Mother in Keene and visiting Dublin and Cornish. I scraped along and made few inroads on Father's legacy.

Witter Bynner was among my new friends in New York. Hal, as everyone called him, was a poet, a vivid young man, witty, high-spirited, full of ribald laughter. We shared various literary tastes and hatreds; a boyish worship of George Meredith, *The Shropshire Lad,* the acting of Mrs. Fiske and contempt for "Great-Aunt" Thackeray. We talked endlessly, and looking back on those days I feel something of Justice

"Young Girl in White." Drawing by Barry Faulkner of his sister Katharine, which appeared as an illustration in the *Century* magazine, August 1908

Shallow's nostalgia for "The Chimes at Midnight." Bynner
was to the left in politics; fond of left-wing causes; and for
a time influenced me in that direction. Since then I have
inched steadily to the right, never quite getting there, living
in a skeptical state of mind, pleasing to nobody but myself.
At this time Hal was assistant editor at *McClure's* magazine,
and the first of his many books of poetry, *Young Harvard*,
came out in 1907. He also translated Chinese poetry, and
later his own poetry became increasingly condensed and
oblique. He went to China and upon his return moved to
Santa Fe, New Mexico, whose distance from New York
broke our intimacy but has not dimmed the memory of the
enthusiasms we shared and our laughter over things trivial
and serious.

I enjoyed my new acquaintances, but the sculptor Jimmy
Fraser was my standby, my elder brother, my advisor. His
studio was at 3 MacDougall Alley, I was not far away; I had
a hall bedroom on West Tenth Street over Cecchina's res-
taurant, across from the Marlborough Arms where Homer
Saint-Gaudens and Hal Bynner shared an apartment.

Before the days of Greenwich Village fame, MacDougall
Alley looked almost rustic. It was paved with cobblestones
and shaded, here and there, by trees leaning over from the
backyards on either side. Some of the North Washington
Square houses kept their stables there, and on pleasant
days the stable boys washed the carriages and groomed the
horses outside in the sunlight. Edwin Deming, the painter
of Indians, lived with his family next to Fraser. The young
sculptor Victor Salvatore was across the way, and Daniel
Chester French worked at Number Eleven in the studio I
afterwards occupied. French, a New Hampshire man, had
yet to create his monumental seated Lincoln for the Lincoln
Memorial in Washington, but he was already considered
an "Immortal" in American sculpture.

The Alley was a sociable place. One night a week we drew
from the model in Fraser's studio, and there I learned more
from watching Jimmy and John Flanagan at work than I had
at any art school. Flanagan, then in his late thirties, had
studied in Paris and had also been a pupil of Saint-Gaudens—

of whom he later did a fine portrait bust. We young men often lunched at Mrs. Bertollotti's Bar in the basement of a house on Fourth Street. The Bar was largely patronized by huge truckdrivers, but there was a table or two for those hungry as well as thirsty. Mrs. Bertollotti was a very handsome woman, who always served us dressed in fresh white muslin and sparkling with diamonds. Under her skillful management the Bar grew into a famous restaurant.

Presently Blendon Campbell, Fraser's chum in their Paris days, took a studio in the Alley. His wife Delia, a charming, warm-hearted woman, loved to have her friends around her and seemingly could not have too many guests at her bountiful table.

One morning I heard a tap on my bedroom-studio door and there stood George Brush, fresh from Italy. Having left his family in Florence, he was in New York to paint the portrait of a young boy. He had taken a studio in the old *Life* building and wanted me to help him settle it. I introduced him to MacDougall Alley. The Alley welcomed him and couldn't have enough of him; his charm, bubbling humor and sincere interest in the work of the young artists endeared him to one and all.

Brush was a born comedian, with an actor's mobility of facial expression. The Campbells, who kept open house at their studio, would sometimes give a charade party. Blendon was also an excellent actor, and together he and Brush gave the most amusing charades, in which young Ruth Draper joined. At the end of these evenings we could sometimes persuade Brush to dance the Dog Dance with its repeated rhythms and accompaniment of barks, which he had danced years before with the Crow Indians on their reservation in Montana.

It was a good time to remember, a time with everything before us and as yet few regrets.

Saint-Gaudens continued his kindly interest in my welfare, and in the autumn of 1904 I was in Cornish gilding and tinting in water-color small reductions of the head of the *Sherman Victory*. I lived at the Westgate farm about a mile above Aspet with three of the Saint's assistants, Frances

Grimes, Elsie Ward and Henry Hering. Elsie was a gifted sculptress, a small and vivacious girl, whose hair, when she uncoiled it, was so long it reached the floor. She later married Hering, who was a devoted disciple of the Saint's and had been with him most of the time since 1900. Another of the assistants was Harry Dickinson Thrasher, a talented and good-natured Cornish lad two years my junior, who was to become a good friend later on. One morning Saint-Gaudens went to New York on business taking with him Hering and two other men assistants to freshen them after the privations of country life. I was alone at the Westgates' with the girls. After our six o'clock supper, Frances stepped out the door, and came back saying she had seen what looked like a fire in the direction of Aspet. I pelted down the road while Mr. Westgate hitched up his horse and followed with the women.

At Aspet, no one was on the place and the fire was burning fiercely. Mrs. Saint-Gaudens had taken the night watchman off duty to drive her out to dinner, and the house servants had left for an outing. The fire started in the sheds and storehouses attached to the Big Studio, and afterwards no one could or would explain its cause. The roof of one of the storehouses had already fallen in, and the fire was eating into the east wall of the Studio. I slipped into the studio and the first thing I carried out was a small low-relief portrait by Frances Grimes, her first original work, and hid it in the bank of the ravine behind the studio, knowing that Mrs. Saint-Gaudens would be annoyed if she knew what I had done.

And now the girls and Mr. Westgate arrived, as well as Michael Stillman and Marion Nichols, a niece of Mrs. Saint-Gaudens' and the yard was filling with friends and neighbors. We carried to safety the heavy bas-relief portraits but the two large, nearly completed statues of Parnell and Marcus Daly on their pedestals we could not budge. Clever Elsie Ward sprang up a step ladder and rescued the heads which were detachable from the bodies. The heat, the fury of the fire, and the confusion increased, but we saved modelling tools and stands, big turntables and other valuable

Mount Ascutney from Cornish. Pencil sketch by Barry Faulkner

studio apparatus. Mr. Westgate sprained his back carrying out a large cast-iron stove. Rose Nichols, Marion's sister, frantically begged us to come out, which we did just as the studio's great north light crashed to the floor. Mrs. Saint-Gaudens stood upon a rise of ground, black, silent and motionless.

The blaze was now at its height and a breeze was carrying sparks onto the horse stable near the house. I climbed to its low roof and covered it with wet blankets which were handed up to me. The disaster was all but complete; not only were the big statues destroyed, and valuable studio apparatus too heavy to move, but Saint-Gaudens' portrait by Bastien Lepage, letters from Robert Louis Stevenson, and the furniture from his former home in New York.

Next morning, somewhat stiff from last night's exertions, I went to inspect the ruins. Mrs. Saint-Gaudens met me there and without a word of thanks dismissed me from the place. She said there was nothing more for me to do. She was right but I resented her ungraciousness.

Homer Saint-Gaudens, Witter Bynner and other friends were often at my family's summer place at Silver Lake near Chesham, and it was here that Homer met Carlota Dolley. In June 1905 they were married. Carlota's father, Dr. Charles Dolley of Swarthmore College, and his family spent the summers nearby at Nelson on a hillside overlooking the lake. Carlota, blonde, handsome and Junoesque, had attracted scores of eager young admirers before Homer triumphed.

The Dolleys were part of what was then called the "Pennsylvania Settlement" of Nelson, whose nucleus was a remarkable woman named Miss Olivia Rodham. Miss Rodham was a learned Quaker lady from Swarthmore, an ardent botanist, a lover of poetry and early nineteenth century literature, who radiated light and inspiration to all who knew her. Around her in Nelson gathered a group of her scholar friends and their families: the Dolleys who lived at her place; J. Duncan Spaeth, Shakespearean authority, crew coach at Princeton and apostle of the "outdoor life;" Professor Henry Rolfe, also a Shakespearean scholar; Professors

Seneca Egbert and Thomas Lightfoot, the latter a noted
naturalist; and Margaret Redmond, a painter and worker
in stained glass—all of them with Philadelphia roots or con-
nections.

Miss Rodham lived on the highest hill above Silver Lake.
Her establishment was an enormous old barn which—much
in advance of her time—she had converted to cathedral-size
living quarters. The barn was the living room, the bedrooms
were in the hayloft, divided off by curtains, beneath them
a library, and a tiny kitchen and dining room were attached.
On one of the high boarded walls hung a huge lithograph of
Rosa Bonheur's *Horse Fair*. Miss Rodham named her place
"Headlong Hall" after one of the mid-Victorian novels of
Thomas Love Peacock. Swift and precise in thought and
motion, tender yet discriminating toward human weakness,
endowed with a bubbling sense of humor, she was a magnet
to young and old. Young people were in and out of "Head-
long Hall" during those summers: Bynner, Homer Saint-
Gaudens, the Dolley brood, and Rosamond Elliot, whom I
had known since boyhood and whose family's place Lead
Mine Farm was up the road.

Back in New York I began studies for a small mural for
an imaginary building. My sister Dora and Annie Rule,
Mother's housekeeper and devoted companion, posed for
some of the figures. I painted it later at the Thayers' in a
studio over an open woodshed. It was zero weather and I
sat on a small schoolroom stove, which was supposed to
heat the studio, painting as fast as my ice-cold hands per-
mitted. The canvas was well hung in the Architectural
League exhibition in New York.

Early in the autumn of 1906, Miss Simpson, secretary of
the Architectural League, asked me to bring her samples of
my work; she refused to tell me why she wanted them.
Hoping it might be for a mural commission, I went back to
the flat in an old house on West 24th Street which I then
shared with Hal Bynner and Freddy Pope, and waited in
uneasy expectation. The flat had hot water but no central
heat, and we depended on coal grates which too often died
in the night.

I slept late one morning, after a convivial night, and at nine Fred roused me saying a gentleman wanted to see me. Bynner was loudly singing in the bath as I tottered, bleareyed, into the living room. Fred was kneeling among the cinders of last night's fire trying to revive it, while a gentleman in morning coat and silk hat stood by, uncertain of a clean place upon which to sit.

My visitor was the mural painter, H. Siddons Mowbray, who told me I had been chosen to go as student-painter to the American Academy in Rome, of which he had been director a few years before, and was now a trustee. I was half awake; I knew little of the Roman Academy; I liked my New York life where I believed I was making my way; so I boorishly mumbled, "I don't care to go."

Mowbray realized my bewilderment and hangover and said I should think it over and meet him at the Century Association that afternoon at four. I talked with Fraser who advised me to accept, for it meant three years' study in Italy with all expenses paid. So at four I entered the Century Clubhouse for the first time. Mr. Mowbray was the only member in the vast half-lighted rooms where years later I was to enjoy much good compansionship. At the time they seemed as gloomy as any tomb, and gloomily I accepted the scholarship.

Just before I sailed I had an extraordinary windfall: Fraser, who was an intimate of the E. H. Harriman family, told me that the Harrimans would commission me to make studies for two murals in the house they were building on a mountain top at Arden, New York.

I rode the crest of the wave and in dazzled excitement boarded ship to find in my cabin a sheet of verses by Bynner, illustrated by Carlota Saint-Gaudens, Homer's wife, which showed a fat boy—myself—leaning against an Ionic column, a fiasco of wine beside him, puffing a fat cigar. The verses ran:

> Here's to dear little Barry
> Who's going by London and Parree
> To Rome to raise prices, mustachios and vices
> His companions, Young Nick and Old Harry.

VII

Rome and Florence

The crest of the wave was high and choppy developing into storm. I shared a cabin with Edward McCartan, the young sculptor, who was on his way to Paris, and to save our pennies we went second class. It was February 1907, and our boat, the *Etruria,* an old Cunarder, was cold as a refrigerator. In second class the smoking room was our warmest retreat, and we reached it along the spray-lashed deck, clinging to a taut rope stretched to prevent a sudden big wave from washing us overboard. Only a few passengers joined us in the smoking room and most of them came in feet first, landing angry and bruised under a table on the far side of the cabin. At the height of the storm a passenger died, and the next day we watched his canvas shroud slip into the ocean.

The *Etruria* stopped at Cobh, then Queenstown, and I saw the lovely hills of Ireland for the first time. McCartan and I gave London a hasty goingover, had a calm Channel crossing, and parted company in Paris, when I went on towards Rome.

Next morning I woke in Italy; glittering Alps on one side and on the other, silver olive orchards on terraced hills, gaily painted farm houses, slender campanile piercing the groves of ilex and stone pine. All was as enchanting as the memories of my first visit.

I crawled out of the Paris-Rome express, stiff and tired

after my two-day trip and drove to Villa Aurora, the tempo-
rary home of the Academy. The villa stood on a huge out-
cropping of rock and earth jutting like a small Gibraltar out
of the Pincian Hill. Modern streets had cut into its sides and
high retaining walls supported it. From its small garden
filled with ilex and nightingales the student could look
down on Rome or watch the trim American girls entering
and leaving the Hotels Boston and Beau-Site. When there
were no more girls to watch he turned his attention to the
panorama of the city, the shabby, enticing, splendid city of
Rome. Over its tumult of tiled roofs he faced the Janiculum
Hill, crowned with the statue of Garibaldi; to his right was
Piazza del Popolo, the bubble of Peter's Dome, and every-
where emerging from the maze of streets and roofs were
the domes and pinnacles of Rome's thousand churches
framed in the Campagna and the Alban Hills.

The student should look searchingly at the town, for
here lie the influences likely to decide his career for better
or worse. Rome is an over-rich layer-cake of civilizations
and periods in art which, if eaten greedily, results in indi-
gestion. After a series of stomach-aches, the shock lessens;
his mind becomes less agitated and he begins to feel at home
with the repose of the Classic and the fire of the Baroque.

In spite of overeating of this feast, the eight or ten stu-
dents I found at the Aurora took kindly to the surprises of
Roman life.

The villa combined splendid surroundings with primitive
living conditions: the ground floor was handsomely frescoed
by Guerchino, yet our small bedrooms on the top floor had
no running water or baths. Each morning, hot water in big
brass containers was carried up from the kitchen, and we
busied ourselves with our sponges. Once a week we had a
general boiling out at one of the public baths.

We each received a gigantic key to the outer door of the
villa, a key fully ten inches long and heavy in proportion.
This we attached by a string to the keys of our studios which
were nearly as big and balanced the two carefully in the
armholes of our waist coats, thus preserving the linings of
our pockets and the symmetry of our figures.

Our studios were down in the city. We ate at the cele-
brated but all too ancient Caffè Greco. Since the beginning
of the seventeenth century the Greco had been the resort
of foreign artists; Claude and Poussin were reputed to have
take their ease there. Whatever ease they enjoyed they took
away with them, for in our day it was a dark, dingy, hard-
seated place, with poor food and just passable coffee. We
ate in a narrow corridor at one side of the Caffè, decorated
with faded landscapes by German artists who at one time
had eaten there. This nook we shared with some lively stu-
dents from the Academy of Malta, and to keep our minds
off the quality of the food we pelted one another with hunks
of the hard stale bread.

Elihu Vedder, whom I had met with Thayer in 1901, was
now in his eighties, with velvet skullcap and impressive
mustache. He might join us in the evening, and entertain us
with stories of his early days in Rome, when he smoked his
pipe and took a nap under the stone pines in the arena of
the Colosseum, when Garibaldi and his Red Shirts entered
the city and the Forum was a cow pasture. He was thought
by many to be the greatest American muralist of his time.

My studio was in Via Margutta, a side street off the
"Street of the Baboon." It was an Italian MacDougall Alley,
filled with the studios of Italian and foreign artists. My
studio was large and high with a north window looking up at
the Villa Medici among the pines on the Pincian Hill.

I never tired of my walk from the Aurora to the studio,
down the Spanish Steps, past the flower stands, splashed
with color, and the medley of peasant models waiting to be
hired. Here were models for every artist's need and taste;
young Madonnas, wrinkled Witches of Endor, ripe Junos,
slim shepherd boys, old men with grizzled beards, and plenty
of alluring young nymphs. These models came from two
mountain villages in the Abruzzi, Anticoli and Saracinesco.
The models from Saracinesco claimed descent from a band
of the Saracen pirates who in the Middle Ages infested the
Italian sea-coast. Their ancestors, cut off from their boats
and pursued into the hills, took refuge on an inaccessible
peak, kidnapped peasant girls and bred there. I believed the
tale when, on a trip to the Abruzzi, I rode on muleback up

the only access to the village, a dizzy spine of rock dropping into bottomless valleys. The village was gaunt and tiny but the people gay, strong and healthy. The features of some of them carried distinct traces of their Moorish ancestry.

After exploring the wonders of Rome with my new friends Arthur Bein, Ernest Lewis, Fenhagen and Lucien Smith I began my prescribed academic work, a life-sized figure picture, subject: *The Archer*. My small study for the picture had promise; when it was enlarged the alarming fact stared me in the face that I knew little about full-scale figure painting.

When the weather turned warmer in March, I began my second assignment, the copy of a Renaissance work. I chose the interior of the loggia at Villa Madama on Monte Mario. It had been a papal casino, designed by Raphael, whose pupils decorated the loggia with delicious stucco designs accented with color. The villa was deserted, damp and mouldy, yet in its dilapidation the beauty of the loggia survived. French soldiers may have billeted there, at the time of the siege of Rome, for high on the stucco were French names scratched in pencil. I delighted in the lonely spot, free of tourist or fussy guardian.

In August 1907 Mr. Saint-Gaudens died. His death was a grief to me for I loved him and owed him much gratitude for his many kindnesses. My depression was deepened by the rejection of my studies for the Harriman murals. I was bewildered and shattered, and paced the battlements of Bracciano and considered casting myself into the dreary lake. However, youth and conceit upheld me, for the rejection was accompanied by the suggestion that I try again with a more decorative scheme. I had received an invitation from George de Forest Brush, who was in Florence with his family, and decided to seek Brush's counsel. I journeyed by way of the hill towns, and imperceptibly the works of art and the incomparable landscape took hold, and my hope and ambition revived. I settled into Perugia and in ten days made a fresh project: *Famous Men and Famous Women* based (with variations) on Perugino's frescoes in the Sala del Cambio.

What would Brush think of them? Well, on arrival in

Florence I found Brush not only approved, but heartily ap-
plauded them. "Give them to me," he said. "I'm going to
New York in a few days and I'll show them to Tommy Hast-
ings. [Hastings was the architect for the Harriman house]
You can bet he'll accept them!" When I voiced doubts about
my ability to paint competently the many figures, he said,
"Nonsense! Come up to Florence next winter and paint
them. If you need any help from me, you shall have it!"

I came back to Rome and to the Academy's new home, the
Villa Mirafioria outside Porta Pia; a villa built by King Vic-
tor Emmanuel II for his mistress, Countess Mirafiori. Its
grounds were large and dreary, planted with American
spruce and hemlock. Our quarters were comfortable with
plenty of showers and toilets. We no longer ate at the "An-
tico Caffè Greco," for we messed in a large dining room
under a ceiling frescoed with grapes, birds and monkeys.
But in spite of the Mirafiori's many comforts, I missed the
distinction of the Aurora.

There were new faces around our dining table, among
them, Edgar Williams, the architect, and Sherry Fry, sculp-
tor and friend of the Brush family. Fry was a tall, reddish
young man, energetic, impulsive, full of tall stories of his
experiences to which I delighted to listen. He was a mid-
Westerner, had studied under Lorado Taft in Chicago and
with Frederick MacMonnies, and was now on a three-year
fellowship at the Academy.

A week before Christmas the architect Charles A. Platt,
a director of the Academy, knocked at my studio door and
greeted me with an invitation to go sight-seeing. Platt was
twenty years my senior. I had first met him in Cornish,
where he had a house not far from Saint-Gaudens, and we
had renewed our acquaintance in New York. He had not
been in Rome for several years, and since his last visit one
or two interesting places had been opened to the public,
notably the castle of Sant' Angelo. Platt delighted in the
frescoes in the papal apartments, and on the spot commis-
sioned me to make a copy for him of a frieze by Piero del
Vaga. We then went to the near-by Penitensieri Palace
with ceilings in the style of Pintorrichio and Michaelangelo.

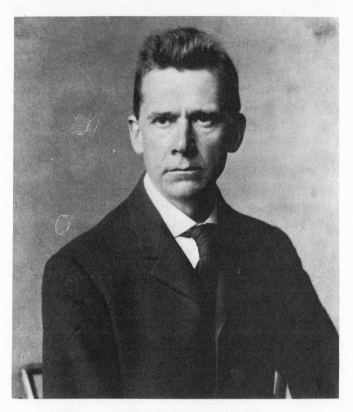

George de Forest Brush

Pageant at Florence, Christmas 1908. Robert
Pearmain, Gerome Brush, Barry Faulkner, and
George de Forest Brush

From there we rushed to his old friend, the photographer
Moscioni, and Platt commissioned him to photograph the
ceilings complete. After lunch at the Concordia, I showed
him Villa Madama, and then we went to his hotel for din-
ner and bridge. Platt was usually a man of few words; chit-
chat seemed to bore and tire him, and he took refuge from
it at the bridge table or at poker. All the way to Rome he
had played bridge, three-handed, with his wife and her
sister Miss Hardy. All were heartily sick of it and warmly
welcomed a fourth, even a tyro. Bridge and sightseeing
continued through the week and we celebrated Christmas
Day at Tivoli and Villa D'Este. There were no other tour-
ists, and we wandered at will through the as yet unrestored
beauty of the gardens. I had guessed at its splendor in boy-
hood, from Platt's photographs in his book *Italian Gardens.*
After lunch at the Syrene in the mist and music of the
waterfalls, we climbed to see the view from the Castello,
and visited the local jail, where Platt bought a Christmas
treat of wine for the prisoners—a treat most of which I sus-
pect the jailer kept to himself. Beneath his reserve, Platt
was a man of sensitivity; he was talented and versatile. After
winning distinction as a painter and etcher in his youth, he
went on to become one of this country's foremost archi-
tects and landscape architects. His love for the Italian Renais-
sance is visible in much of his work, notably the Freer Art
Gallery in Washington.

In the meantime, much to my relief, the Harrimans had
accepted my new studies, and after the New Year I left for
Florence. Brush had been as good as his word; his compel-
ling enthusiasm had carried all before it and persuaded Mr.
Hastings and the Harriman family to give me the commis-
sion. I was elated but still very far from being out of the
woods, for I had no experience at drawing and painting on
such a large scale, and my sketches called for fourteen or
fifteen life-sized figures. I had no thorough instructions at
art school, and my early instruction with Thayer, although
invaluable, in no way fitted me to dash off two murals, ten
by twelve feet in dimension. Fortunately at the time, I did

not fully realize the hole I was in, but I was well worried. Worrisome too was the attitude of the Academy. To leave Rome for a long period (except in summer) and to accept a commission while a student, was against the rules, and naturally the director, Mr. George Breck, objected. I replied that if the New York trustees also objected I would give up the scholarship.

I reached Florence early in 1908 to find that Mr. Brush still lingered in New York. But Mrs. Brush was there with her son, Gerome, and her six beautiful and lively daughters, from Nancy, the eldest, then almost eighteen, to little Thea, who was only four or five. They were living at that time at the Villa Gioiello in a fine situation near the Michelangelo Piazza. The house was the remains of a medieval building, where Galileo had once taken shelter, and its grounds looked down into the Boboli Gardens. The property was worked as a market-garden, the peasants came and went, and all around were the pleasant sounds of country life and of other people's labor. The interior of the house was austere and handsome with vaulted ceilings and tiled floors, and the Brushes lived there with the same simplicity and warm hospitality as they did in Dublin. They urged me to use Mr. Brush's studio, and Gerome offered to teach me his father's method of drawing which he understood thoroughly.

Gerome had strained his heart and by doctor's orders was spending a quiet year with his family. Gerome was a Personality. His high spirits spread a feast for his friends, a feast of wit and good humor. His character had no ugly traits. He had no formal education, yet with wits as quick as those of a fox, from the talk of his father's distinguished friends he picked much information which he understood and remembered. His talents were versatile; he became a sculptor and painter, and in his last years he wrote several admirable essays on the lives of famous Italian women painters, expressed in an original and exciting form of poetic prose. Our friendship was easy and undemanding; after years of separation we were able to pick it up just where we had left off.

Gerome quickly taught me his father's method of draw-
ing and I made a creditable life study for Leonidas, one of
the "Famous Men" in the Harriman murals; then painted
the figure life-size with a portrait of Gerome for the head.
This I offered to the Academy as the prescribed figure
painting of my second year.

When Mr. Brush returned from America in the late spring
he was well satisfied with this first figure. I now buckled
down to work in earnest, and by the end of the year, when
I left Florence, Brush had taught me competent academic
drawing, and one of the murals was half-finished. After his
return I rented a studio on Lungo il Mugnone on the north
side of town, sharing quarters for a time with Robert Pear-
main, a young artist from Boston, who had come to study
with Brush and subsequently married his eldest daughter,
Nancy. Here under Brush's guidance I continued the life
studies and ordered the canvas for the final painting.

The leisurely tempo of life in Florence was admirably
suited to Brush's habits of work, which were: work all day
and every day. The serene monotony gave him the freedom
his industry demanded. There were few friends in the city
to press their claims upon him; and the friends who passed
through lent a pleasant variety to life. In the Villa Ball, a
little beyond the Roman Gate, he had a roomy double studio,
and there spent his long days working with precision and
energy. He laughed at artists who could not work without
inspiration. "Get before your canvas and paint," he said.
"Don't hang around. Inspiration may come to you unawares,
and if it does, there you are ready to do something about it."

The studio was large, lofty, and as bare as my hand, a
curious contrast to the tiny crib in which he painted in Dub-
lin. The furniture was of the simplest kind, a couple of
peasant chairs, an easel, a lay figure for posing drapery, a
hand-carved frame or two, and a few pieces of rich velvet.
His family were his models. They were his most genuine
inspiration, and in Villa Ball he created some of his happiest
masterpieces.

Brush had a gayer attitude towards art than most artists.
Few of his contemporaries gave out the same sense of joy-

ous crusade that he did, the happy dedication to the rocky
road to perfection where you lost your life to find it. "After
all," he said, "how could you more nobly perish?"

The severity of his instruction, however, was no joke.
One of his all-too-frequent comments, of which Gerome
and I made a byword, was: "Well, that's pretty good! Now,
start all over and begin it again!" Stiff medicine, when you
might have worked for two months on your luckless canvas.
Many of his pupils couldn't take it, but those who could
profited immeasurably. It freed them from uncritical smug-
ness, and gave them muscles to wrestle with perfection. His
approval of work, his enthusiasm and praise more than com-
pensated for former censure. The charm and persuasion of
his instruction was infectious. He was so completely a mas-
ter of his craft, that his explanations made problems seem
easy; and when you understood him fully, your work im-
proved by leaps and bounds.

The contrast between the painting and the characters of
Brush and Thayer could hardly be more marked. Brush built
up his pictures with the care and foresight of a Van Eyck.
Thayer's canvasses were battlefields, whose issue was
sometimes long in doubt. Brush was interested in methods.
Thayer went at painting hammer and tongs, and had a
relish for obtaining immediate effects by unorthodox means,
such as rubbing dust over a spot of paint he thought slightly
too light, or smudging a drawing with his thumb.

I recall an incident to illustrate the point. One day the two
men were in Brush's studio in Dublin looking at a freshly
completed painting.

"Wonderful, George, wonderful!" said Thayer. "One of
your finest things, but I think if that high-light on the brow
were reduced a fraction it would be improved."

And reaching down into a dim corner of the studio for his
favorite light reducer, he started for the canvas. But Brush
was quicker than he and darted with outstretched arms
before his picture, horror-stricken and amused at the same
time.

"No! Not that, Abbott, not that!"

My year in Florence with the Brushes was not all peace

and serenity. In the spring of 1908 tragedy struck the family.
Their third daughter, Georgia, sickened and died, just be-
fore Mr. Brush's return from America. When her death
was approaching, her mother asked Nancy and me to take
the other girls to Forte dei Marmi, where the family often
summered. The younger children, unaware of what was
happening at home, viewed the trip as a joyride and seized
every opportunity for fun. We changed trains at Pisa, and
having to wait a couple of hours, we went to the Campo
Santo, where—before I could stop them—the girls were run-
ning up the Leaning Tower. The exterior gallery by which
one ascends the Tower had no protective railing; my young
charges paid no attention to their chaperone's commands
and curses and gaily ran up and down regardless of him and
equilibrium. Years after, I asked Thea, the youngest, if she
remembered my terror. "Oh yes," she said, "and we were
just as frightened as you were."

August 1908, and a happier interruption. From a dock in
Liverpool I watched the S.S. *Republic* come into her berth;
compared to the *Tartar Prince* she was imposing. The waving
figures on the deck looked tiny. Among them I saw a gay
bonnet, a little girl's hat, and thought "One of those over-
dressed American children." A moment later I saw Katha-
rine waving frantically, then Mother, then Dora, under the
bright hat; grinning from ear to ear they waved until their
hands almost came off. How good it was to see them, after
a separation of a year and a half! Mother's beauty was un-
changed, Dora as darling as ever, and Katharine, a lively
and beautiful girl of twenty-one just out of Vassar, much
stared at in the streets.

We spent a week in the Valley of the Wye, then on to Ox-
ford and London. After the heat and brazen blue of the
Italian summer I revelled in the soft English rain and cloudy
skies. I returned to Florence with them the first week in
September, and we put up at Villa Trollope, an English *pen-
sione* near my studio. Mother and the girls decided to stay on
during the fall and winter.

Villa Trollope was a large comfortable house built by that
copious novelist, Mrs. Frances Trollope, the mother of

"Mrs. Pearmain." Drawing by Barry Faulkner of Nancy Brush soon after her first marriage, about 1911

Head of Barry Faulkner. Pencil sketch made by Nancy Brush about 1909

Anthony and Augustus. It had been a favorite *pensione* among British authors ever since George Eliot had been delivered of *Romola* in the upstairs front drawing room. Thomas Hardy, Anthony Trollope and Eden Phillpots had written books there, and in one of the downstairs drawing rooms was a low, crimson-upholstered chair with sweeping fringes known as "Ouida's chair," upon which the authoress had reposed in the evening after dinner.

The winter of our stay at the Trollope lacked authors but was a hotbed of drama. Its proprietors, Mr. and Mrs. Hope, were retired actors and in one of the drawing rooms put on the genteel comedies of Tom Robertson. The Hopes rather prided themselves on not learning their parts thoroughly, and I had a busy time as prompter, occasional footman or telegraph boy.

In the meantime I completed the studies for "Famous Men," enlarged them on the canvas, and laid in the background. Just after Christmas our peace was broken by the giant earthquake which totally destroyed the city of Messina and more or less rocked all Italy. On more than one night the tremors shook my bed and I awoke to the tinkling of the carafe and glasses on the night-stand. The weather was foul and rainy; at the Cinema the pictures of the disaster added to our gloom and depression.

Soon after the New Year, word came from the American Academy Trustees in New York that I must go back to Rome or forfeit the scholarship. The Brushes were leaving early in 1909 for their farm in Dublin, New Hampshire. I had accomplished my purpose in coming to Florence; the family wanted to see Rome, so I easily swallowed my declaration of independence and returned there in April.

My scholarship now had less than a year to run, and in Rome once again I renewed friendships and took up the threads of life at the Academy. The family intended to stay on another month or more. Katharine was an eager and intelligent sight-seer, and with Mother somewhat reluctantly in tow, we sallied forth into the Alban and Sabine Hills, to Frascati, the Lake of Nemi, Villa d'Este and the Cascades

of Tivoli. Eleven-year-old Dora, who hated picture galleries, ancient monuments, and "atmosphere," spent mornings at my studio cooking our luncheon of eggs and chicken livers which the concierge, Sora Giulia, brought for us. When the hot weather drew on, the family left for home and Keene.

At the Academy I found the Brecks had vanished, and Mr. and Mrs. Frederick Crowninshield had taken charge of Mirafiori. They were a wonderful pair, sharply contrasted in temperament and physique; a muralist himself, he was tall, thin and somewhat withdrawn; she ample, witty and outgoing. He craved heat, she liked cold. So on the rare evenings when they had no guests and they invited me in for a chat, I found Mrs. Crowninshield in the chill, pink *salone* and Mr. Crowninshield in the adjoining card room shivering over a smouldering Italian fire.

Among the new Fellows at the Academy in 1909 was Paul Manship, and that summer and fall we formed a friendship that lasted for more than fifty years. When we first met, Paul, then about twenty-four, was slim, short and sturdy, and his head was covered with a fuzz of hair on its way to baldness. He was a lyric sculptor whose humor enlivened everything he touched. He possessed an exceptional power of concentration and an ardor for all things connected with sculpture.

Before I left Rome, the Wright Brothers came on their tour of Europe and I saw my first airplane in flight. On a level stretch of the Campagna, a high platform with sloping runway had been built. On the top of the platform sat the Wrights in their fragile-looking plane. Presently the plane slid down the runway, took off near the ground, rose slowly, circled the field at an altitude not greater than thirty or forty feet; yet there it was in the air—and this was Flight! It was the moment human beings had craved since time out of mind; to fly like a bird—even a slow and clumsy one. Drunk with pride and wonder we rushed after the plane and beneath it, screaming and sobbing with excitement. A new era had begun; but I did not see another plane until seven years later in the First World War.

I left Italy in good spirits. Just before I packed up, a group

of Academy Trustees came to Rome to investigate the Academy's problems—among which I was an item. Mr. Crowninshield brought them to see the Harriman mural and to decide whether I had broken the academic rules too seriously to receive a diploma. At the time they made a few comments, but they gave me the diploma and I returned home, if not spotless at least belatedly dry-cleaned.

Famous Men. One of Barry Faulkner's mural decorations for Mrs. E. H. Harriman's home at Arden, New York. His first mural commission.

VIII

Commissions and Friendships

Three years, even if one is in Italy, is a long time to live away from friends and country. I was heartily glad to get back. Fraser, Bynner, the Campbells and the denizens of MacDougall Alley welcomed me warmly. In Keene, I found Mother and the girls flourishing, and Philip, now through law school, was established in Judge John Allen's law office. The next few years—until the First World War dislocated all our lives—were a time of expanding friendships and the appearance of new commissions. New York remained my headquarters, and there were summers in New Hampshire and an occasional foray to Europe.

In the summer of 1910, George de Forest Brush invited me to spend three months with the family at Brush Farm in Dublin. Here I converted a nearby barn into a studio, and by fall I had completed the *Famous Men* for Mrs. Harriman. I lived at the Farm five days a week and went home to the family for weekends. On Monday mornings I took the seven o'clock train from Keene, got off at Chesham station near Silver Lake and drove to Dublin with George Bemis. George, who had known me since I was ten years old, was seething with curiosity as to how much I was paid for the Harriman picture, but refrained from pumping me. One morning, however, when he drove Witter Bynner, who was visiting friends at Silver Lake, to see the picture, he gave tongue:

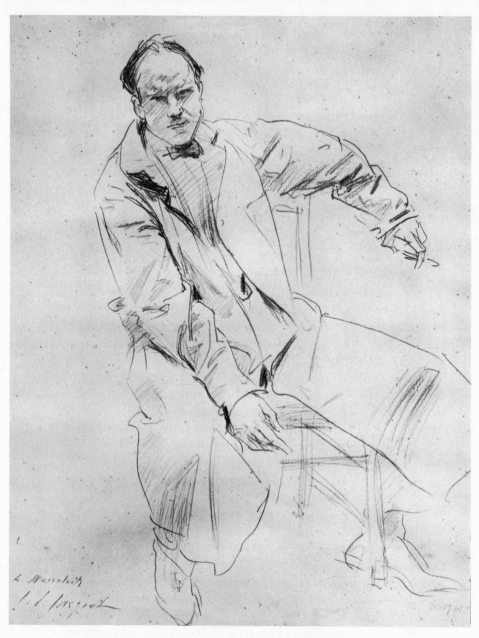

Paul Manship. Drawing by John Singer Sargent, 1921

George: (cautiously) "They say that Barry is getting a thousand dollars for that picture."

Bynner: "I think he's getting a good deal more than that."

George: (long pause) "And to think there was some folks who thought Barry Faulkner was a goddam fool!"

Having finished *Famous Men* in Dublin, I began *Famous Women* that fall in New York in a loft in the Tiffany Studios on Fourth Avenue. "The Men," when I exhibited it at the Architectural League, aroused considerable comment, tepid among the critics, favorable among the architects. Taste had begun to change even before the Armory show, and although the mural created no furor the architects employed me steadily from that time on.

It was fine to be in New York with old friends and new. Gerome Brush dropped in from time to time and his sister, Nancy, now married to Robert Pearmain, lived there one winter. Sherry Fry, returned from Rome, had a studio in the Lincoln Arcade Building (now replaced by Lincoln Center).

Fry was born in Iowa and left home to study sculpture at the Art Institute in Chicago, supporting himself by peeling potatoes in the kitchen of a hotel. He invented a potato peeler which peeled potatoes faster than any such device then known. From Chicago he went to Paris and became assistant to Frederick MacMonnies at Giverny. Fry was a brilliant sculptor, swift and sparkling in execution.

When we caught up together in New York he was living with a boa constrictor. On his steamer returning home from Italy he had met a pseudo-East Indian couple—probably Cockneys—on their way from India to seek vaudeville engagements in the States. Not long after they landed, the woman came to Fry in great distress. Her man had been arrested and left her penniless. Fry gave her money and took in exchange the boa constrictor, a handsome carved screen and a small East Indian idol of evil countenance, which the woman said her companion had stolen from a temple. She warned Fry that the idol brought bad luck— witness her own misfortunes—but with bright disdain of supersitition he insisted on having it.

For a time all went well. The boa was gentle and contented, living most of the time in the jungle of water-pipes and electric wires in the walls of Fry's studio, and only coming out to be fed an occasional squab or rabbit.

Then the idol began to show his power and a strange chain of misfortunes resulted. Fry lost an important commission which had been promised him and then, one day when he was fishing, his wallet with his last hundred dollars slipped overboard. This was too much, so when Robert Pearmain asked for the Jinx, he gave it to him, warning him of its evil power. Robert claimed to be immune to superstition; but he sickened and died soon after he came into possession of the idol, and the Horrid Imp sat on the fireplace mantel of the cottage which Robert had built for Nancy and himself on the Brush Farm. One day Nancy's sister, Tribbie, went to the empty cottage and suddenly felt such horror of the idol that she seized the ugly imp and hurled it far in the woods. It was never seen again—but Tribbie did not long survive the consequences of her impulsive act. The finish was a fire in the woods, which destroyed Robert's cottage and later another fire that burned down Mr. Brush's studio with paintings and many drawings.

Were these events a chain of coincidences or a demonstration of the powers of Evil? Choose for yourself.

I moved into a studio at 11 MacDougall Alley and worked there for the next fifteen years. The building was two-storied, the rent sixty-five dollars a month. A tiny entrance hall blocked off the furnace, a sink and toilet. The studio on the upper floor had a good north light with a balcony for storage. I slept and breakfasted at Hotel Lafayette.

The studio furnace was coal-burning, and I engaged a man who lived near the alley to stoke it night and morning, and to give the studio a brush-over. All went smoothly until late at night I went on an errand to the studio. On opening the door I tripped and fell over Raymond's sprawling body. He snored blissfully and beside him lay an empty bottle of my whiskey.

Next morning, instead of Raymond, a smiling little man of about my height, stood beside the furnace: Raymond's brother-in-law, Luigi (Gigi) D'Olivo. From that morning until his death forty years later, Gigi was my friend and a major figure in my life. There were few limitations to his capabilities and none to his kindness and good nature. He was born in Pieve da Cadore, Titian's birthplace, and did his military service in China, during the Boxer Rebellion, in the forces which relieved the Peking Embassies. He was married and had four sons, one of whom was badly crippled by infantile paralysis.

Gigi's hands and mind were capable at almost any kind of work. He was a plumber, electrician and competent carpenter. He had worked with the A. C. Frederick Art Supplies Co. and could build stretchers, could prepare raw canvas—he would have painted the murals if I had asked him. He made 11 MacDougall Alley liveable. It had no celler and he covered a part of the basement's cement surface with a raised floor of wood, making a snug bed-dining-room with connecting dressing closet, toilet and shower. He installed a gas stove beside the sink and then found a cook, Gilda Pellecane. Gilda was a slender handsome woman in her early forties, who walked with a seductive wiggle. She was a widow, had reared and married off her children and now shared her bed and the cask of red wine under it with a burly policeman. Gilda was a native of Mirandola in Northern Italy where the cooking is more delicate than in the South, and I put on plenty of weight eating her delicious risottos and fettucines. Gilda liked to have parties, and after accepting so much hospitality from friends I delighted to have them about my own table.

Paul Manship returned from Rome in 1912. After he married Isabel McIlwaine, they leased a small house and large studio in Washington Mews, off Fifth Avenue, a counterpart to the East of MacDougall Alley. I did not have enough work to give Gigi constant employment, so he passed over to Manship and proved as skillful at plaster-casting, building armatures and helping with Paul's other drudgeries as he had been with my less frequent chores.

With this burden of work Gigi couldn't have slept more than four or five hours a night, yet he was constant in his care of the Manships and of me.

"Faccio Io" (I will do it) was his motto.

Manship's first exhibition in New York was a memorable success. The artists and architects bought all he exhibited, and at his next show at a commercial gallery the public followed their example. Paul struck a fresh note in American sculpture, a note of lyric grace and robust humor expressed with exquisite technical skill. I know of no man with a keener intelligence and more avid curiosity as to all forms of art and their techniques. At work his concentration was formidable but when he relaxed he was a kind, genial and humorous companion.

I recall an incident typical of Paul's humor. He had modelled a pair of griffins to surmount the gateposts of a rich man's estate on the Hudson. The griffins were cast from identical molds, but to make them face one another the head of one had been recast and reversed on the body of the other. The magnate arrived at the studio in a whirl of importance and had but a minute to stay. He approved the fabulous beasts and then suddenly said, "But, Mr. Manship, why is the right hand griffin taller than the other?" Manship looked at his client with amusement and said, "Sir, you surprise me. I've measured them carefully and I believe them to be the same size, however, I'll measure them again." He climbed a stepladder and pretended to measure them with the calipers. Then he turned and said, "Mr. Netherthales, what a wonderful eye you have! I find that the right griffin is an eighth of an inch taller than the other." The wonderful eye relaxed, forgot business and chatted in the studio for more than an hour.

Paul and I had both enjoyed two successful years, and in August 1914 I sailed with the Manship family for Italy. We read of the Sarajevo murders, but had not foreseen their consequences, for at Venice we were amazed to find the banks closed. We had enough cash to reach Rome where we had the backing of the Academy and settled into a small *pensione* in Piazza di Spagna. I had a letter of credit on the

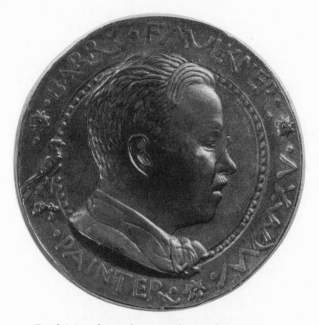

Paul Manship often made medals as personal gifts to his friends. This bronze of Barry Faulkner was cast in 1915. Reverse of medal is below

nearby bank of Sebasti Reali and each morning received five dollars from the hands of genial Mr. Sebasti. I waited in long line with bewildered, prosperous-looking Americans whose florid gratitude at receiving their five dollars was touchingly comic.

A new and magnificent home for the American Academy was being built high on the Janiculum, and Paul, in a month, designed and modelled a fountain capped by the Infant Hercules strangling the Snakes, a symbol of the youthful students' struggles and success. He gave it to the Academy in gratitude for the years he had spent there. It stands today in the inner courtyard of the building and is one of his happiest inspirations. (Another was his *Prometheus* in Rockefeller Center, New York—done much later—and probably his best-known work.)

The Manships and I lingered in Rome until the first tourist stampede for home was over and then returned to New York in the *Europa*, a small ship jammed with Americans and refugees fleeing the impending holocaust.

I had not been entirely idle during our Italian journey, and busied myself with studies for a new commission that had come my way shortly before our voyage. Edwin and Sarah Holter had asked me to paint murals for the large entrance hall of their house at Mount Kisco, New York, and after our return they approved my studies for *The Tempest*. I worked out a scheme in white, gold, green and warm red and finished the decorations in 1915. The Holters were generous hosts and more or less adopted me. He was large, genial and calm, and she enthusiastic, excitable and a lover of both painting and sculpture. Sarah was a skillful gardener and an artist at landscaping. She gradually developed the bare surroundings of "Two Pine Farm" into a series of well-planned gardens and terraces, accented with Manship's sculpture. Her final achievement was a romantic path, carpeted with wild flowers and hedged thick with flowering shrubs and young cedars, which led to a marble swimming pool.

Another friendship gradually developed with Mrs. E. H. Harriman who was pleased when the mural *Famous Women*

received the Architectural League's Medal of Honor. As a result she commissioned me to paint twelve panels depicting the history of New York City for the Washington Irving High School in New York. Mrs. Harriman was a tall, handsome woman, straight as an arrow, with a gentle voice and manner. The portrait of her in low relief by her friend the sculptress and medallist Laura Gardin Fraser (wife of James Earle Fraser) is a true likeness. She invited me now and then to Arden House for house parties, and I remember well the night of a tremendous thunderstorm when from the tower of the house, the naturalist John Muir, Fraser and I watched the chain lightning tumbling and crackling around us and in the Tuxedo Valley below. Mr. Muir said that in his long life observing nature, this was the first time he had seen this phenomenon.

Sometimes I was Mrs. Harriman's only guest at Arden House, and one night as we were playing Russian Bank, an enchanting young woman in a scarlet velvet house-gown came into the room. She was Kitty Lanier, Averill's young wife. The young Harrimans had their own menage in the east wing of the house, and whenever we were at Arden at the same time they would smuggle me down the long corridor to their apartment and ply me with martinis which they knew I preferred to Mrs. Harriman's single glass of excellent sherry. I am sure that Mrs. Harriman knew of these illicit capers, but she said nothing for she knew they were instigated by Averill and to Averill she could refuse nothing.

Most of 1916 was occupied in the more serious pursuit of designing and painting the murals Mrs. Harriman had commissioned for the Washington Irving High School, and by the following spring I had finished ten of the twelve panels. The last two, as it turned out, had to wait upon more momentous events.

When the United States joined the Allies in 1917, Sherry Fry showed me the photograph of a French train and railway station painted in bold disrupted patterns, according to one of Abbott Thayer's theories of protective coloration. He also knew that the French Army had a Camouflage Corps

Indian Hunters. One of 12 panels for the Washington Irving High School in New York City depicting the history of New York. This was among 10 decorations completed 1916-17. The last two murals were finished in 1920.

made up of sculptors, architects and painters, as well as of skilled technicians from the movies and the theatre. In one way or another, many of our friends were engaged in the war effort, and we decided to do our bit by enlisting artists in an American Camouflage Corps. Neither of us had clear ideas of how to apply Thayer's theories to warfare, but most other people had even less; and my association with Thayer gave us bogus prestige. (Thayer himself had made a trip to London in late 1915, hoping to win the British War Office to his theories, but owing to his erratic behavior and increasing nervous disability nothing came of it at the time. This abortive mission further debilitated Thayer and he spent much of the next few years under medical supervision.) Meantime we bustled about, called meetings of the older artists who blessed our project, and collected the names of younger men eager to enlist. We went to Washington, where we interviewed General Leonard Wood and the financier, the younger J. P. Morgan. We even wangled a half-hour with President Wilson's alter ego, Colonel House, who was suave, sympathetic—and noncommittal. There we came to a dead end, for the real problem was to persuade the government to accept the project.

The Officers' Training Corps at Plattsburg, New York solved the problem; unknown to us they had been at work on the same idea. Major Everett Tracy, the architect, was a leading spirit at Plattsburg and through his excellent military connections a Camouflage Corps, the 40th Engineers, became part of the new army. Fry and I enlisted as privates. One September night in 1917 I waited by Blow-me-down Brook in Cornish for the car to take me to the train for Washington; a musty night lit by the flash of fireflies, thick as stars in the firmament.

Major Tracy took Fry and me to the War College for summary physical examinations and typhoid and other shots. He then sent us to a camp on the grounds of George Washington University on the outskirts of the city. Our camp consisted of a single army tent pitched between two white marble buildings. In the tent we found a minstrel, easing his solitude by playing Hawaiian airs on a ukelele. He came

from the Islands and was pleasant and companionable. Our tent was soon filled; there were Dwight Bridge, and Everett Herter, and other friends. When a second tent was pitched and strangers came, we looked on them with contempt and dislike. When a third group filled still another tent, tents No. 1 and No. 2 ganged up against them, the Vets against the Greenhorns. This prejudice continued until we forgot about it and mingled together comfortably.

After several weeks under canvas, the Camouflage Corps moved into regular barracks. My old friend, Lieutenant Homer Saint-Gaudens, fresh from Plattsburg, was our commanding officer. Dwight Bridge was Company Sergeant and I was corporal of the 2nd Platoon. The Corps was fortunate to have Bridge for Company Sergeant for his character gave us a standard to live up to. He was just, sympathetic, and good-humored.

In the mornings the Corps did calisthenics and elementary drill, and in the afternoons took hikes or worked at camouflage. I had no combat training except for one afternoon on a rifle range. Fry's specialty was camouflage, and under his direction the men painted cars and trucks in disruptive patterns; constructed papier-mache dummies of fallen tree-trunks from whose interiors an unseen sniper could shoot; and dug trenches covered with sods and bushes from which soldiers could pop out and discomfit the enemy. President Wilson inspected our labors and complimented Fry on the quality and ingenuity of his work.

As winter came on there was a shortage of winter overcoats, and the Army Quartermaster issued us long blue coats with shoulder capes lined with yellow or red which had been in storage since the Civil War. I noticed that many men in the 2nd Platoon lacked sweaters, mufflers and other warm things. My family and women friends were eager to be useful. Little Dora wrote me, "I know they serve who only stand and wait, but I don't like it." So my family, Keene friends, and the Holters needed no persuasion to "adopt" a soldier, and the sweaters, knitted helmets, scarves, wristlets, cigarettes and candies poured in. I too profited from this enthusiasm, for young Betty Holter kept me in Fatima

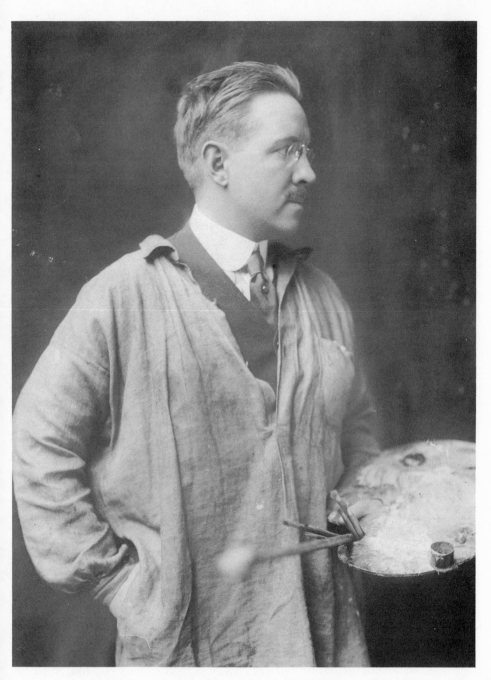

Barry Faulkner with his palette. Photograph taken about 1915

cigarettes while the war lasted. Some of the boys wrote
thank-you letters to their unseen friends and in many cases
a correspondence developed. Lucky Betty received an offer
of marriage from her soldier.

The men of the Camouflage were a lively and talented
lot; the Corps included Dwight Bridge, Everett Herter,
William Nell, Robert Lawson, painters; Bernard Hoyt, archi-
tect, and John Lester Ward, stage carpenter. We published
a newspaper and Lawson, Hoyt, Herter and Bridge wrote
and acted an amusing and brilliant skit on army life for
which "Wardie" managed the scenery and lights. The skit
was so well-liked that they played it in the other camps
around Washington.

I liked army life, but was fifteen years older than most of
the men and sometimes missed the comforts of civilian life.
Homer, who was my age, sympathized and very often gave
me leave to go into Washington from Saturday noon to Sun-
day night. Over these weekends I had a room in Hotel
Powhatan from whose window I looked at Arlington and
saw the morning sun strike the sturdy pillars of the Custis-
Lee Mansion. Later in the morning the room filled with
steam and cigarette smoke while Wardie and his friends
filled the bathtub. They came in either for a hot soak or to
wash their underclothes.

Philip came to see me, somewhat indignant that, without
telling him, I had enlisted as a private, for with his political
connections I could have been a major right off the bat.
Later, in France, I saw more than one of these ready-made
majors fumbling about. I did not regret my decision. There
was a weekend with Katharine, Dora and Mother. Paul
Manship and Witter Bynner came to say good-bye when the
probable date of our going overseas approached; Paul soon
to depart himself with the Red Cross for the Italian front,
and Bynner to become an instructor in the Student Army
Training Corps in Berkeley, California.

Toward Christmas the signs of departure thickened and
in a blustery snow-storm, the Camouflage Corps marched
sturdily and well, in review, before high brass at the War
Office. On the last night of 1917 we entrained for Ho-

boken and at six o'clock on New Year's morning we boarded our transport, a huge German liner interned at the beginning of the war, and slipped past Manhattan, whose towers and pinnacles, studded with lights, made a lasting impression on our minds, excited by dread and anticipation of the unknown.

IX

Camouflage Corps, France

Landing at Brest, we saw that camouflage had preceded us, for the harbor was full of boats, both French and American, painted in a riot of disruptive patterns. We entrained for Dijon, our Corps H.Q. tightly squeezed into battered third-class carriages. Our spirits were high; we sang continuously, getting out at every stop to stretch our legs and buy *vin rouge.* Our route lay by Tours and Nevers, and as we jolted up the Loire valley I was amazed to see the dwellings of the modern troglodytes built into the side of the cliffs. We reached Dijon at midnight of the second day, and as we detrained in a black-out, a voice with a familiar twang asked, "Aren't you Barry Faulkner from Keene? I'm Oscar Nims. Shake!" Oscar and I lost sight of each other until we met in Keene two years later.

We waited for two weeks in Dijon before going to the front, and I had plenty of time to explore the old town, its steep-pitched roofs brilliant with black, yellow and red tiles. One day it snowed, and the snow-laden trees in the Public Gardens looked like the best of Japanese prints. Indeed, I came upon a Japanese gentleman meditating upon the effect. At least I judged him to be so from his dress, for we conversed only in dumb-show.

On the second of February, 1918, Sherry Fry, Harry Thrasher and I left Dijon for the front. On our way to the station Homer Saint-Gaudens, now Captain, passed us in his Ford. He thumbed his nose at us with vigor. At the time

I thought he was playful but afterwards he told me he was as glad to be rid of us as we were to leave. We brooded little over the incident, for we were agog at lifting the mysterious curtain of the front. It lifted quickly when we detrained at midnight in the ancient garrison town of Toul. If we had been experienced in war-travel, we would have stretched out on the station floor and thought no more about it. But we were green, and when the station master told of an *"asile"* where we could spend the night, we started out through the black-out, bent under our packs, dragging our heavy barracks bags behind us. It was like being projected into outer space. We dragged, we puffed, we halted, we fell down; then suddenly a door opened into the darkness, light streamed out and we saw our *"asile,"* an ancient lousy barracks. Inside there were two rows of shelves, covered with wire netting and dirty straw, with Senegalese soldiers coiled up on them in various stages of sleep. Others, bunched about a stove, chanted together in an endless minor key. We made ourselves inconspicuous for we believed that the musette bags of the black soldiers were filled with German ears and noses. We rolled up together, slept hard and woke cold.

We found Camouflage Headquarters in the village of Ménil-la-Tour, and we serviced the Sixth Field Artillery of the Regular Army who in this quiet sector were receiving their combat training from the French. In February this part of Lorraine is bleak and joyless, a sea of mud under gray clouds spilling rain. The living trees were leafless, and those shattered by shell-fire were naked as pokers. In the first years of the war this sector had seen desperate fighting; most villages were roofless, crumbling and deserted. Others, less damaged, sheltered a handful of inhabitants.

Thrasher and I moved with our detail into Ansonville, a village with a few people still living in it. It lay behind Beaumont Ridge and faced the German stronghold of Mont Sec. Between the ridge and the mountain lay a wide desolate No Man's Land, pock-marked with stinking water-filled shell-holes among the pathetic shadows of what were once farms and villages—a landscape of the moon.

Thrasher and I managed our detail together in a harmony

which we both agreed was due to his good nature. I had
known him off and on for many years. He was a native of
Cornish, had worked in Saint-Gaudens' studio and later
had been a fellow of the Academy in Rome from 1911 to
1913. He was a good companion, brave, kind and patient,
full of dry humor and little catch-words. He had the odd
habit of referring to himself as "He," or "Harry." He was
resourceful with domestic arrangements and constantly
planned improvements in our billet which he seldom had
time to make.

We worked under Captain John Root, the Chicago archi-
tect. Captain Root was a good man to work for, cheerful
and patient, full of ideas and ingenuity, and he pulled us
out of the messes we at first got into, with amazing dex-
terity. He was a snappy and attractive figure as he strode
toward us, over the boggy fields, in his big horn spectacles
and leather overcoat, swinging his swagger-stick with the
black and white woven handle.

Our first attempts at camouflage were crude, and we
had no air-photographs to show us our mistakes. We sur-
rounded the batteries of 75's and the larger guns with posts
connected by heavy wires over which we stretched the
camouflage material very much as the Connecticut Valley
farmers cover their tobacco fields. The camouflage material,
made in our Dijon factory, consisted of rolls of chicken wire
with multicolored rags attached to them. The hard-boiled
veterans of the First Division who at first jeered at camou-
flage and at us, the "window-dressers," grew to like it, for
it gave them a sense of protection, false yet comforting,
and in summer the rags shed a thin, pleasant shade like an
unprosperous grape arbor.

My old friend, Fry, camouflaged machine guns and trench
mortars. He had little sense of fear and less of discipline.
Ignoring the regulations, he prowled the abandoned
trenches between Beaumont and Mont Sec, returning with
German helmets, belt buckles and other junk. I went with
him once to the ruins of Beaumont Village and peered
through a loop-hole at the leprous landscape of No Man's
Land. As we did so, two trench rats as big as dachshunds

scampered between our legs. Fry resented taking orders and had interest only in explorations, so the "higher-ups," knowing his fluency in French, transferred him as liaison officer to the French Camouflage at Chantilly, where he lived at ease and spent his weekends in Paris. We did not meet again until after the Armistice.

Our sector was indeed quiet, almost placid, for our artillery did most of the firing and the Germans sent over a few shells only at morning and evening chow. At Ansonville I saw my first example of the morale of the French peasants. The long, straggling unpaved street of the village was as deep in mire as the fields outside, yet on Sunday morning, its inhabitants filed to Mass in decent black, hugging the shattered walls of the village to preserve the gloss of their well-cleaned boots and shoes from the all-encroaching mud.

Across from our billet was an undamaged house, in whose dark kitchen Thrasher and I often took supper. The kitchen was mostly fireplace, in whose chimney nook sat the old grandmother, toothless, with just enough wits left to throw twigs on the tiny fire over which we cooked our delicious omelettes, omelettes sometimes of twenty eggs. Often as not Root joined us for a hunk of omelette and to discuss plans. Other companions might be French soldiers or a drunken M.P.

Toward the end of March, when the trees budded and the first green spears pushed up through the mud, the First Division left the Mont Sec area for Montdidier to plug the gap in the British line made by the Germans. I was sent after them with a Camouflage detail and joined my old friends the 6th Field at Chaumont-sur-Oise. From there we marched seventy or eighty kilometers to our new headquarter at Ménil-St.-Fermin on the Montdidier front. I teamed up with a sergeant major of one of the batteries, a thirsty man. We worked successfully to liquidate his trouble. We lived high and if there was any food or drink to be found, we found it. We marched at the rate of seventeen or eighteen miles a day and as we dressed our blisters we expressed our faith and admiration for our commanding offi-

cer, General Summerall, by chanting our theme song, "March 'em all, fuck 'em all, fight 'em all, Summerall!"

We soon met columns of refugees evicted from their villages, a pitiful procession of young and old; the old folks and children riding in carts piled high with feather beds, farm tools, poultry, mirrors and bird cages; the able-bodied pushing wheel barrows and baby carriages loaded with household treasures, some leading cows and goats. Each successive village was dirtier and worse shell-shattered than the last, and finally the villages were empty of people.

One evening I strolled between the high walls of the gardens and orchards of one of these deserted villages when around a corner came a procession of most curious objects, the like of which I had never dreamed. The objects lurched and wobbled like a string of baby elephants or a procession of sea-turtles, turtles of gigantic size, for they were Mr. Winston Churchill's Baby Tanks, long rumored, but never seen. They were a wonder.

Our village of Ménil-St.-Fermin was deserted but less damaged than many others. I worked under St. Laurence Hitt and billeted in an empty house which still had some furniture in it. Its forecourt stank, but behind was a garden still pretty in its neglect. In the house next to mine were some friendly French soldiers, who had been commercial travellers in England and we practiced our languages on one another.

Our new sector was a lively one. A network of crossroads hemmed in the village, and the Germans kept them under shellfire night and day. To choose the right moment to pass these intersections was a nice problem; when to wait, when to dash. My first assignment was to camouflage trench mortars in the front line at night. For two hours before we started my feet were icy. There were four crossroads between us and the trenches, and to pass them was nerve-racking, for a direct hit would have made mincemeat of us all. It was easier for me than for the men, for I had control of them and threatened court-martial if they jumped from the truck or lost their tools. Preoccupation with their gear calmed them, and after the first night no one jumped

from the truck: calming them calmed me, and there were no more panics.

Spring and warm weather came and the countryside broke into a rash of fantastic color and geometric forms. Such a profusion—such an intensity of color I never saw: great fields of cruel red clover, turning to purple with the vetch; grass as green as Ireland, and everywhere miles of screaming yellow mustard. Doubtless my perceptions were heightened by the circumstances, for it was glorious and fearful to walk in this battlefield of color, more shrill than the shells whining overhead.

I serviced one interesting battery of 75's in the grounds of a chateau in the village of Coulemelle, which was concealed under fruit trees. The men had transplanted big peony bushes and placed them along the path leading to the battery. At the guns themselves was a circle of Louis XV brocaded armchairs and delicate lacquered tables, littered with ancient copies of the *Saturday Evening Post*. Coulemelle had been a rich village but few of its luxuries were left, for the French dug-outs that I visited were cheerful with cheval glasses, inlaid sideboards and delicately brocaded sofas. When I asked why they plundered their own people, the war-weary men shrugged, and said they might as well enjoy the things until the Boche took over.

On the night the First Division attacked and captured the village of Cantigny the barrage was tremendous: the earth seemed to rock and the roar of guns struck chords of sound that were almost musical. When I got into the village it was a mass of smoking ruins. There was mustard gas about, and my friend the Thirsty Sergeant burned himself badly and was evacuated.

Cantigny was the first offensive staged by the A.E.F., a small but entirely successful operation which gave prestige to the First Division and to our entire Army.

Just after Cantigny, Homer Saint-Gaudens—now Major —ordered me to join him at Château-Thierry. I left the 6th Field Artillery with regret. They were the only group during the entire war with whom I worked long enough to become well acquainted. They were a superb lot, intelligent and

aggressive. I recall the names: Potter of E. battery, Lieutenant Evans of F., Captain Jones of A. and Lieutenant Flanders of the anti-tanks.

When I reported to Homer I did not make the neatest of appearances, for the night before I had burrowed into a haystack and slept there until a hungry cow woke me up. Homer put me to work on a wide plateau overlooking the Marne and the valley of Condé-en-Brie, where the lovely cheeses are made. On the morning of July 15th he called for me in his car to inspect my battery positions. As we went along we saw that during the night the plateau had been heavily shelled; branches torn from trees filled the road, dead horses lay about and soldiers hunting for their outfit were wandering around, dazed and disorganized. No one could tell us what had happened. We found out when I took Homer to a battery of whose camouflage I was proud. As we approached it by a narrow path, there were signs of confusion and flight; helmets and mess-kits, suitcases and bed-rolls strewn about; finally pools of blood and a strong smell of gas. At the guns we found more blood, my camouflage in tatters, a gun pulled out of position and then abandoned.

It was obvious that the Germans had attacked the night before, but we had no notion that they had crossed the Marne and were perhaps half a kilometer away in the smiling valley of the Brie. Neither of us wanted to go further, but I hurried Homer to another camouflaged position well hidden in a grove of trees. On arrival, I barely recognized the place, for the position was a mass of blasted trees, its debris full of dead horses and dead men; it smelled foul. We beat it away from the gassy wood.

The night of that same day the A.E.F. drove the Germans back across the Marne and I crossed the river with a division unknown to me. The Germans had retreated and entrenched themselves along the river Vesle. At Dravigny, a village half way between the two rivers, I met up with Thrasher, looking well in his second lieutenant's uniform. I had been upgraded to lieutenant myself, and we now both rode in side-cars with drivers.

At Dravigny we billeted in the house of a sweet old woman who had been unable to get away before the Boche occupied the village. They had carried away most of her things but had not found her most cherished possession, a young billygoat which she concealed in a closet. During our stay when the shells began dropping in the street, she retired to this closet, holding the billygoat in her arms until the unpleasantness was over. Harry and I shared our rations with her and with the goat, for we had plenty, and if we got hold of something especially good she would cook it for us.

A long highway ran from Dravigny to the town of Fismes and the German positions along the Vesle. Halfway between the two towns a wide shallow valley branched off to the west, its north side just high enough to give shelter to the dugouts of officers and company clerks. The naked valley itself gave no possible opportunity for concealment, yet almost an entire artillery brigade took up positions in it, followed by their horses, trucks and field kitchens. The valley was lively and crowded as a country fair; long lines of horses tethered or being led to water, fat bunches of puptents, men bathing in the brook, convoys of ammunition coming and going and the field kitchens smoking merrily.

The Camouflage Section protested strongly against this willful madness, and then camouflaged the guns as well as they could. Several days passed without incident and the officers cheerfully reminded me that the Germans had not spotted the position. But the enemy found it between four and five of the afternoon of the 11th of August, and shelled and gassed "Death Valley" heavily for two hours. Two hundred horses were killed, about fifty men, and direct hits were made on the guns.

Harry Thrasher was among those killed. On the afternoon of the 11th, he was looking for fresh gun positions to the north of Death Valley when a shell got him. Next morning I went to identify his body which lay, wrapped in a blanket, by a ruined mill. I dreaded turning down the blanket from his face, yet when I nerved myself to do it, I

Sergeant Faulkner and comrades in the Camouflage Corps, France, 1918

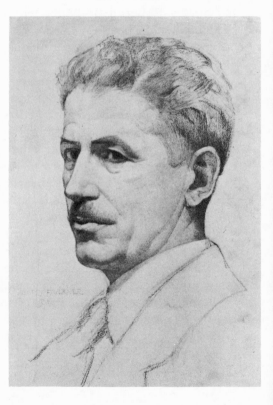

Homer Saint-Gaudens,
drawing by
Barry Faulkner

found Harry's face calm and peaceful as though he were asleep. I believe he died instantly. Thrasher made no great stir in the world, but those who knew him will remember him long and tenderly for his character was truly distinguished and noble. His nature was harmonious and well balanced. He loved beauty in any form; he had humor, a shrewd wisdom and a fine intolerance. Among his outstanding qualities were integrity and imaginative thoroughness. Where others procrastinated, he accomplished. He had no sentimentalities, and called all spades by their names. He had had too much hard experience to be a gay optimist, but it never dimmed his courage and his cheerfulness. He was a New Englander to the core and of that rare type which New England too seldom produces.

My gloom at Thrasher's death was not lessened by the news that Everett Herter had been killed in a nearby sector, but army life permits few active regrets and I have a few pleasant memories of our life along the Vesle. One of these was the airplane battles around our observation balloons. We watched these skirmishes for hours, betting on their outcome; the German planes darting in to destroy the balloons and our planes beating them off. If the Boche had luck we saw a puff of black smoke, the balloon ablaze, and the parachutes of our observers floating lazily down from the havoc like the petals of great white flowers.

Another memory is of driving along a country road shadowed by a forest. Suddenly I found myself between the immense piers of a lofty viaduct. Astonished, I stopped to examine this marvel. It was a great bridge leading from a promontory of land to a conical hill of earth and rock. The hill was crowned by the shell of a round-towered medieval castle. Forest trees had thrust up through the steep, paved glacis of the castle, enhancing its desolate mystery. The bridge leading to the castle was ornamented with Renaissance sculpture and nearby was a cosy small Louis XVI chateau. I faced four centuries of French history, for on the ground at my feet was the debris of recent battle. I learned later that the castle and viaduct had been the property of the Count de la Fère, the legendary Athos of the Three Musketeers.

On the Marne-Vesle offensive I saw a specimen of German camouflage. It was simple, and more effective than ours because of the discipline imposed upon the troops. The guns and the access to them were usually under trees with an occasional patch of camouflage strung between them. The paths were strongly wired in, as were the batteries, and no man was allowed to pass beyond these fences.

Such discipline was difficult to enforce in our army, for the Camouflage Corps had few air photographs to inform themselves or to convince the battery commanders of the necessity of this discipline. In a photograph from the air, fields of grain and grass photographed black because of the shadow between the stalks. Let a man walk once across a field and a delicate white line appears on the print. Our men went in front of their batteries to relieve themselves, or crossed a field to gossip with a friend. So gradually the best chosen position became the center of a web of converging lines and meat for the enemy. I confess that before I knew this I took convenient shortcuts myself.

During the St. Mihiel Drive I had a short rest in the Pont-à-Mousson sector, a lovely place tranquil as the grave. I had few duties and plenty of time to examine the fleshpots and architectural beauties of Nancy. On its glorious Place Stanislaus is a famous restaurant of the same name, and on Sundays the entire A.E.F. tried to eat there. We lined up in the Square for an hour or longer before we were seated. We sat for an hour to select from the menu and after another hour we ate. War was ignored at the Stanislaus; none of the ritual of dining was skimped. We had place plates, damask napkins, finger bowls, delicious wine at its proper temperature and exquisite food. This miracle of service was achieved by two ancient waiters, spry and unhurried.

It was during one of the long waits at the Stanislaus that I heard of the "Bandits of Malzeville," a curious backstairs story of the war. In the Château de Malzeville, on one of the high plateaus which overlook Nancy, a group of A.W. O.L. American soldiers had gathered. They belonged to a division which fought long and nobly and which had been promised a well-earned rest. Hardly had they begun to enjoy Nancy, when a military crisis put them again into the

line. This apparent breach of faith was too much for the bolder spirits, and in small groups they made off on their own. They led a jolly life stealing officers' cars and selling them cheap to covetous Frenchmen in towns behind the lines. They marked the place where their victim had garaged the car and at night broke in and resold it at the next city.

Community of tastes and interest brought the scattered bands together, and they made the Château de Malzeville their headquarters. They organized in company style, with officers, clerks, typewriters and machine guns, and from their stronghold preyed on the riches of the A.E.F. Our Military Police knew of their activities but at the time were too busy to deal with them. After the Armistice they blew them out of their fortified nest, but before that happened I made my own contact with the bandits.

Life in Nancy and at Pont-à-Mousson was too pleasant to last, and in the middle of September I moved into the Purgatory of the Argonne, a grim unhappy area, much fought over, filled with the ghosts of shattered houses, pitted with shell holes. I was attached to a division fresh from training and the morning before we attacked the Adjutant gave the position of our new headquarters. My driver Perley Moore and I knew the convenience of reaching a new position by daylight. We took the main road and found it easily. It was an old French emplacement. Our guns were on a wooded ridge and our dugouts underneath. As yet there was no sign of headquarters company except for Signal Corps men, installing field telephones. There were plenty of field kitchens about, and Perley and I ate a hot meal. The evening wore away and still no General and staff; but at about eleven they came limping in on foot, carrying suitcases, out of breath and out of temper, having lost themselves in the tangled footpaths of the forest.

I curled up in a dugout and slept until shocked from my dreams by the grandest and most shattering noise I ever heard. The guns were over my head and the dugout trembled with every detonation. It was said to be the greatest barrage of the war and extended for miles on either side of us.

Next morning I went to the Adjutant for orders as to

where to meet him when the division advanced. He desig-
nated a farm house beyond the town of Varennes. Varennes
is built on two levels, an upper and a lower town, both de-
serted and horribly shot up. It was in the upper town that
Marie Antoinette and Louis XVI stopped for fresh horses,
were recognized and arrested while their fresh relays
waited for them in the lower town.

As we left Varennes we saw more and more dead bodies
of American and German soldiers lying on the road and by
the wayside, and the rattle of machine guns came nearer. I
asked a dazed soldier how far ahead was our front line;
"Hell, right here!" he yelled and dodged an incoming shell.
We reached our rendezvous; its only occupant was a dead
German, and we decided there was no demand for camou-
flage and drove back to our old base.

There we stuck, until a few days later the First Division
marched in and relieved the division I had been with. I
watched the First come in, while German planes swooped
low and machine-gunned them. Then Perley ran to me, eyes
wild and hair a-bristle, and shouted that our "old friends"
had stolen our motorcycle. He rushed to repair shops, and
through diplomacy and a bit of physical persuasion, re-
trieved the cars' scattered parts and put them together with
the help of the good-natured thieves.

The First Division cleaned the Germans out of the Valley
of the Aire and we marched to new quarters at Châtel Chery
under a huge black cloud, vast and menacing, whose mem-
ory Kerr Eby preserved in a fine etching. German resistance
was crumbling, and frequent change of positions made
camouflage unnecessary. My detail were past masters at
finding good chow and comfortable billets and I did my best
to keep them clothed and promptly paid. As the weather
grew colder I was glad of my Jaeger undershirt and long
drawers which I had worn through the hot summer, sweat-
ing profusely and losing twenty-five pounds. Their excel-
lent material absorbed the sweat so completely that I never
felt chilled. I must have been pretty high, yet nobody com-
plained of my "esprit de corps."

On the ninth or tenth of November began the Race for
Sedan, French and American Divisions competing for the

distinction of entering first the famous town. Perley and I
did our best to be there too, but news of the Armistice
stopped us twenty kilometers this side of it. We curled up
on the dinner table of a filthy inn and slept. I cannot com-
municate the delight of riding back next evening with head-
lights on, passing the lighted farms and chateaus which had
escaped destruction. For months, on night duty, Perley had
driven me through inky darkness while the racket of our
motor prevented our hearing any vehicle bearing down on
us. More than once, by a sort of sixth sense he had dumped
us in the ditch, to avoid a heavy *camion* coming at top speed.

Orders came to report to Nancy. I found the "luxury"
hotel filled with old friends, but no empty bed. I took a
room in a small disreputable hotel nearby, which was "out
of bounds." I did not know that it was a resort of the "ban-
dits of Malzeville," closely watched by our M.P.'s, until one
night two M.P.'s pulled me out of bed and took me to the
police station. The immediate cause of the trouble was that
orders had come for me to report to Dijon at once, and a
driver from our motor pool came to fetch me. Instead of
taking his own machine he grabbed the first at hand. At my
haunt of vice, the M.P.'s, watching for bandits, found that
the number of his motorcycle did not agree with the number
of his driver's license, so they took us away for question-
ing. It was unpleasant and my explanations made little head-
way until I heard the voice of Captain Hoffman Burrill in
the next room. Hoffman was of our outfit; he convinced
the police I was not a bandit and they released me on con-
dition that I was out of Nancy by six next morning. I was.

Many familiar companions were gathered at Dijon: Fry,
Hitt, Wardie, Griswold, Bridge and Hoffman. They enjoyed
Hoffman's account of me as a bandit. I also met for the first
time our commanding officer, Colonel Howard Bennion, a
West Pointer from Utah. He was human, humorous, keen-
witted and not overmilitary. After the war we met often
in New York. He later became an Elder of the Mormon
Church.

After a month in Dijon the Camouflage Corps found it-
self in the rain-soaked fields near Brest, our port of em-

barkation. This part of Brittany has an unusual feature—
the fields are not divided by hedges, but by high earthen
dikes, and the enclosed fields became so many water-pens.
We encamped in one of these. I was Sanitation Officer and
shared a nearly dry tent with Fry. After I had seen that the
latrines were clean and the camp tidy, I would go with Fry
to the cottage of an old peasant woman for cafe-au-lait and
a bath. The old woman would get out her wash tub, fill it
with warmish water and we would strip and scrub. Then if
the rain was not heavy we would take a tramp.

One rare morning of sunshine we trespassed upon the
grounds of a nice little manor house and saw two girls
spreading linen on the grass to dry. They looked good to
us and we made ourselves agreeable. Soon they were cook-
ing our lunch. The girls were so pretty and the food so good
that we came back for dinner and persuaded the girls' father,
who was the guardian of the empty manor, to take us as
regular boarders. Our girlfriends drove to Brest each morn-
ing bringing back vintage wines, lobsters, mussels, oysters,
crabs and other choice things of the season.

The news of our good luck spread, and six or eight of
our friends horned in on our privacy. The single room of the
porter's lodge became raucous with fun and alcohol. It was
a typical Breton interior: dirt floor, huge fireplace with
eating nook beside it, lined with closed-in Breton beds. Vil-
lage girls joined us in the evenings and there was plenty of
frolicking in and out of the beds. Christmas Eve was a
drunken spree and most of the men and girls went to Mid-
night Mass. I was too drunk to go, and some who went were
in a sad state for they became sick and threw up in the
church.

Next day we embarked for home on a small mongrel
transport manned by specimens of the world's more back-
ward nations. It was a tedious month-long passage. I slept
and played bridge. Nothing at all happened until we were
off Bermuda, when we passed a burning ship. Its crew had
been rescued and only a hull glowing with dying fire was
left.

At last there was New York and homecoming.

X

Reconstruction

The sirens blew, the whistles squealed, we passed Madame Liberty. At the dock we all but capsized the boat when everyone rushed to her port side, next to the landing shed filled with relatives and friends, cheering and waving. I had reunions with the Manships, Gigi, the Platts and the Holters. My sister Katharine was still with the Y.M.C.A. in France, but I went to see Mother and Dora in Boston, where Dora was studying housewifery at Simmons College. My well-cut uniform and slender figure pleased them, for if I lost no blood on the fields of France I lost a great deal of weight.

The change from army life was as welcome as it was startling. I was now a member of the Century Club, which was filled with artist friends and new acquaintances—quite different from the gloomy place I remembered from the meeting with Mr. Siddons Mowbray twelve years before. I was full of work. I finished the last two panels of the historical scenes for the Washington Irving High School, which the Mayor of New York accepted for the city in a brief ceremony. Edward and Elizabeth Robinson commissioned a map for the Marine headquarters at Quantico, Virginia, a memorial to their only son Philip. The result was a decorative map of Belleau Wood painted from air photographs. It was well-received, and other commissions of a similar kind followed. One of these was four large charts of the world,

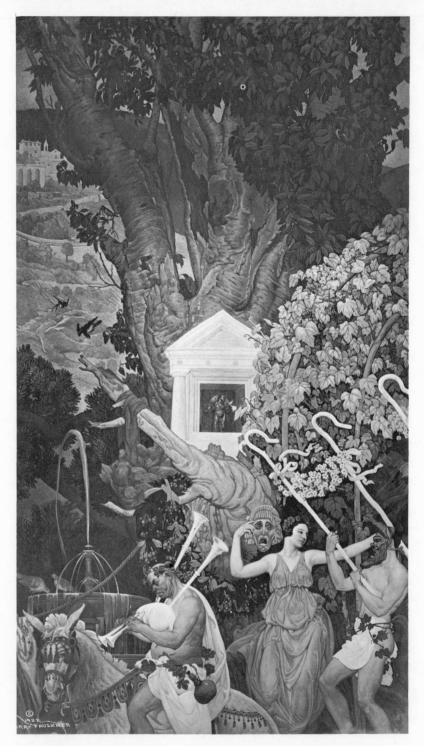

Dramatic Music. One of Barry Faulkner's series of decorations for the Eastman Theatre, Rochester, New York, completed in 1922

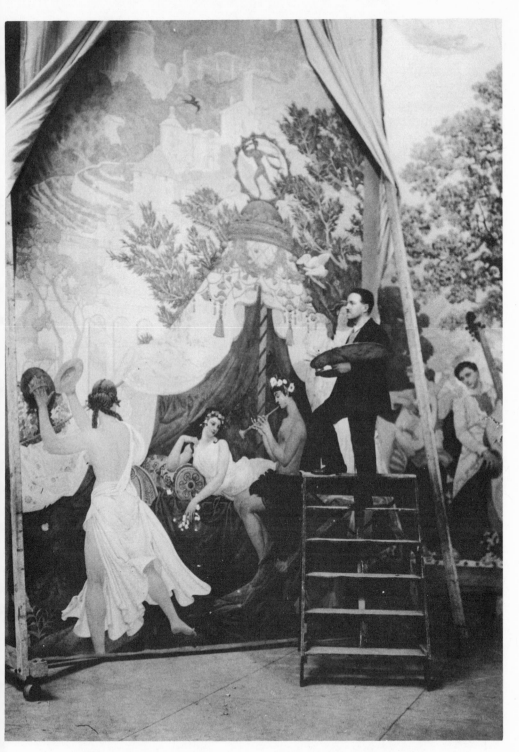

Barry Faulkner painting his mural, Pastoral Music, for the Eastman School of Music, c. 1922. The decorations were painted in the loft at Grand Central Station.

showing its commercial sea routes, for the Great Hall of the
new Cunard Building at Broadway and the Battery. If I
recall correctly it was the first important commercial build-
ing to be completely decorated. It was an all-Academy-in-
Rome effort, for Ezra Winter painted its splendid ceiling
and John Gregory designed handsome bronze panels in the
floor. Ezra later painted the historical scenes in the Bank of
the Manhattan Company. John Gregory was to create the
marble Shakespearean heroes who decorate the Folger
Library in Washington.

The New York members of the Camouflage Corps, after
a year of civilian life, began thinking kindly of their war
buddies, and wanted to see them. Led by John Lester Ward
they chose 11 MacDougall Alley for their reunion. They
brought with them gallons of bathtub gin and carloads of
oranges. The result was riotous and fraternal. We revived
war memories and learned of one another's civilian doings.
We even forgot old grudges, for when Homer Saint-Gaudens,
who had been intensely disliked by the men, asked if he
might come, we received him cheerfully. Our meetings came
to an end when I awoke one morning and found the floor
of my small bedroom four inches deep in orange peels! It
was fun while it lasted, and we must have been still in good
condition to have survived that woeful flood of raw alcohol
and orange juice.

When Katharine returned from France, she gave up her
former position at the Spence School and became a success-
ful businesswoman in the firm of Hemphill Noyes. Cousin
Ellen Faulkner had a position at Bryn Mawr College as
assistant to the president, and Katharine and I often spent
weekends with her, meeting her Quaker friends and tramp-
ing the pleasant lanes and paths around the college.

Old friendships flickered out, newer ones took root. Uncle
Abbott Thayer died in Dublin in May 1921, a victim of fail-
ing health and the prolonged nervous malady which had
steadily worsened in the last years of his life. The end of a
brilliant career. Gerald Thayer asked me to help arrange a
memorial exhibition—in the company of some of Uncle
Abbott's close friends and contemporaries—Brush, Thomas

Dewing, Daniel Chester French, Charles A. Platt, and a few others. The show was held at the Metropolitan Museum less than a year after his death, a powerful display of the full range of his work.

Charles A. Platt had been asked to design a house and lay out the grounds for Meredith and Elizabeth Goodwin Hare in Huntington, Long Island, and I was commissioned to paint two murals for the entrance hall and stairway. Thereafter I was often at "Pidgeon Hill," first as an artist and then as a friend. Betty Hare was a sister of Sarah Holter's. She was a restless woman, a whirlwind of energy who wrote verse and children's stories and was an accomplished violinist. But her most important role was as a patroness of the arts. She had been deep in the councils of the revolutionary Armory Show in 1913; she had formed friendships with many painters and sculptors, both avant-garde and moderately academic; and she bought the work of many men as yet unrecognized: Walt Kuhn, Arthur B. Davies, James Earle Fraser, Harry Thrasher, and Brancusi among them. A woman of perception, she bought Brancusi's *Bird in Flight*, then considered radically avant-garde, and later gave it to the Fine Arts Gallery in Santa Fe. Her sharpness and wit disguised a kind and giving nature. I like to remember best Betty Hare's imaginative generosity in smaller things; her help to struggling artists, and especially the time she bought two fine Gilbert Stuart portraits from some southern friends whose finances were at a low ebb. When their fortunes improved, she returned the ancestral portraits—with thanks for the pleasure the paintings had given her while in her possession. After Meredith Hare's death, Betty sold the Long Island place, and shortly afterwards I learned that the house had burned to the ground.

Elizabeth Warder Ellis was a friend of Betty Hare's, and like her, surrounded herself with artists and writers at her place on Long Island. And there I spent many delightful weekends in the twenties. She was a brilliant but unhappy woman whose life was shadowed by anxiety for the ill-health of her only son, and to distract herself sought the company of stimulating and creative people. Another friend-

ship ripened with Dean Sage and his family of Manans, near Albany, New York. The Sages were also deeply involved in the arts—as painters and sculptors—and I had first heard the name many years before when I helped rescue a portrait of Dean Sage from the Saint-Gaudens fire.

When I had finished the Sea-Charts for the Cunard Building, McKim, Mead and White commissioned me to paint four of the eight panels for the vast Eastman Theatre in Rochester, New York. Eight large panels were more than one man could finish in time for the opening, so the architects divided the work between Ezra Winter, my collaborator at the Cunard Building, and me, each having one side of the theatre. We both had a panel sixteen feet high and neither of us had a studio high enough in which to paint it. By chance the painter Augustus Tack told me of a vast empty attic in the south end of Grand Central Station. It was adequately lighted and we leased a space sufficient for us to paint the murals side by side. We enclosed our studio space with a ten-foot wall of heavy plywood and divided it down the middle with a partition. This partition was valuable, for through it Ezra and I saw how each other's work progressed and kept the panels harmonious in tone and color without discussion or effort.

Mr. George Eastman's inspection of the murals depressed us. He gazed at them with a heavy eye and made no comment. But my father's elderly college classmate, the muralist Edward Simmons, came and was encouraging and benevolent. We met our deadline, I put up my murals and prepared to sail for France and Italy.

My opportunity to return to Europe in 1922 resulted from the energy and imagination of Eric Gugler. Two fellows of the American Academy in Rome had been killed in the Great War: Walter Ward and my friend Harry Thrasher. Gugler organized a competition for a memorial to them to be put up in the courtyard of the new Academy building on the Janiculum. He obtained the money for the memorial from Walter Ward's family and the competing teams were made up of an architect, painter and sculptor, all alumni of the Academy. The team of Manship, Gugler and Faulkner won.

Eric Gugler

Mrs. Meredith Hare. Sketch in
oil by Barry Faulkner

Eric Gugler is an architect of imaginative power and re-
sourcefulness. He is of German descent and came from
Milwaukee, where his father had established a prosperous
lithographic company. While Eric was in college, his father
proposed that they spend the summer together in Germany.
Eric exclaimed, "Oh, Papa, can't we go to Greece?" They
went, and Eric returned a confirmed Graecophile. Greece
rules his mind and thought. It appears in the noble simplic-
ity of the public buildings he designed. His private houses
have charm of arrangement, full of unexpected surprises
of beauty of detail. He is also a master of lettering and in-
scription.

Eric was dark, and at the time of which I write was a com-
pact handsome young man, with a magnificent mane of
hair; his every movement expressing the energy and pre-
cision of an athlete. Surprisingly he had unusually small
and sensitive hands. He hated the mean and ugly in charac-
ter and life, and loved all beautiful things, generosity of
spirit and the simple animal pleasures. Over the mantel-
piece of his great fireplace at Sneden's Landing he carved,
"Nothing in excess, not even moderation."

XI

European Journeys

En route to Rome in the late summer of 1922, I joined the Manships in Paris where they had been living for a year or more. At the moment Paul was away on a trip to Germany, but Isabel and her sister Janet McIlwaine welcomed me. It was the period when Dr. Coué of "every day and every way I am getting better and better and better," was at the height of his fame, and Janet, who was overstrung, wished to consult him. So we made up a party and drove to my favorite town of Nancy.

We gathered with other groups under the orchard and espaliered pear trees of Dr. Coué's sunny garden and waited for admission to the Doctor's consulting room above a small stable. Our group came from all stations of life and with all varieties of troubles; many had crutches or canes or were supported by relatives.

We were in the second wave of patients and when the first wave left the stable-clinic, we climbed the stairs to a small upper room and sat against the wall around a circular table. Dr. Coué first interviewed new patients in a low confidential voice. He treated me successfully for neurasthenia, and I witnessed several other examples of the Doctor's treatment. A man spoke who had not spoken for years; an old woman who thought she could not walk, under the Doctor's encouragement chased him around the center table. Others who had come on crutches or canes threw

them aside and walked away unaided. Dr. Coué's personality was inspiring and benign, and his cures seemed little short of miracles.

When Paul got back from Germany, we began a series of expeditions, wonderful and exciting, to study French Romanesque art. Neither of us knew very much about it, nor of the charm of the little towns and the remote countrysides to which we penetrated. With us came Paul Dougherty who kept a studio in Paris at this time. Dougherty, then in his early forties, was largely self-taught and had made a name for himself as a painter of seascapes but was keen to branch out into fresher fields. We bought a Chevrolet and in late August started on our quest by way of Sens and Auxerre and southeast to the village of Vézelay. There we stayed for a few days painting the landscape and drawing the sculptures on the exquisite twelfth-century abbey church, which had been restored by Viollet-le-Duc.

We drove to Poitiers, stopping at the frescoed church of St. Savin. The principal fresco covers the barrel vault of the nave. The figures are on a white ground and reminded me of paintings on the lid of an Egyptian sarcophagus. They are the most complete ensemble of Romanesque painting I have seen. Paul Dougherty left us for Paris, but even his departure did not dim our delight in the town of Poitiers, seated in its lovely landscape, both country and town jewelled with architecture, sculpture and stained glass. Unwillingly we left Eleanor of Aquitaine's cathedral, the stained glass of Ste. Radegonde, and the crumbling facade of Notre Dame du Port, and pressed on to Angoulême (where we had our first hot bath in a really long time); then to Beaulieu to see the prehistoric paintings in the caves of Font de Gaume.

At the hotel in Beaulieu we ran into Professor Henry Fairfield Osborne, head of the Museum of Natural History in New York. He gave Paul a letter to the Count de Beguin, who was shortly to take a party of archaeologists into a newly-discovered cavern on one of his estates in southern France—the first to contain sculptured figures. Paul wrote the Count, and a few days later came a cordial invitation to

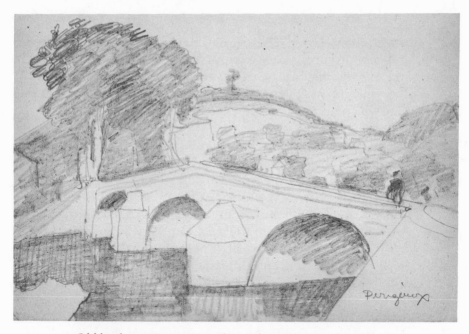

Old bridge at Perigueux, from the author's sketchbook

see the sculpture, and the suggestion that we stop en route at Foix to see an interesting cavern on another of his estates. Paul's wife Isabel and his little girl Pauline joined us, and off we set for Foix.

There the Count's huntsman met us in full regalia, but carrying, instead of his horn, acetylene torches. We drove up a wild mountain valley, and stopped at a signal from the huntsman who leaped out, climbed the steep hillside, stooped under a bush and disappeared. We followed, grasping our torches, and descended into utter darkness. We toiled for four kilometers into the bowels of the mountain, through caverns so vast that at times we could see neither roof nor sides. We crept beside lakes and a river which in the spring filled the cavern to its roof, past stalactites and stalagmites. We were thoroughly chilled by the time we reached the paintings. They were drawn in black on the side of the cave, as sharp and clear as though done yesterday; very different from the shadowy figures in the Font de Gaume, for they were covered with a transparent mineral deposit that pre-

served their clarity. The subject matter was fish, numerous and monotonous. This experience was horrid, fascinating and exhausting. All of us, even Pauline, were completely done in and we telegraphed our regrets to Count Beguin that we could not join his expedition the next day.

Autumn was approaching, and I had arranged to meet Charles and Eleanor Platt at Arles, and from there to drive down the Mediterranean coast and make a tour of Spain. The Manships drove me to Arles, where after a brief inspection of the Roman buildings and much high enjoyment, Paul and Isabel returned to Paris. On the way to Spain with the Platts, we passed the little village of Aspet where the Saint-Gaudens family originated, and also passed the town of St.-Gaudens. At Pau, Charles suddenly developed one of his influenzas, and we stopped for a week for him to recover.

While Charles was convalescing, I went for a day to St.-Bertrand de Cominges, a tiny walled town, high on a hill, jutting from a rich valley. It was as pretty as a toy; I wanted to take it in my hand and caress it. Though diminutive it had everything: a fine cathedral, a town hall, a good inn, and shops and dwellings clustered against the town walls. Its unique architectural feature was the cloister of the cathedral which, besides a sculptured *trumeau*, had in its outer walls wide rectangular openings which looked out on the wild mountains.

We arrived in Spain at the wrong time of year. It was cold, and there were no bullfights. We could not speak Spanish, and did not adjust gracefully to dining at ten o'clock at night. I admired little of the architecture I saw, except the Escorial, against its wild tumble of hills; but our visits to the Prado were a daily delight. We visited Toledo and stood before the wonder of El Greco's *Burial of Count Ortiz*, and then fled to France and a softer life.

The Platts and I parted at Bordeaux. In Spain I must have suffered from tourist fatigue. I had seen too much in a short time. My introduction to Romanesque art had opened a new world of beauty and ideas. I relished its rude strength, its austere spiritual grandeur and its lusty humor, most

often expressed in the capitals of the pillars. It gave me an artistic jolt comparable to the one I had received from the Italian frescoes years before.

About the first of November I rejoined the Manships at St.-Cyr-sur-Mer, whence we started for Rome by the Italian Riviera. The Chevy was an open car; the weather was chilly and we arrived at our stopping places bone cold. Our temperatures rose to normal after three rum punches and a good Italian meal. Between Siena and Rome the highway goes through Radicofani, a town on a mountain top. From Siena to this town we followed a beautiful new *autostrada*, very steep, built up a spur upon the mountain, from which the misty depths on each side looked bottomless, and half-way up the ascent the Chevy went dead. We were out of gas. But clever Isabel remembered that the car had gravity feed, and Paul with admirable promptness reversed the car. We entered Radicofani backwards.

The town is infamous in the diaries of early tourists for its filth and discomfort. We could not see that it had changed in the last hundred years. Neither could the southern descent have changed much since medieval days, for it was a zigzag track for pack horses and mules, narrow, with hair-pin turns so sharp that Paul had to back and fill to get around them.

Finally we entered the Rome of Benito Mussolini.

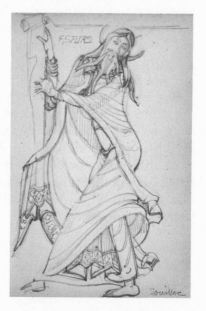

Romanesque figure
Souillac, France,
from B. F.'s sketch book

To the tourist's eye Fascist Rome had changed little from the old days; but this tourist's eyes were opened soon after his arrival. I walked down town to see how a general election was carried on. To my astonishment, not a soul was on the streets, except for myself, while heavy trucks bristling with armed Fascists whirled past me.

The American Academy had not only changed its position but its composition. The School of Fine Arts and the School of Classical Studies had merged, and added to themselves Schools of Music and Landscape Architecture. The new building was then still raw in texture. It was built in the form of a Roman palace, with fore- and interior courts and accommodations for forty men, their studios and living quarters.

I had a studio with a splendid view on the second floor and my bedroom on the floor above. Paul took an apartment in the city and worked in a studio at the Academy. Except at dinner I ate with the students, and became well acquainted with many of them. My new friends were a talented lot: among them were the composers Randall Thompson and Howard Hanson, the painters Francis Scott Bradford and Frank Schwarz, and my good comrade in the war, Ralph Griswold, the first landscape architect to come to the Academy. I was especially interested in the architects, James Kellum Smith and Wallace Harrison. Harrison was already chafing under the classic tradition, searching for new forms of expression, which he developed with signal success in his later work. "J.K." was a classicist to the bone, but his adaptation of tradition to modern needs flowered in many places, particularly at Amherst College, a masterpiece of planning and continuity of tradition.

Besides Griswold, another old friend was Salvatore Lascari, once a pupil of Mr. Brush's, who had worked with me in New York and was now translating four large paintings by Edwin Blashfield into the medium of mosaic. Blashfield, since the appearance of his murals in the great Columbian Exposition of 1893, had become one of America's most popular decorative painters, and his collaborator Lascari was keen and knowledgeable in techniques. He was kind and

helpful when I painted the Thrasher-Ward Memorial which I had decided to do in true fresco. I had never painted in this medium, but here was the climate and opportunity to make the experiment.

The Memorial was placed in the central bay of the arcade on the west side of the Academy's inner courtyard. Beneath the fresco Manship designed a bench in red marble with the figures of two kneeling soldiers with inscriptions, and a frieze of soldiers in combat. The fresco progressed slowly under my unskilled hand and before I finished, it was mid-summer. Most of my friends had left Rome and the Academy was empty of students.

I took many of my meals under the grapevines of a rustic trattoria to which Randall Thompson had introduced me. It was built up against the side of the church of San Pancrazio, a half-mile beyond the Gate, and was surrounded by a fine vegetable garden. Two pleasant and obliging sisters owned the place and cooked deliciously vegetables which never knew an icebox but came straight from the earth to pan or kettle; fennel, broccoli, artichokes and green salad. I loved the place, even though once in a while a centipede dropped into my soup from the grape vines. My solitude was seldom broken except by the visits of one or another of the Workmen's Eating Clubs from Trastevere. They came early and stayed all day, the men drinking and playing Boccie, the women gossiping, nursing their babies and admiring their older offspring.

The winter of 1922-23 had been lively and varied with a number of friends stopping or staying in Rome. Edwin and Sarah Holter spent the winter there with their youngest daughter, Mary Frances, whom they put into the Girls' School. With Paul and Isabel Manship we made expeditions to the showplaces around Rome.

During the winter I did not forget my new interest in Romanesque art and was eager to examine Italian examples. I made brief trips to Toscanella, Subinco, Spoleto, and Ravenna, where I made studies of the frescoes and mosaics. My memories of these trips are associated with pierc-

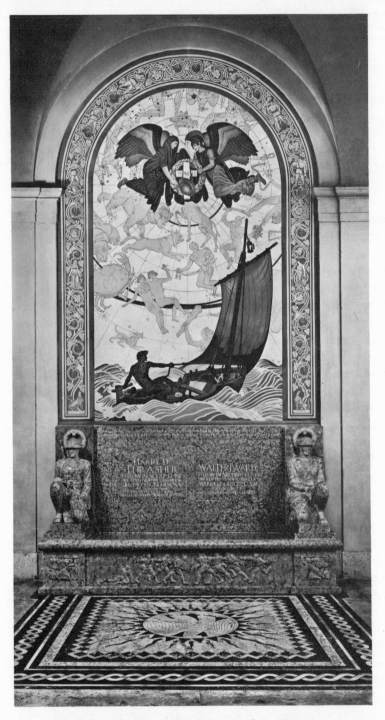

Thrasher-Ward Memorial at the American Academy in Rome. Architecture by Eric Gugler, sculpture by Manship, and fresco decoration by Faulkner, 1922-23

ing dampness and with very cold feet. On the coldest of these excursions, Ralph Griswold went with me to hunt for the church of Sant' Elia and its frescoes. We took a train to Cività Castellana, an ancient Etruscan stronghold, standing high on a cliff and separated from the mainland by a deep, artificial chasm. We crossed its bridge and entered the town through a nasty-smelling passageway beneath one of the castles of Cesare Borgia.

It was January and freezing. We hastened to our inn, a vast, sprawling establishment big enough to house an army. Over its threshold we entered the Middle Ages. The distance between kitchen and dining room was so great that our pasta arrived at the table stone cold. The place had the chill of a glacier, and that night we slept fully clothed with our greatcoats on top of us. The rigors of that night surpassed any of our memories of the war days.

At dawn we climbed down a steep goat path to the plain below, facing Mount Socrate—black as ink against the reddening sky. Our descent from the rock and the long walk to Sant' Elia warmed us, and we found the church gaunt and desolate, with nothing to explain its size and obvious former importance. Having triumphed over cold and hardship—and in hopes of a "discovery"—the frescoes, when we gazed at them, proved to be dull and of interest only to art historians. We returned to Rome with a sense of anticlimax.

When I completed my own fresco at the Academy in the summer of 1923, I joined the Kellogg Fairbank family in Venice. I had met the "Laughing Fairbanks" in Chicago after the War and had been drawn into the lively hospitality of their house on North State Street, which constantly overflowed with authors, musicians, architects, professors, and art-collectors. Janet Fairbank, tall and handsome, lived in an uproar of achievement, goodwill and generosity. She was a zestful Democratic politician, a builder of hospitals, a sponsor of benefits and fairs, one of which she had opened riding into the hall on the back of an elephant. Kellogg, quiet and reserved, watched with amused geniality the alarums and excursions of his wife and their three children, Kellogg, Jr., Benjamin, and young Janet. So from Venice

I set off with the Fairbanks in their car on a rollicking and unpredictable journey to Domodossola, through the Simplon Pass into Switzerland, and eventually to Paris.

In Paris, I joined the Manships for a few weeks, and there Paul concocted a plan to spend the following winter in Egypt, Turkey and Greece. He asked Welles Bosworth and me to go with him, and we readily assented. Bosworth became a great friend and was a fine architect; designer of the impressive buildings at the Massachusetts Institute of Technology. We left in November for Rome, where Paul and I wanted a couple of months to finish up some work before going to the East. I was painting some decorative screens; before leaving home Mrs. Harriman had commissioned me to do one, and with this commission as a nucleus I had decided to paint three or four others, and exhibit them on my return to New York.

I was working at the Academy one morning on the design for one of the screens when the porter brought up a visitor to see me. He was a total stranger, short, heavy, and adenoidal. He wore loud checks and a gray derby. Without introduction, he thrust a newspaper clipping into my hand and ordered: "Read that!" The clipping was from a Vermont newspaper and said, "Barry Faulkner of Keene, N.H. is spending the winter in Rome at the American Academy."

"There!" my visitor said. "I read that and decided to call on you. I'm Doc Cady, the uncrowned Poet Laureate of Vermont. Shake! Now, come on down and have supper with Mother and me tonight."

Full of curiosity I accepted the invitation, a curiosity which was not lessened when he said to come to the Hotel Excelsior. At that handsome establishment I was shown up to the large salon of a private suite in which sat "Mother," Mrs. Cady, a New England lady as typical of her kind as her husband was atypical of his. She was gracious, dignified and handsome; she wore a double strand of magnificent pearls. Doc explained the pearls and much else when with thumb pointing over shoulder he whispered to me, "Her *first* husband was Paines Celery Compound."

Our common New England background was a bond, and

I thoroughly enjoyed these new and unexpected friends. They too were on their way to Egypt for the winter and we arranged for a meeting in Cairo. Just before we started for Egypt, my childhood friend from Keene, Pearl Richardson Neville turned up, as eager, fresh and companionable as ever. We spent a few days in Naples together, and she joined Isabel Manship in Rome for the months that Paul was to be away.

Paul Manship, Welles Bosworth and I landed in Alexandria in January, 1924, having taken a boat from Brindisi in southern Italy and stopping for a day in Crete en route. My most salient memory of our first day in Alexandria was a huge Nubian porter at the hotel, standing by the desk with outstretched tongue, while the desk clerk moistened upon it the stamps for our postcards and letters.

The first sight of the Egyptian desert overpowered me with the weight of its monotony and latent menace, its vast infertile drabness. The endless diversity of the street life in Cairo was a welcome antidote to the empty desert; its Rolls-Royces, elegant horse-drawn barouches and European sightseers mingling with camels, desert nomads, the swarms of small donkeys hidden under their burdens of this and that, the yelling, thwacking boys who drove them, and the veiled Moslem women, each looking like a black bag of suet. We looked at the Sphinx, the Pyramids, the stately Moslem mosques, the curious Coptic churches and the newly discovered treasures of Tutenkhamen in the Cairo Museum.

There was an eclipse of the moon when we were in Luxor, and the people surged through the streets beating pans and tom-toms, screaming and yelling to restore life to the dying planet; people who had changed little since their forebears reared the immensity of Karnak and hewed out tombs for Kings and Queens in the cliffs across the river.

At Aswan we boarded Cook's boat for Wadi Halfa and the second cataract of the Nile. The trip was skillfully managed. Twice a day we landed at some point of interest—a small temple, or a sphinx half buried in the sand—and

stretched our legs with satisfaction. In the evening, we anchored near a village and a line of white-clad figures appeared on the river bank and sat silently watching the boat, while we slept to the drone of the waterwheels and the irritable snorts of camels.

Early one morning we landed at Abu Simbel, the rock-hewn temple of Rameses the Great. The grandeur of the setting of this monument, cut into the cliff above the river, with the shifting sands of the Nubian desert constantly threatening to rebury it, and the gigantic size of its colossi, lift this temple wholly above the mass-produced banality of too much Ramesean work. Paul and I sketched all day and climbed the facade of the temple as high as the falcons at the feet of the huge statues. That night the facade and the interior of the temple were floodlit, and at sunrise next morning we watched the first rays of the sun strike full upon the wall of the temple's inner sanctuary.

As we approached the Second Cataract, a swarm of men and boys greeted us, swimming down the white angry waters, begging for baksheesh. We anchored at Wadi Halfa and in the bazaar I bought a fly switch identical with the one Aunt Lizzie had bought sixty years before.

Back in Cairo I was standing at the bar of Shepheard's Hotel when suddenly someone clapped his hands over my eyes and said, "Guess who this is?" There was no mistaking Doc's bumbling voice, so I dined with the Cadys that evening and afterwards went to their room, where Mrs. Cady began to teach me a new game of solitaire. Cairo at that season was crowded with tourists and the Cadys had only a big single room, filled with large wardrobe trunks, half-packed, for they were leaving the next day. Mrs. Cady and I were absorbed in our game when I looked up and saw Doc wandering disconsolately, mother-naked, among the wilderness of packing.

"Why, Doc, what are you up to?"

"I'm looking for my nightdress. If Mother and you won't talk to me I'm going to bed."

Long afterward, I called on the Cadys at the big mansion in Burlington, Vermont, and Doc gave me a volume of his poetry which proved to be rural verse of quality, touching

and humorous. Mrs. Cady planned that when she died she would rest beside Mr. Paine, and Doc built himself a white marble mausoleum on a hillside near his birthplace from which, as he said, he could look out on the "backsides" of Ascutney Mountain as he had done in his boyhood.

Welles Bosworth prolonged his stay in Egypt and Paul Manship and I went on to Constantinople. On the boat Paul had an attack of his old enemy the asthma, and on our arrival he went to bed. It rained continuously during the week of our stay and the few times that Paul ventured out he quickly got back to bed. I saw the opulence of Santa Sophia by myself, and the fine Museum, and I had good times in the underground bazaar beneath whose vaulted roof the temptation to buy was painful to resist. I succumbed to two Persian miniatures, fakes probably, but pretty. In the evenings we laughed together over *Tarzan of the Apes,* the only book printed in English that I found in Constantinople.

One sight I determined to see: the famous triple walls of the city which for long had protected it from its besiegers. The walls extend for four or five miles from the Sea of Marmora to the Golden Horn. I left by the Marmora Gate and slogged on through the rain, more preoccupied by keeping out of puddles than by any interest the stupendous walls might offer. Also Baedeker warned pedestrians against making the trip alone because of the ferocious dogs who haunted the neighborhood, so I kept an eye out for them but the few strays I met were too soggy from the downpour to take any interest in me. I passed by the eleven or twelve gates of the city and reentered from my fool's errand by that of the Blanchernae.

We could not see the Seraglio, for in the spring of 1924 the Sultan and his ladies were packing up to go into exile. An advance guard of these ladies was said to be on the boat which took us to Athens, but if they were aboard we did not see them.

Greece is a jewel shining in my memory. The glories of antiquity did not entirely divert me from my interest in Byzantine art, and I went more than once to the small and

lovely church of Daphni, outside Athens. Here the mosaics have a clarity and directness, an elegance of conception and skill of execution which the mosaics of Ravenna and Venice lack. The head of the Pancreator, looming in the dome, is terrible and magnificent.

Welles had rejoined us in Athens and we motored to Epidauros and Mycene. A day of purple cloud and threatened storm enhanced the stern grandeur of the Lion's Gate and made the tiny acropolis a fit setting for its bloody dramas. On the road to Epidauros a pack of savage shepherd dogs pursued the car. Their leader dashed in front of us; the car hit him and broke his leg. But before we could do anything, his wolfish followers killed and ate him.

To my surprise, in the Argolid medieval castles dominated the landscape, outnumbering the classic remains. They were forcible reminders of the Frankish, Catalan and Venetian lords who ruled Greece and the Island for nearly three hundred years. There was a Frankish duke in Athens, and the anomaly of medieval and classic in Shakespeare's *Midsummer Night's Dream* is no greater than in the landscape of Argos.

The vigor of this medieval life continued on our way to Delphi. A landslide had closed the usual route by the Corinthian Canal, and we went round about by car over a finely engineered military road, past deep ravines and castle-crowned hills, arriving at Delphi in the high flood of spring. There we spent three days amidst the exciting and awe-inspiring scenery. On our final evening in Delphi, Paul and I climbed a goat trail up Parnassus following the rays of the setting sun. The widening view was so exhilarating that up we went until the sun set and left us in deepening evening. Down we scrambled to the temple area, followed by small avalanches of the stones we dislodged. We were lucky they were no bigger.

We decided to stop at Corinth for a night and rise early the next morning to take the one daily train that went through to Olympia. We were not early enough. Welles caught the train at seven a.m., but Paul and I were left on the platform gazing at the vanishing train with the prospect

of twenty-four hours on our hands. We were ignorant of
the archeology and history of Corinth—except its fame for
easy morals and beautiful women—but at seven-thirty of a
fine morning none of the latter were about. We drank at
the fountain of Pegasus and gloomily poked about until we
raised our eyes to the giant rock of Acro-Corinth and de-
cided to investigate it. The Acro-Corinth was the strongest
acropolis in Greece, and had never been captured before the
use of gun powder.

We hired a donkey and, accompanied by a bodyguard of
boys and girls, we climbed the long ascent, passed through
the triple gates and walls built by the Venetians, and stood
on a plateau sloping gently to the south, its vast circum-
ference girdled by a single wall above sheer precipices. The
great bowl was empty except for flocks of goats and two or
three tiny mosques damaged by time and weather. We
found no sign of classical or medieval remains. It was a day
of wind and flying cloud, a battle of sun and shadow and
as we gazed into the shrouded depths of the Peloponessus,
sudden shafts of sunlight revealed unguessed details in the
welter of blue mysterious hills below us.

The next day it was a sudden jolt from the great rock at
Corinth to the sandy rain-sodden plain of Olympia whose
sad monotony gave no hint of the bright excited multitudes
which once crowded racecourse and palestra. The rain was
constant; I spent the days inside the Museum, drawing the
Centaurs and Lapiths battling around the stately Apollo.
It is as glorious a piece of sculpture as I have seen or dreamed
of. One source of delight to me, as it had been in the case of
Romanesque art, was the excitement of discovery, for the
sharp edge of strangeness quickens the eye and warms the
perception.

At Brindisi, on our return to Italy, we met Cole Porter and
his beautiful wife, who were travelling eastward. They
were friends of Welles Bosworth's and as we lunched to-
gether I mentioned that I was looking for a studio in Paris.
Mr. Porter offered me the use of his, for he expected to be
in the Orient for several months. I accepted gladly but be-

B. F. and Isabel Manship

Manship and Faulkner at Sens, France, August 1922

B. F., Manship and Welles Bosworth at Sunion, March 1924

Charles and Eleanor Platt

fore I moved in I discovered there were two studios for rent in the Rue Val de Grace, one for a painter and another for a sculptor. I wanted a permanent studio and knew that Manship needed a larger studio than the one he then occupied.

The sculptor's studio proved to be just what Manship needed and for several years it remained his headquarters when he came to Paris. My studio and bedroom were on the second floor of another building. I took back Mr. Porter's key to his agent, with a note of regret and thanks.

I worked on my decorative screens the summer and autumn of 1924 in Paris, and finished three of them. Then an ex-soldier living in Chicago ordered a war map of the sector of Fère-en-Tardenois where he had seen his hottest fighting. I lodged in the town of Fère, and as I slogged over its clayey fields, some association with the name tugged at my memory and finally resolved itself in Athos, Count de la Fère, whose castle and astonishing viaduct I had seen one evening back in 1918. On inquiry I found it easily. I sketched there in great excitement, explored the round-towered castle, and the viaduct leading to it which replaced the castle's drawbridge. I had been walking and sketching since early morning, and at two o'clock I was hungry and turned my eyes to a wing of the little chateau, from whose chimney smoke was rising. I knocked at the door, the caretaker opened it, and when I asked if his wife would make me an omelette and coffee, he took me in. Madame served a luncheon far more delicious and elaborate than anything I could have expected. Madame was a *Cordon Bleu* cook and catered to all the festivities of the neighborhood, so it was easy to persuade her to make a luncheon for a small party of my friends when we came out from Paris. We came: Paul and Isabel Manship, Paul and Marion Dougherty, Eleanor Tweed and myself. The little fête was a riot.

The summer and fall of 1924 passed pleasantly with friends passing through. I spent a delightful week of motoring and sightseeing with Laura Fraser and Kitty Harriman. The trips in search of Romanesque art and architecture continued, and on the final one in Brittany, Eric Gugler was of

the party. It was high tide at Mont St.-Michel, and burly fishermen carried us pig-a-back, across the rising water which separates the Mount from the mainland. Isabel and Paul had been there before and were tired from motoring, so Eric and I climbed the steep stairs to the cathedral and monastery. It was twilight and long past closing time, but we beat loudly on the entrance door; after a wait a tired guardian appeared and refused us admittance, but relented at the sight of a fifty-franc note on condition we would dispense with his *"explication"* for his voice was worn out, to which privation we gladly agreed. We were in luck to wander, without drone of guide or cackle of fellow-tourist, beneath the massive glory of the nave of the Cathedral, to gaze from the refectory window upon a waste of waters whose loneliness reached to infinity.

This was the last of my memorable surprises and I returned home ready to resume American life.

XII

Seventy Second Street

In New York again after almost three years absence, I forsook my old haunts in MacDougall Alley and moved "uptown." Paul Manship had bought four tenement houses on East 72nd Street between First and Second Avenues, numbers 315 to 321. Two of them he kept as tenements, but Eric Gugler remodeled 319 and 321 into studios and apartments. The houses were unusually broad and deep, and on the fourth floor of 319 I moved into a spacious studio with unimpeded north light. The remainder of the fourth floor made a small but comfortable apartment, which my sister Katharine now came to share with me. The Manship family occupied the rest of the house, and Paul built a large studio over the backyard. Presently Luigi D'Olivo—Gigi— our incomparable carpenter, sculptor's assistant, framer and man of all talents, was installed in an apartment in the house next door. Our domestic arrangements were complete.

At times I must have tried Katharine sorely, but I think on the whole she enjoyed our life together. Gradually at 72nd Street she met new and stimulating friends, although she never let flag her old loyalties to business and Spence School associates. Katharine had a sweet and beneficent nature; her innocent serenity of manner was clothed in humor and good sense. She was gently religious and loved music and books.

Eric Gugler had created a small octagonal dining room

for our apartment, and here she and I entertained modestly at an octagonal table which conveniently seated eight. Katharine was an excellent housekeeper and delighted in good food and in experimenting with new dishes. After a few rather dismal experiences with help, Carrie Dwyer came into our lives and remained there off and on for many years. She had been born in Norway, and when she was still a girl, married Dwyer, a handsome, feckless Irishman in Concord, New Hampshire and had been his chief means of support through the years. A gentle voice was her great beauty, and her grace was tenderness and humility, but with due provocation she could become spirited and resentful—crises which fortunately seldom occurred. Under Katharine's tuition she became a superb cook with a flair for combining dishes that enhanced one another's flavor. Her devotion was unwavering.

In the summer after our move to 72nd Street, my mother had an operation for cancer. It was "successful," but a week later, after she had returned from the hospital, she died of an embolism. At the time of the operation, Katharine, Dora and I gathered with Philip in Keene and then went about our affairs, confident that all was well. I was visiting Edwin and Sarah Holter in the Adirondacks when the black telegram came, and hastily we converged in Keene again.

After Mother's death we spent Christmas and New Years in Wellesley Hills, Massachusetts, with my sister Dora. She was now married to George Mowbray, eldest son of the muralist H. Siddons Mowbray, the memorable gentleman who long ago had induced me to go to the American Academy in Rome. They had three young children, Helen, Harry and James; and a near neighbor in Wellesley was Pearl Richardson Neville, whom I had last seen in Italy. She doted on Dora like a daughter, and in her cheerful, bird-like way was solicitous of the whole family's happiness. Her husband, Louis Neville, was a stockbroker, and their son Gregg had recently set up in New York as an investment counsellor himself under the name of Neville Rodie and Company. One upshot of our Christmas reunion was that Katharine left Hemphill Noyes for Neville Rodie, where she remained

happily and usefully for many years. It didn't take much persuasion to shift my own investments there—with fortuitous results for all concerned.

Katharine and Isabel Manship became fast friends, and we went often to the Manships' parties, always with pleasant anticipation, for the guests, native or foreign, were often distinguished and usually interesting. In her new home Isabel was in her element, as hostess, all her greathearted, outgoing qualities had full play. Her wit, gaiety and response to friendliness spread around her an aura of matchless well-being. Even at their large dinners the Manships set an excellent table, the food prepared and served single-handed by Louise Portalier, who doubled as the children's French governess. Outside the kitchen Louise was charming, with pleasing manners which she firmly imparted to the Manship children. But in the kitchen, what a dragon! She became a fiercely jealous woman, quarreling with anyone else brave enough to enter her domain, and even driving away Isabel's favorite—fat, sweet-tempered, black Sadie of the famous deep-dish apple pies.

Paul Manship loved handsome things, and he furnished their apartment with haphazard richness: French and Italian tables, brocaded chairs, a fireplace of yellow marble, and pieces of carved panelling acquired in his European travels. The dining room was studio height, two stories high; its most splendid feature was an enormous dining table, which could seat twenty-four, its top made of a single piece of polished wood, whose surface Paul decorated with the signs of the Zodiac and of the Seasons.

Those first years on 72nd Street were busy and productive for both Manship and myself. Paul was designing his handsome bronze gates for the new Bronx Zoo, as well as numerous other commissions. As he was drawing and modeling the birds and animals for the Zoo gates, he delighted in the feline strength of the figures, in the absurdity of the apes, and the amusing pomp and solemnity of the ibis, the crane and the heron. Ironically he could keep no pets at home or in his studio from apprehension that their fur or feathers might provoke his recurring asthma.

Manship's power of concentration was complete. At work he lived in a world where nothing could touch him, yet when the spasm passed, he emerged from his dream avid for fun and amusement. Laughing, smoking and drinking with Gugler, and sometimes myself, he would plan many imaginative projects. With his limitless curiosity, his brain and fingers were always at work. In the evenings he busied himself making designs for a statue or modeling a figurine in wax, while Isabel read to him ponderous books on the art of India, Cambodia or China. In his occasional low moments she bolstered his ego with tenderness and understanding.

The technical problems of sculpture fascinated him, and he did not rest until he mastered them and could direct with authority even the bronze founders. For relaxation he made small portrait medallions of his friends, and decorated the reverse side with humorous designs symbolic of their tastes or character. The study of Oriental art in the museums was another relaxation, but he believed his early and best inspiration came from the study of Greek vases in Italy.

Manship was staunch and discerning in his personal relations. His life, after his initial success, became crowded with honors—too many for me to mention here. But he lent himself generously to the furtherance of art in this country through the American Academy of Arts and Letters, the National Sculpture Society, as a trustee of the American Academy in Rome and the Saint-Gaudens Museum in Cornish, and as chairman of the Smithsonian Commission on the Fine Arts.

Paul was little given to making apothegms, but one I recall well: "The genius is the brute with the delicate touch."

While Paul was in the midst of his Bronx Zoo gates, I was occupied designing mosaics. The first was a large commission for the entrance hall ceiling of the Metropolitan Life Insurance Company in Ottawa, Canada, then two smaller ones: a decorative altar piece for the chapel of the American Military Cemetery in Suresnes, France; and another mosaic interior for the American Cemetery at Thiaucourt, France. I made full-sized paintings for these mosaics, and they were

beautifully carried out by the Ravenna Mosaic Company, a German firm (ironically enough) with a branch office in New York.

Charles A. Platt had been instrumental in bringing me the commission at Suresnes, and during the late twenties he commissioned me to do much of the mural work in his own buildings. Notably there was the University of Illinois Library at Urbana, where I executed two great maps in oil— a commission which gave the Manships and me a wonderful pretext for an expedition through "Lincoln country." Another project was Platt's faculty dining hall at Phillips Andover Academy in Andover, Massachusetts, where I put up six grisaille murals of the New England countryside. Later I believe he also influenced John Russell Pope (by this time known as "dean of American architects"), who respected his opinion, to employ me to paint the murals in the National Archives in Washington. When Platt became president of the American Academy in Rome in 1930, he put me on the Board of Trustees, where I functioned for twenty-two years.

Although my friendship and admiration for Charles Platt had gone back many years, it was only after transplanting to 72nd Street in the mid twenties, that our relations became close and intimate. The Platts lived on a corner of Lexington Avenue and 66th Street in a duplex apartment which Charles had designed, one of the first of the type to be built in New York. The rooms were rich and handsome, their walls hung with silks and brocades equally becoming to the American paintings of Twachtman, Metcalf and Bellows or to his Old Masters of doubtful attribution.

Charles Platt was a taciturn man, but responsive when interested or emotionally touched—as I had discovered during our wintry tour of Spain. And he was a true and zealous friend. His wife Eleanor's temperament was as warm and impulsive as his was cool and restrained—a happy combination for both of them. Eleanor Platt was noted for her beauty in her youth, and in middle age was a handsome woman, gracious in her ways and as protective of her family

Paul Manship

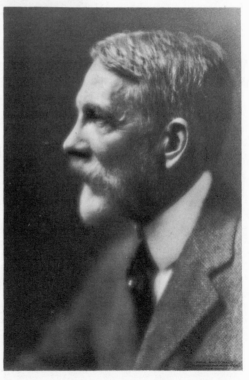

Charles A. Platt

as a mother partridge. Two sons, William, at this time in his late twenties, and Geoffrey the younger, had both finished Harvard and joined their father in his architectural firm.

The Platts spent their summers in Cornish, where they lived on the hill above Saint-Gaudens' Aspet, and in years past I had often visited them there briefly. Now they suggested I spend the entire summer and paint in one of the vacant rooms in Charles Platt's studio. Eleanor found me living quarters at the Jordans' in Plainfield, a small village about a mile and a half from the Platts' house. I followed Frances Grimes' sound advice and bought a one-seated Ford roadster.

Susie Jordan, my hostess in Plainfield, was a remarkable woman; I soon became friends with her and with her husband, Ralph. Susie had to her fingertips the skills and economies of the finest New England housewife. Breakfast was her finest hour—homemade bread, eggs from under her own hens, jam made of wild strawberries which she picked herself, delicious honey from her beehives, and on the griddle cakes the clear syrup that Ralph made from their sugar maples. I soon established ten o'clock Sunday morning breakfasts for my friends and their guests. William Platt and his wife Margaret could be counted on, and their two little girls, Eleanor and Clarissa, in bright dirndls, waited on table and afterwards had a splendid gorge with Susie in the kitchen.

On weekdays I began work at nine in Platt's studio. Charles appeared around ten and at the blast of the noon whistles in Windsor he would always call out, "Barry, how about a bit of relaxation?" and we played picquet until lunch, which I had with the family, and often dinner too, if I had no other engagement. Some days I would pick up Charles in the little Ford roadster, and we would drive in search of undiscovered places to sketch, especially to that delicious section of Vermont country north of Hartland Four Corners with its bad roads and glorious prospects.

During these summers the younger Platts—William, Margaret and their three children—were part of the Cornish

household. William worked in his father's New York office during the week and joined the family over weekends. He combined the most characteristic qualities of his parents, calm and tempered judgment, rich depth of feeling, and a quick response to the ridiculous. Margaret, who was the daughter of Fanny and Philip Littell (her father was an editor of the *New Republic*), was a girl of intelligence, humor and understanding. Charles Platt was deeply attached to his daughter-in-law, whom he valued for her fearless response to life and her intuitive understanding of art.

One of my last associations with Charles A. Platt occurred in January, 1933. He organized a stag houseparty at Cornish and gathered around him his younger son Geoffrey, James Kellum Smith, Lawrence Grant White—all of them architects—and myself. Charles intended to sketch the winter landscape, but on the night of our arrival from New York, he had an attack of bronchitis, took to his bed, and thereafter got up only in the evenings. I don't remember that we others sketched much, but Larry White and I made the discovery that we both delighted in playing piano duets. And in spite of my faulty sense of rhythm, there in the Platts' unheated drawing room we banged away at the glorious chords and climaxes of Mozart's *Jupiter Symphony* until the chill was forgotten.

In the summer of that same year, Charles Platt suffered a stroke of paralysis and died without recovering consciousness. He was seventy-two years old.

XIII

Irish Interlude

During the late twenties, I spent a summer with the Holter family in Ireland. The date is forgotten but the experience remains sharp and clear. The Holters had rented Bective House in County Meath, a place belonging to the Bird family, which they leased in the off-hunting season.

I was to go on the same boat with the family, but when I reached the dock in New York only the three oldest children, Sarah, Betty and Olaf, greeted me. No Pa and Ma, nor Mary-Frances, who had been operated on for appendicitis that morning, and her parents were staying with her until she was able to travel. I was somewhat flustered to be in command of the little party, but no further crises developed and the responsibility proved a light one.

Young Betty Holter loved poetry and found one of her favorite poets on the ship. Padraic Colum and his wife Molly were amused and interested by our little band. They were friendly and sympathetic, and when we reached Cobh found us a reasonably clean hotel; and the next day after we had kissed the Blarney, they put us on the train for Dublin, where Tom Lavin, the estate manager at Bective, met us and drove us to the house, some twenty-five miles northwest of Dublin.

Bective House stood on a high bank overlooking the River Boyne, the tiny village of Bective clustered about the river crossing below. The house was without architectural

pretensions and was painted white inside and out. Inside, turf fires smoldered in their grates, and turkey-red window shades enhanced the incredible emerald of the landscape.

Edwin, Sarah and Mary-Frances arrived ten days after we did and social life began to bubble. Each morning Edwin received one or more neighbors, primed to sell him a fine hunter or a hound of spotless pedigree. The ladies of the smaller gentry called on Sarah to invite her to tea parties and an exchange of hospitality. A sporting curate took Olaf on fishing parties, when, in the dark of the moon, they poached on the fish ponds of neighboring manors.

The days were long, and light lasted until ten o'clock. I awoke to a world shrouded in river mists, and after a late breakfast set off on foot with my pad and water colors. Although it showered every twenty minutes, the showers were brief and resulted in glorious skies. The Hill of Tara was only three miles to the east. I painted there and at Loricor, where Dean Swift's Stella had lived. Then to the town of Trim, past the ruined keep of the Wellesley family, where I sketched the so-called "King John's Castle." (Most old fortresses in Ireland are attributed to that bad and restless man.) I climbed the keep at Trim whose staircase was in the thickness of the wall, and was startled to come head on with the village idiot, a mewing kind of girl.

I usually had a bite of lunch at a village pub, most of which were poor and dirty. I had been warned against meeting tinkers and gypsies, but on my tramps I saw none. I returned to Bective in time for a dish of the imcomparable Irish tea and a game of tennis on the grass court. On days of heavy rain we went by train to Dublin and explored the antique shops with an occasional glance at the Book of Kells and other rareties.

However, the finest rareties and chiefest pleasures of our stay were the Irish people we met, people like the Colums. Through their kindness I met George William Russell, "AE", the poet, painter and ardent Irish nationalist. Even captious, fussy George Moore loved and admired him and wrote a moving tribute to him in his *Hail and Farewell*. I went to "AE" to get names of sketchable places in Donegal where

he himself often painted, and found him in the low and wide editorial offices of his newspaper the *New Irish Statesman*, on the top story of an old house in Merrion Square. He was a big man, cordial and genial, and for the moment interested in nothing so much as in my tiny problem. Later he invited me to his house in Rathmines to see his paintings. They were pictures of moonlit dancing fairies, which he said he had seen in visions.

Another artist-in-the-bud was Lord Dunsany, the playwright, poet and devotee of the supernatural. George Northrop, a New York friend of the Holters and mine, came to Bective with the news that Dunsany had taken up watercolors and wanted a teacher. Northrop told him there was an artist handy a few miles distant at Bective, and Dunsany demanded my presence. I went full of curiosity.

The entrance to Dunsany castle was true Norman, heavy and impressive, enlivened by one of the owner's African trophies, the head and forequarters of a lion in vitrine, a counterpart of the one in the Harvard Club in New York. An ample staircase, hung three deep with landscapes of the Dutch school, led to a large drawing room whose tables overflowed with silver-framed photographs of the family and of royalty in true Edwardian taste. Except for its Norman entrance, the house with its sham battlements was what Molly Colum called "Sears-Roebuck Gothic."

Dunsany himself, under his human battlements of nonsense and affectation, was genuine, bursting with an energy and enthusiasm which I found attractive. He was then in his forties, tall and blond with good features. Naturally he wished for no instruction in painting. Admiration was his goal. He painted with a desperate and astonishing minuteness. The only time I attempted a correction and tried to wash these minutiae into a larger generalization, he grabbed the brush from my hand and cried, "Oh no!"

Dunsany played tennis in a heavy Burberrry with a floating yellow scarf around his neck, and after successful returns he dashed his racket to the ground, clapped his hands and shouted, "Goody! Goody!"

Toward the end of my stay at Bective, Ernest White, a

cousin by marriage of Sarah Holter, came for a visit. He was a keen sportsman, devoted to hunting, and was in search of a couple of good mounts. Together we made the rounds of the stables, drank much Irish whiskey, well diverted by the wit and blarney of the grooms and of their employers.

After visiting the stables we made a social call. Ernest had a letter of introduction to the Marchioness of Conyngham whose estate was on the Boyne a few miles down river from Bective. The grounds of Slane Castle were gorgeous, studded with great oaks and beeches with glimpses of the river between them. The castle, although not ancient, was all of a piece and more convincing than Dunsany's place. It had an echo of Windsor, which was appropriate, for the first Marchioness had been the mistress of George the Fourth. The first object to greet our eyes in the drawing room was Sir Thomas Lawrence's full length portrait of "Prinny."

The present Lady Conyngham, a daughter of the Earl of Kerry, was an agreeable and hard-headed woman of the world, who had come through the "Troubles" whole-skinned and unmolested, probably because of personal popularity and influence in the right places. Before I left I asked for permission to sketch in the Park. She invited me to come as often as I liked and to stay to lunch, which I did several times, enjoying her forthright talk, for her experiences in life were so remote from any of mine in America.

XIV

Country Studios

The presiding genius of Sneden's Landing, New York was Mary Lawrence Tonetti. From the time she was a young girl in the 1870's her family had summered at Sneden's, then a cluster of old Dutch houses nestled in a pastoral tract at the northern end of the Palisades, along the Hudson River. Gradually Mary's father, Henry Lawrence, a New York merchant, bought the waterfront and much of the land behind it, and Sneden's Landing became a family center.

The Lawrences were a well-to-do, genteel and conservative New York family, and unconventional Mary ill-fitted their social framework. A large, robust girl, bursting with humor and vitality, she alternately perplexed and scandalized her family. Her loves were dogs, horses, stable boys and fishermen, and her talent a gift for sculpture. She studied with Saint-Gaudens in New York and became his favorite pupil. So great was her promise that he recommended her as his successor teaching the life class at the Art Students' League, and at the age of twenty-three she was commissioned to carve the monumental figure of Columbus for the Chicago World's Fair. In 1900 Mary Lawrence married the Italian sculptor Francois Tonetti, and Saint-Gaudens, hearing the news, is said to have broken down, wept, and said: "And now the finest sculptor in America will never work again!" He was right. Instead she

raised a large and talented family and nurtured the gifts of her innumerable artist friends.

I first saw Sneden's Landing on a hot summer day in the twenties. In company with my architect-friend Tom Ellett and his wife, I took a train from New York to Dobbs Ferry, and there we boarded a launch to take us across the Hudson. The spray-splashed coolness of the water passage washed away all memory of heat and fatigue and refreshed us for the weekend. Sneden's was the oldest ferry on the Hudson River. It had operated continuously for two hundred and fifty years, and there is a tradition that during the Revolution, Molly Sneden, a strapping lass, rowed Madame Washington across the river.

Mrs. Tonetti, who had inherited the family property at Sneden's, maintained the ferry as long as she lived. Embarkation on the ferry when Mrs. Tonetti herself decided to go to town produced moments of crisis. Upon embarking, the passengers—most of them commuters fearful of missing the train to town—would hear shrieks from the Palisades above. "Wait for Mrs. Tonetti! She is on the way!" Much fidgeting in the boat as she descended. Then the majestic woman would climb aboard the launch, settle her floppy hat and finish buttoning her dress.

Her house at Sneden's Landing was called the "Pirate's Lair," where after her husband's death in 1920, she lived in the summers. It was a very old house facing the river, built on three levels, with the hill sloping steeply behind it. From the hillside driveway one walked to the house over a long shaky wooden bridge which entered the living room on the second floor. Beneath was the dining room with an enormous fireplace and a kitchen, and on the third floor were the bedrooms. Inside the effect was one of warmth, comfort, a sure color sense, and a touch of grandeur.

Mrs. Tonetti's property at Sneden's included not only her own "Pirate's Lair," but a generous acreage and many of the other old houses, some fifteen of them, which she rented—at very nominal sums—to artist, architect and writer friends in the summer. And there were others like me who found a haven on the weekends. Among my own

close friends were the architects Tom Ellett and Lawrence Grant White, the latter a cousin of Mrs. Tonetti's; the delightful Betty Hare; and Eric Gugler, who married Mrs. Tonetti's daughter Anne.

Sneden's Landing was an ideal outlet for Mrs. Tonetti's enormous creative energy. If America had lost a sculptor, Sneden's gained an architect. She delighted in enlarging and renovating the houses, building terraces, or designing pools and pergolas. Sneden's bloomed under her love for trees, vines and gardens. Anne Gugler recalls her once saying: "Here I know as much as these landscape architects, and no one has ever given me a job!" The romantic glory of Sneden's is the Waterfall. It is a superb cascade, leaping the crest of the Palisades into bathing pools beneath, the effect heightened by a Roman pergola by the river's edge.

In New York, years before her marriage, Mary Lawrence had stood ruefully in the bay window of Miss Molly O'Hara's dressmaking shop, and while Miss O'Hara snipped and pinned, her eye fell on the Dutch Reformed Church on the north side of Fortieth Street. She said to herself, "That church would make a good studio." When she married in 1900, the church was for sale. She bought it with two adjoining houses on Lexington Avenue. The nave of the church became a studio, covered with a vast skylight, the finest private studio in New York.

As Sneden's Landing became in the summer, so 135 East Fortieth Street was in the winter a rendezvous for creative spirits. When the Tonettis gave a big dinner party the studio was a magnificent sight. Francois' large groups of sculpture were pushed back against the walls, the less sightly studio apparatus hidden behind tapestries, and the floor beautifully waxed. Great sheaves of flowers separated the statuary, the brass doorknobs shone, and in the middle of the floor the long tables gleamed with damask and silver, heaps of spun sugar, colored candles and garlands of smilax. Mary called it "An oasis in the midst of controlled disorder."

Francois Tonetti, who had been orphaned at seven, came to this country in the nineties as an assistant to the sculptor Frederick MacMonnies, and after he married Mary, executed

Mary Lawrence Tonetti in her garden at
Sneden's Landing

Celebrating by the waterfall at Sneden's Landing;
left to right: flute player, William Platt, Eric Gugler,
Barry Faulkner, Bernard Beck. The occasion was
Margaret Platt's birthday.

work for the Customs House and Public Library in New
York and the Library of Congress. When he was over fifty,
he volunteered for service during World War I as an assis-
tant to Dr. Dakin and Dr. Alexis Carrel at Compiegne, but
he exhausted his strength and died of pneumonia at the
close of the war.

When Eric Gugler bought a house across the street from
Mrs. Tonetti in the twenties, a fresh and enduring element
entered her life. They formed a society of mutual admira-
tion and benefit. Both loved the grand manner in architec-
ture and life. His enthusiasm and genius renewed for her
a partnership which in her youth she had shared with Saint-
Gaudens and the architect Charles McKim. And Gugler,
through his admiration for her talent and vitality, learned
how important gardens and landscaping are to a house—
and discovered the pleasures of reckless hospitality. His
admiration for Mrs. Tonetti was so evident that for a time
her friends spoke of him as "Mary's beau," but when they
heard that at her daughter Anne's suggestion he had
washed the windows of his house on 40th Street, the cat
was out of the bag. Eric and Anne were married in Judge
Cardozo's chambers in November, 1931, and left for a
honeymoon in Italy.

In 1935, when she was sixty-seven, Mrs. Tonetti sold
her New York property and moved permanently to the
"Pirate's Lair" at Sneden's, where she lived with her daugh-
ter Lydia Hyde and Lydia's three children. At the "Lair"
James Arthur Holmes was prime minister in the kitchen
and Mrs. Tonetti's overseer above stairs. At one time he
telephoned Anne in New York, "Please, Miss Annette, buy
your mother a dress, I haven't a thing to put on her."
James' father was black, his mother was white, and one of
his grandmothers a full-blooded Cherokee Indian. He had
been valet and handyman to Diamond Jim Brady and re-
ceived a thorough education in the ways of Broadway and
the theatre. The glories of Grand Opera became an obses-
sion with James and he quit Mr. Brady to join the chorus
of the Metropolitan Opera. From there he progressed to the
ballet and when he grew fat enough he was chief Eunuch

in *Aida*. He was gentle, emotional and affectionate, and entertained the little Hydes with loving skill. He amused them with tales of Diamond Jim and Jim's lady friends, and enlivened the housework by acting out the operas he knew by heart and singing their music in a pleasant falsetto.

The dream of James' life was to go to Paris. After Mrs. Tonetti's death, Anne Gugler arranged the trip for him. Every hour of his stay was provided for; tickets to the Opera and the Folies Bergères, tours to Versailles and Fontainebleau, and a round of Montmartre night clubs. James' happiness was complete. The trip was the climax of his life, for he died two months after his return. Anne buried him in Woodlawn Cemetery at Mrs. Tonetti's feet, as he had often begged her to do, and gave his funeral the handsome circumstance that he deserved and under other circumstances would have appreciated.

Anne Gugler inherited many of her mother's great qualities and took her place at Sneden's with ease and grace. From her Latin father she inherited a sound business sense. She is a beautiful woman with a lovely, rich speaking voice and her kindness and helpfulness know no limit. Anne had a thorough training for the stage. She studied the dance with Elizabeth Duncan and then, under the guidance of Yvette Guilbert, became an accomplished character actress. When she married she left the stage, for her hands were full indulging Eric's whims and the management of Sneden's. She had a license as an interior decorator and furnished many of Eric's houses.

Gugler designed two fine houses at Sneden's, a large one for Guthrie McClintic and Katharine Cornell and a delicious small one for Miss Gertrude Macy, that bright spirit, who was Miss Cornell's personal manager. Eric's great delight was the Pavilion he designed for himself on the edge of the Palisades where in spring the Hudson gleams through masses of dogwood. The Pavilion forms the basis of a house which I doubt will be completed. Its grand feature is a semicircular colonnade. It faces the Hudson over a round fountain filled with little ducks. Trellises covered with grapevines are supported by a curving wall and by handsome

marble pillars, which years before he had salvaged from the Herald Square building when it was torn down. At either end the trellis is domed. When I last saw it, there were pleasant box gardens around it, and here and there plaster casts of bits of Paul Manship's sculpture. Inside was a fully equipped kitchen.

Here at any pretext Eric gave large parties whose extravagance would have delighted Mrs. Tonetti's heart. The grandest of these parties that I remember was given in honor of Dick and Jo Kimball when Dick was leaving for Rome to become the Director of the Academy. There were over a hundred guests. We sat at scattered tables while a flute player, hidden in a tree, played snatches of Bach and Handel.

The number of distinguished people who have lived at Sneden's Landing at various times reads like the pages of Who's Who. I will name-drop only a few of them: Marcel Duchamps, the composers Aaron Copland and Igor Stravinsky; John Dos Passos, Maxwell Anderson and Elsie Sergeant; and from the theatre, Maurice Evans, Noel Coward and those three charming ladies, Margalo Gilmore, Laurette Taylor and Ina Claire.

Among the architects who came to Sneden's from time to time was James Kellum Smith, whom I first knew in Rome in 1923 when he was winding up his architectural course at the Academy. He and Elizabeth Walker were newly married, and back in New York the next year, Jim joined the distinguished firm of McKim, Mead and White, an association that continued for many years to come.

After a couple of winters in New York the Kellum Smiths began exploring the rolling hills of Bucks County, Pennsylvania for a permanent country home. On these expeditions their friends often joined them; among them Jim's colleague Lawrence Grant White, his wife Laura, and my sister Katharine and myself. We stayed at the Valley Inn, a comfortable old stone place along the Delaware River a few miles above New Hope. We called these jaunts "sketching parties;" we briefly water-colored, but spent more time scouring the

countryside and drinking the excellent applejack, which we
bought from a bootlegger across the River.

The Kellum Smiths found a fine old stone house on a hill
above Lumberville, a riverside village north of New Hope,
and Betty and the children settled into country life, while
Jim came from New York on the weekends. One winter
weekend there remains sharp in my mind. On a Saturday
afternoon I arrived in a thriving young blizzard. What bliss
to sit before a blazing fire in the embrace of a stout stone
farm house, with the wind howling and the snow drifting
outside! We heaped logs on the fire and read aloud from
Whittier's *Snow Bound*. We awoke the next morning to clear
dancing sunlight, and the crust, over deep snow, was so
thick and strong that Jim, his boy Kellum, their dog and I
wandered at will across the glittering fields, over the hidden
fences in a dazzle of crystalline beauty. That walk had the
same unreasoned magic that sticks in my memory of the
March sugaring-off, long ago with Philip and Gerry Whit-
comb beside the Ashuelot River in Keene.

The gentle country surrounding New Hope and Lumber-
ville had begun attracting painters as far back as the 1890's,
and gradually the "art colony" grew. One of my friends
who had settled in New Hope was John Folinsbee, a land-
scape and portrait painter, who with his wife Ruth had built
a charming house and studio overlooking the river. John
had been crippled with polio in his youth, but with his un-
flagging spirit, his lean and handsome countenance and
quick agility in his wheelchair, one was never aware of any
physical infirmity. One of his beautiful daughters, Joan,
married Peter Cook, a gifted painter in his father-in-law's
mold, thus continuing the tradition in the family.

The guiding spirit of the New Hope "colony" and one of
its founders was William L. Lathrop, whom I met through
the Folinsbees. He was an older landscape painter of the
vintage of Brush and Saint-Gaudens, a lovely man with a
white beard and bright blue eyes. His avid interest was sail-
boats, an enthusiasm shared with his friend Henry B. Snell,
a marine painter of the same era. On one visit to New Hope
in the late twenties I found Mr. Lathrop transforming his

hobby into reality. There on the lawn behind his studio was a sturdy full-scale sailboat under construction. He said she was an all-weather craft modeled after the North Sea fishing boats he remembered from a youthful journey in England. He was building her with his own hands and the aid of a local carpenter and, in subsequent years, he spent his summers aboard her painting off the Long Island and New England coasts. In September 1938, Mr. Lathrop, by then in his eightieth year, was on a solo voyage at Montauk Point, Long Island and was lost in the violence of the hurricane.

Branchville, Connecticut, had been the home and summer studio of J. Alden Weir, a friend and contemporary of Lathrop, Twachtman and Brush, and after Weir's death (in 1920) his daughter Dorothy had inherited the old farm. I visited Dorothy and her husband, Mahonri Young, often during the twenties and thirties. The place was a treasure house of Weir's own work and the pictures his friends had given him. Weir was one of the best-beloved of artists, handsome, genial and benevolent. Dorothy inherited her father's qualities; she loved Mahonri, her painting, her farm of Jersey cows, and her herb garden.

Dorothy was Mahonri Young's second wife. He was born in Utah, one of Brigham's many grandsons. Mahonri was not a practicing Morman, but some of its mythology still clung to him, for when we visited Palmyra, New York, the scene of Joseph Smith's early revelations—the birch grove where he first heard the Voices, and his attic chamber where the Angel appeared to him—Mahonri was all quiet reverence. He was muscular and heavy, a formidable trencherman, and nourished on the cream of Dorothy's Jerseys he became as fat as Falstaff. He was amazingly well-informed and I enjoyed hearing him pontificate, but any interruption to his flow made him as irascible as Dr. Samuel Johnson.

Mahonri Young was one of the finest draughtsmen of the time, and the pithy drawings in his innumerable sketchbooks are a remarkable record of life in the West, in New York, and in Europe. His first consuming interest was in the Navajo Indians, and later he became identified with the so-

James Earle Fraser

Mahonri Young

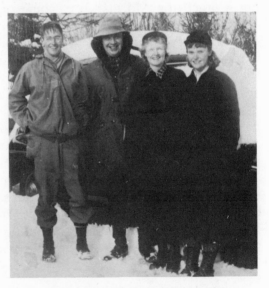

J. K. Smith and his family:
young Kellum, Betty and Nancy

called "Ashcan" school in New York. He was a sculptor, painter and etcher, and down in the roots of his being there lived an illustrator and teller of stories. Mahonri believed that his life hung on three pegs: Art, History, and the West. His pegs held firm in his most important work, the Mormon Centenary Monument. In its sculpture we read the story of Utah from the time of the Spanish explorers and the early Mountain Men to the moment when Brigham Young thumped his gold-headed cane on the ground and exclaimed, "This is the Spot!"

Connecticut had also lured my friend James Earle Fraser, who had bought an old Colonial house at Westport and built a superb stone studio across a field at some distance from it. Here we continued our friendship which had begun in Cornish and flourished in MacDougall Alley. In 1913 Fraser had married his pupil, Laura Gardin, a gifted sculptor and medallist (she created one of the Congressional Medals of Honor); Fraser's own work had become extremely popular and he was much sought-after as a portrait sculptor.

On entering the Westport studio you were greeted by the barks and swift onrush of two cocker spaniels. Then you might glimpse Fraser, high on a ladder, working on a colossal horse whose head nearly touched the roof; or again you might find him crouched in a corner, bent over a tiny medal or sketching the design for a pedestal. If at first sight neither of the Frasers was visible I searched for them through a plaster labyrinth of generals, statesmen and scientists, a maze of robust form and human drama. Here was genial Franklin, brooding Edison, crisp Harvey Firestone and the twin figures of the Brothers Mayo. At the time when Laura modelled her superb equestrian group of Lee and Jackson, their workshop was the stable for four monumental horses. Laura's equestrian interests extended beyond the studio. She was grandly courageous and for years battled a chronic sinus which affected her eyes and caused her a great deal of pain. When she could not model, she entertained herself by playing the horses over the telephone—and for a time was well ahead of the game!

Fraser's aim in sculpture was to express in outward form the inner spiritual force which animated his subject. That he often attained his goal is clear when we compare the brooding expression of the young painter, Olaf Olsen, with the quizzical Jack Garner; Elihu Root sunk deep in thought, the patrician elegance of Albert Gallatin, and the bounce and vitality of Theodore Fraser was of noble presence, his fine head set firmly on broad shoulders. His manner was quiet and self-assured, open and friendly. Jimmy's character was like a good piece of Scotch tweed, handsome, durable and warm. No surface brilliance tricked the eye, it was honest stuff through and through.

Laura centered her life on sculpture and Jimmy. Her sculpture was powerful and masculine. She loved horses and won the competition for the equestrian group of Lee and Jackson over the most competent sculptors in the country. Her admirable bronze doors for West Point depict American history in a fresh and imaginative style.

I usually spent two or three weeks in September at Cape Ann, north of Boston. The color of the fishing fleet at Gloucester, the intimate landscape and picturesque coves and harbors made Cape Ann a natural attraction for artists as far back as the 1880's. Paul Manship had bought a place near Lanesville, and within easy reach were the summer places of my friends Leon Kroll and Gifford Beal. It mattered little in whose house I laid my head, for the three of them lived so near together that we saw one another constantly. But their places were as different from each other as the men themselves.

Manship's house was on a sightly neck of granite between two disused quarries, and to the site he moved a huge barn, which he converted into a studio. Espaliered pear trees grew on the walls of the studio; gradually lawns appeared, and on them Paul placed his garden sculpture which he often sold "on the hoof." The place expressed his sturdy character, his shrewdness, and his inclination to elegance and refinement. He loved fruit trees, and his grape arbor with its seventeen varieties of grapes was supported by

huge posts, sections of quarry derricks so big and bold that one visitor seeing them exclaimed, "Why! Woodhenge!"

Isabel Manship's evenness of temper and gaiety of spirit made the interior of the house a cheerful home. There were two large rooms downstairs, a panelled living room and a huge kitchen which was warm and inviting in spite of its size. It was like a French or Italian kitchen, and the life of the house centered around its long table which Isabel heaped with succulent dishes of lobsters, crabs and freshly caught fish. Isabel's mission in life was to make everyone around her happy, and she succeeded gloriously.

Leon Kroll skillfully remodeled an old house at Folly Cove. It was a secluded spot with a garden, where to his intense satisfaction, Leon could paint his nude models out of doors. Leon was a native New Yorker, who had studied in Paris with John H. Twachtman, the American impressionist, and had himself become a superb teacher. He made a name for himself as a painter of women and for the strong color and expert modeling in his canvasses. His wife Viette, with her sparkling Gallic vivacity and unerring taste, created an atmosphere of welcome and warmth in the house at Folly Cove.

Gifford Beal was a sailor, and his house overlooking Rockport harbor, with its agitated panorama of gay sailboats and screaming gulls, was as spotless and taut as a ship's cabin— as spotless and sunny as Beal's own nature. I did not come to know him and his wife Maude until later in life, but we developed a close companionship. Giff painted the surface of life with love and sympathy: the glitter of the circus, the crowded beaches, the panorama of Central Park; sailboats gliding out of Rockport harbor. He had known tragedy but was unobsessed by its gloom. Beneath a sunny exterior lay a keen intelligence and a highly emotional nature; he was quick to anger at injustice and cruelty, unafraid to applaud nobility and fine achievement. In his presence egotism and antagonism faded; he had the gift of inspiring others to emulate his own wisdom, simplicity and good will.

XV

Capitals and Colonnades

Not long after Charles Platt died, I received the commission to paint two murals in the National Archives Building in Washington. John Russell Pope was the architect of the building and, as I have mentioned before, it was undoubtedly on Platt's recommendation that I was chosen to do the murals. The commission was awarded in 1934 and I was given two years to complete the job. The panels were large, fourteen by thirty-six feet; their subjects were standing portrait figures of the Signers of the Declaration of Independence and the Constitution of the United States, which documents were to be placed in a shrine between the two murals. My knowledge of history was inadequate to select the statesmen to be represented in murals of this importance, but a historian in the Library of Congress suggested that I take two representatives from each of the thirteen states and supplementary figures who had been powerful in the two conventions.

Then began the search for portraits of the Founders, which ranged in quality from Gilbert Stuart and Charles Willson Peale to a more than dubious woodcut of Button Gwinnett. My assistants were three gifted young men, Olaf Olsen, John Sitton and Cliff Young. When we had found the portraits and hunted out costumes suitable for them, and my small studies for the pictures were finished, we enlarged my studies on a cartoon at four inches to the foot.

To paint the final canvasses I hired a large space in the north side of Grand Central Station. It had a top light, and the canvasses faced each other. At one side of the studio was a door to catwalks over the thin plaster dome of the Concourse, from which electric bulbs representing the stars in heaven in the ceiling could be replaced when they burned out. For relaxation we explored its fascinating darkness, for the door was often left unlocked.

Before taking the completed canvasses to Washington I gave a large cocktail party and as the crowd of guests moved between the life-sized figures of the murals, there was a slight alcoholic confusion in my mind as to which was which.

I took the canvasses to Washington in the humidity of September, 1936. The recesses of the Archives were cool and I watched with intense excitement the "paper hangers" unroll the canvasses on the slightly curving wall. Each was a few inches too short, but we had allowed for discrepancies in the measurements, and had no difficulty in adding those few inches to the classic building in the murals, and to a spray of foliage. I did not finish the pictures in time for the dedication of the building, so they received little publicity until the original documents of the Declaration and Constitution were placed in the shrine between them.

The New York Times was flattering, however, and its critic called them "beautiful in color and design and of extraordinary fidelity in portraiture."

My final design for the Declaration of Independence panel showed Jefferson and his committee, composed of Franklin, Adams, Livingston and Roger Sherman, presenting the document to John Hancock. In the Constitution panel, Madison submits the original draft to Washington and a group of the convention members.

The Archive paintings were scarcely on the wall when in early 1937 an unexpected and not too welcome visitor came to the studio. It was Frank Schwarz, a student I had known at the Academy in Rome. He asked me if I would join him in painting murals for the new State Capitol in Salem, Oregon. It was a big job of at least thirteen or fourteen

One of Barry Faulkner's preliminary sketches for the National Archives murals in Washington, D.C.

"The Constitution of the United States," one of the two large murals in the rotunda of the National Archives Building, Washington, completed by Barry Faulkner in 1936

panels, too many for one man to finish before the formal
opening of the building. Francis Keally, the architect of the
Capitol, was a friend of Schwarz and wished him to have
half the work if he could find an experienced mural painter
to join him. Schwarz had had an unhappy life and his na-
ture was morose and suspicious. I had never liked him much
and was cool to his suggestion, but times were hard and
both my assistants and I needed work, so with reluctance
I agreed to the proposition.

The chairman of the committee responsible for the mural
came to New York to look Schwarz and me over. To my
surprise he turned out to be Robert Sawyer, a classmate at
Exeter, and he proved an agreeable and helpful companion.
He decided that Frank and I should motor with him over
the Old Oregon Trail to pick up local color. Bob met us with
a car at Ames, Iowa, and we headed for the limitless hori-
zons of the Nebraskan waste. Along the Platte River there
were scattered cottonwood trees but around the few stark
houses we passed there was never a tree or garden, only
rusty oil drums and the whirling tumbleweed.

At Cheyenne and at Green River the landscape took a
turn for the better. We stopped at Fort Bridger, passed
Boise City, looking most inviting in its garment of foliage,
skirted the stupendous canyon of Snake River, and at Pen-
delton reached the glorious scenery of the Columbia River.
We halted at the Dalles, where, below the waterfall, the
Columbia had cut a two-mile chasm through rock, never
wider than two hundred feet and sometimes less. At the
Falls we saw the sorry remnants of the Indian tribes with
whom Lewis and Clark had parleyed; dirty, ignorant, and
forlorn. As we progressed to Portland the landscape took
on a resemblance to that of New England, infinitely grander
in scale, yet alike.

The subject matter for the murals had been decided by
the Committee, and Frank chose the subjects that appealed
to him. The subjects that fell to my share were John Mc-
Laughlin receiving the missionaries Whitman and Spalding
with their wives at Fort Vancouver, the political meeting
at Champoeg and Captain Robert Gray trading with the
Indians for sea-otter skins.

I visited the sites: Fort Vancouver had vanished, but Columbia River remained. Champoeg was a barren field with a few straggling trees. I struck gold, however, at the landing place of the Boston merchant Captain Robert Gray on the Columbia River. From Astoria I took a launch to the right bank. Here an extraordinary sight greeted me: on the beach lay the ivory-white bones and carcasses of mighty trees, uprooted and stranded on the beach by floods of long ago. They looked like the unburied and bleached skeletons of huge antediluvian animals, gleaming, fantastic, beyond reason.

Curiously, the sight I saw tallied exactly with the description in the diary of one of Gray's men, written when they landed at a similar place on the River in 1792. The Indians met Gray there and for a few knicknacks, Gray obtained a cargo of sea-otter skins, which he sold at a fabulous profit in China, where the beautiful furs were in high demand. Thus began the historic New England China Trade.

During 1937 and '38, I made three trips to Oregon, all enjoyable, for many of the Oregonians were of New England descent and were cordial to a native son. Rogers MacVeagh, whom I had known in Dublin, lived in Portland, and Sawyer and his friends of the Oregon Historical Society were unfailingly agreeable and hospitable. Before leaving for the last time Bob took me on a tour of the state. I saw Eugene, and Crater Lake, and spent a night at Bob's house in Bend, located in a lovely valley overlooked by the peaks of the Three Sisters.

On the way back to Portland and my train, we stopped at the ski lodge on the lower slopes of Mount Hood. It was the third or fourth of July, and down the lower slopes of the mountain we saw a solitary skier descending. Robert thought him the final skier of the season, for now the Portlanders were flocking to their cabins on the seashore for swimming and water sports. Next came the hunting season and afterwards the excitement of skiing recommenced. Oregon is a paradise for lovers of outdoor life.

It was my good fortune to have these two big commissions during the years of the Great Depression which en-

"The Meeting at Champoeg". Mural painted by Barry Faulkner, 1937-38, in the Oregon State Capitol, Salem, Oregon. At the meeting the settlers decided by a majority of two votes to join the United States rather than Canada

gulfed a frightened world. Two others had come earlier: a ceiling mural for the Bushnell Auditorium in Hartford, Connecticut in 1931; and the following year an enormous mosaic wall decoration, almost eighty feet long and called *Intelligence Awakening Mankind,* for the west entrance of the R.C.A. Building at Rockefeller Center. Another financial bolster was my sister Katharine's conservatism with our investments. When the crash struck we were as much alarmed as anybody, but after the first panic had subsided and Katharine's wisdom had proved itself, we managed in reduced but still comfortable circumstances.

The anxiety of the Depression was lightened by the formation of the Octomanic Society. The "Octos" grew out of that spirited duet performance of the *Jupiter Symphony* by Lawrence White and myself during that wintry weekend at the Platts' in Cornish in January, 1933. After that, I spent many Sunday mornings at the Whites' house in New York, playing with Larry on his two pianos, and from four hands we soon grew to eight.

The "Octos" first met "officially" in 1934 at the house of Mrs. Bonner Lockwood, who had two Steinways in one of her drawing rooms. Her slender and beautiful daughter Milly, then married to LeRoy King and later to Alexander Knox the actor, had been introduced to our duets at one of the Whites' dinner parties. Soon she was the energetic mainspring of the "Octos." Our fourth pair of hands belonged to Bobbie Cowles, a trained musician and a vivacious and incomparable companion. Our foursome varied and expanded from time to time, as we cautiously introduced new members, Katharine and Rosamond Frost among them, and later on Harriet Potter and Edna LaRocque, the latter both accomplished musicians.

When Mrs. Lockwood moved from her house to an apartment, the Octos gathered in my studio on 72nd Street. There our wintertime social evenings were joined by husbands, wives and lovers, and our noisy pleasures were punctuated by delicious casserole feasts and roast kid dinners, lively games of charades and doggerel verses from Larry White. In the spring there were leisurely outings to

Bobbie and Sheffield Cowles' place at Farmington, Connecticut.

Katharine had furnished the studio with an excellent baby Steinway and Mrs. Bertram Goodhue, wife of the architect, had lent me a good Knabe upright. But the Octos voted my upright inadequate, and Larry White replaced it with a huge oddity of his own, a Steinway concert grand embellished with carvings of ram's heads, cupids and egg-and-dart trim. It was enamelled a gleaming ivory, and when the movers had hauled it from the street through a front window into the studio, they exclaimed with one voice, "Here's your White Elephant!"

Larry White was the son of Stanford White, the celebrated architect who was shot by Harry K. Thaw in one of the *causes celebres* of the early 1900's. Larry followed in the paternal footsteps at McKim, Mead and White and was an ornament to his profession, until his sudden death in 1956. Like his father, he was a prodigy, a man of astounding energy with many gifts and interests. Besides his passion for music, he was fluent in four languages, wrote a verse translation of the *Divine Comedy*, painted attractive watercolors, and his impromptu verses invariably entertained the Octos with their delightful Gilbertian twists and turns. For all his warmth, he was reserved when I first met him and cautious in weighing the character of a new acquaintance, but once his confidence was established, he was a steadfast and considerate friend. Action was his element, and his quickness of mind and spirit remained undiminished to the end.

In the midst of these Depression years, between Archives murals and jaunts to Oregon, came a decision which was to alter the pattern of our lives. Katharine decided we should have a summer place in New Hampshire, and having sampled the delightful country studios of artist friends, I began to hanker after one of my own. My father's cousin, Dr. Herbert Faulkner, owned considerable property near Keene, reaching high onto West Hill. Katharine was a favorite of Cousin Herbert, and since girlhood had been an intimate

friend of his daughter, Ellen, now headmistress of the girls' school at Milton Academy. Cousin Herbert had built a house at the foot of West Hill, and Ellen spent her vacations in a red cottage called the "Rittenhouse" on her father's property. So in 1936, at their affectionate urging, we bought a farm of some sixty acres adjoining Cousin Herbert's property to the south.

Our farm ran from a fine meadow to the east of Base Hill Road up to the ledges of West Hill. The story-and-a-half farmhouse stood on a steep bank overlooking Base Hill Road and the meadow, and in the distance, beyond the city of Keene, loomed the massive bulk of Mount Monadnock. The farm had out-buildings and a huge red cow barn. When we bought it the place was occupied by Charles Roundy, a friend of Cousin Herbert's, a farmer and excellent carpenter, who agreed to run the farm for us and remodel the house.

Excellent, so far: but who should design the renovated house and lay out the grounds? Three of my close friends were architects, James Kellum Smith, Tom Ellett and Eric Gugler, and to choose between them embarrassed me. As usual Katharine bailed me out. She made the choice and chose Eric, possibly because she knew him the best of the three. The one stipulation I made to Eric was that he should not change the exterior proportions of the house which were good rural Greek Revival. He kept the proportions of the house intact and added on its south side a handsome curved bay window with sliding doors which opened on the lawn. He completely made over the interior of the house, tore down the outbuildings and replaced them by a one-storied kitchen and a large servant's bedroom and bath. From the kitchen and our living room, a colonnade, or covered way, went to a garage, and then turning at a right angle led to my studio. It was supported by ready-made wooden Doric columns.

"Bounty" was the name I gave to the place—for Aunt Mary Ripley whose generous legacy enabled us to finish it properly.

The house, the colonnade and the studio formed two

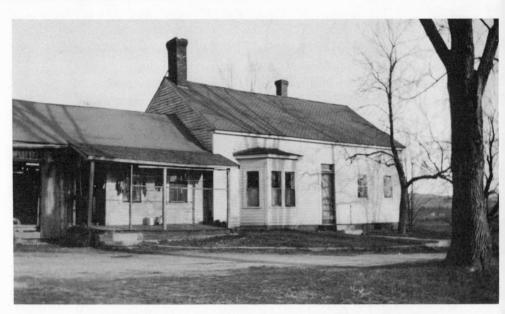

"The Bounty," Keene, New Hampshire. Before and After

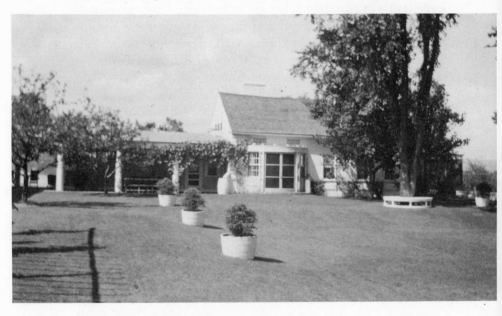

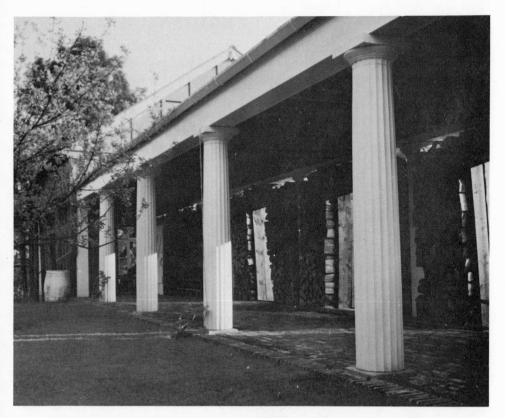

Colonnade leading to Barry Faulkner's studio at the Bounty

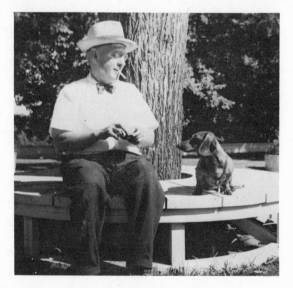

Master of the Bounty and friend

sides of a large rectange, facing a wide sweep of lawn, and
on the other two sides we built long low walls of cut granite.
The effect was one of spacious Classical informality—Eric
Gugler's trademark. From his quarry on West Hill, Cousin
Herbert lavishly provided the granite for the walls and
stepping stones, and a magnificent slab for the north door-
way. There were old fashioned red and white rose bushes
growing by the house, and it was shaded by two trees rare
to find in Keene, a tulip poplar and a honey locust. Milly
Lockwood Knox contributed ajuga for ground cover, and
Katharine began an herb garden with a lovage plant which
Dorothy Weir Young had given us.

Perhaps the most arresting feature of the place is the
studio. The building is an old barn whose exterior is humble
and weatherbeaten. Charles Roundy found it in Nelson ten
miles from Keene. He got it for nothing, conditional upon
filling in the cellar hole, and took it down piece by piece,
hauled it to Keene and set it up again. We glazed in the en-
tire north gable with much of the wall below it. In the south
wall Gugler cut a high roundheaded window, reaching to
the floor, to frame the silhouette of an ancient apple tree,
whose gnarled trunk and branches made a pattern as mar-
vellous as that in any Chinese painting. On the west wall
is a fireplace, storage closets and a balcony. We insulated
the interior, covered the spaces between the beams with
wallboard, painted it all white, and sand-papered the beams
to bring out their hand-hewn texture.

The studio glowed with light and color, when to cele-
brate its completion we gave a dinner party in August 1938
in honor of Eric and Anne Gugler. In the center of the room
we had erected a long makeshift table, covered it with
white oilcloth, scalloped the edges and painted them with
garlands of gold and scarlet. On the table, amidst the bou-
quets of flowers and decorated place cards, gleamed two
fine candelabra which Bill Platt had brought down from
Cornish. Gugler had often spoken of his love for quartet
music, so at a venture I hired the Titcomb Quartet of Keene
to play for us during dinner. Knowing nothing of their
quality, I placed them at a safe distance from the studio, but

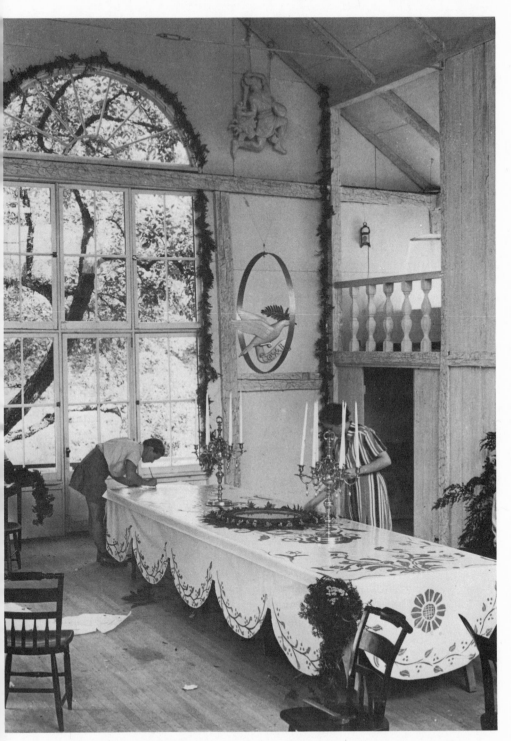

Interior of Barry Faulkner's studio at the Bounty. Betty Cope and
Anne Gugler prepare for the party to celebrate its completion, c. 1938

their tinkle proved so agreeable that at last they played just outside the studio door. When they struck up the minuet from *Don Giovanni*, Mary Pierce, George Brush's daughter, rose and began to dance alone with the matchless grace which is a Brush inheritance. We finished the evening with a thumping Irish Reel on the lawn outside.

Shortly after our studio celebration, early in September Katharine and I left for New York, and a week later the Hurricane struck. In Keene the damage was frightful. The wind uprooted more than a thousand elm trees along the streets, and brought down with them the telephone and power lines; Keene was isolated from the world outside for two weeks. The Ashuelot River flooded, half of the First Church steeple was blown off, and our neighbor Margaret Smith, on her farm, watched the roof of her barn sail over the hill. But our "Bounty" had incredible good luck, for the wind jumped it and landed in poor Cousin Herbert's pine forest. When he woke the next morning he saw his beautiful woodland flattened to the ground. Considering the inestimable damage, the town put itself to rights with speed; crews of lumbermen and volunteers cut up and hauled away the great elms, righted the power lines, manned trucks with mail and food from the outside, and Keene was soon in running order. But the ill effects to the natural beauty of the place were felt for years to come. One aftermath of the storm brought real tragedy to us: Charles Roundy overexerted himself repairing roofs and leaks, and died of a heart attack.

During the previous summer after we had graded the place and finished it up, Charles Roundy had brought the tax collector over to size it up. As they stood outside the red barn looking down at the house, the colonnade and studio, Katharine heard Charles say, with a gesture to her new home, "Well, what about it?" "Oh hell!" said the assessor, "How can you assess such goddam nonsense as that?"

Certainly I cannot assess the pleasure and delight the "nonsense" has been to me for nearly thirty years.

XVI

Pictures on the Walls

At noon on December 7, 1941, Margaret Platt, who was painting in my studio on 72nd Street, went to Katharine's room and turned on the radio for news. She got plenty. Pearl Harbor! And everyone's lives turned upside down. At sixty, I was in no condition to march off to battle, but younger friends rallied to the colors or found niches in the war effort. To the admiration of his friends, Larry White, well over age himself, landed a commission in the Navy and sailed off to the Mediterranean as an interpreter. Bobbie Cowles went to work in the Sperry plant, and the ranks of the Octomanic Society were further depleted. But thanks to Milly Knox's dauntless energy and wide acquaintance, we captured replacements and carried on for the duration. One of our new recruits, as I have mentioned earlier, was Harriet Potter. Blonde and luminous, Harriet was a pupil of Nadia Boulanger and unquestionably one of our best musicians. During the war, when the baby-sitter gave out, Harriet would come to our gatherings with her small son and little dogs in tow and leash them all to the leg of the Steinway grand.

My own modest contribution to the war effort came on the "Triptych Committee". Soon after we entered the war, I was asked to join the art committee, headed by Mrs. Junius Morgan, to pass on the quality of the altar pieces painted for the Army and Navy Chapels both here and abroad. The

altar pieces were triptychs on stout boards hinged together in three pieces. Mrs. Morgan's committee furnished the boards and paid the artists two hundred dollars for their labor, a measly sum, but if an artist had no commissions or steady commercial work the triptychs were a help.

Louise Morgan had vivacity and an optimism which often outstripped her budget. At that time I was chairman of the art committee of the American Academy in Rome, and when Italy entered the war in 1940, we closed the Academy and put the property under the protection of the Swiss Legation. A large part of the Academy's income lay idle, and I proposed to the Board of Trustees that we donate some of it to the Triptych Committee, on condition that all our painter alumni should be invited to participate if they so wished. The Trustees liked the idea and gave the Triptych Committee $15,000 as a part of their war effort.

In the midst of the war, during the winter of 1943, Katharine suddenly died. She was still in her fifties. The blow was as bitter as it was unexpected. Isabel Manship, Milly Knox and my youngest sister Dora Mowbray were invaluable supports, and with our housekeeper Carrie Dwyer's tender and faithful help I carried on at 72nd Street. Carrie's devotion to Katharine had never faltered, and when I asked her if she wished to stay on with me, she broke into tears and said, "Where else would I go?" Another gesture which touched me deeply came from Isabel Manship. After Katharine's death, she organized her friends and bought a triptych to her memory, which is now in the chapel of a U.S. Navy submarine base.

Wartime brought other casualties on the home front: George de Forest Brush, the joyous mentor of my youth, now frail and full of years, died in 1941 in Hanover, New Hampshire, where he had gone to be with his daughters Mary Pierce and Thea Cabot and their families. Our friendship remained steadfast, and I returned from time to time in the summers to my old haunts at the Brush Farm in Dublin, where he spent most of his last years. He kept at his painting almost to the end, small portraits of his adored grandchildren.

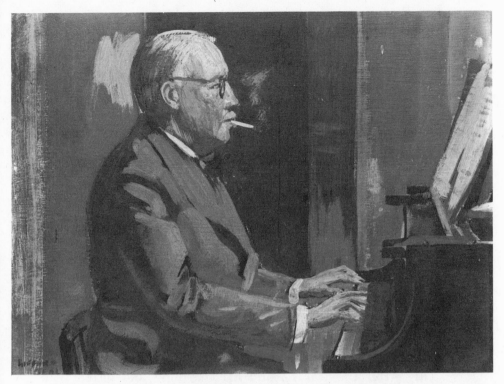

Barry Faulkner at the piano. Sketch in oil by Gifford Beal

Octos al fresco, at the Cowles' place in Farmington, Conn., about 1940. Standing are Milly Lockwood Knox, Sheffield Cowles, Alexander Knox. Seated: B. F., Lawrence Grant White, Betty Cowles, Katharine Faulkner, Rosamond Frost and unidentified man.

After his death, the younger William James (who became the second husband of Brush's daughter Mary) said to me, "How many good and beautiful things we owe to George Brush!" Among them, perhaps the most singular and precious was his matchless faculty for imparting enthusiasm; for getting across to us—the younger painters—so that it became our own, his own unquenchable love of beauty and of life. He was to us a warm house on a frosty night, an Arabian Nights Entertainment, a deep well of inspiration.

The early death of Alexander James at the end of the war brought another irreparable loss to the Dublin community. Alec's path and mine crisscrossed many times, and one of the attractions when I built my studio near Keene was the proximity of the Jameses only twelve miles distant. Alec was one of the truly gifted painters of his generation. He was the youngest son of William James the philosopher, and before the First World War his father sent him to study with Abbott Thayer—with whom he became a favorite. After the war he and his charming and gifted wife Frederika bought an old house in Dublin, where they lived much of the time and raised three sons.

In the winter of 1945-46 I drove up from New York for his funeral. The small church building on the Main Street near his home was already packed with mourners, townsfolk and people from afar, and I joined the crowd standing in the snow outside. Alec never confined his friendships to a select circle; he reached wide. His penetrating mind, his nimble wit and capacity for laughter, his democracy encompassed the village handyman and the society grande dame. His special admiration was reserved for men who worked with their hands, rough Yankee carpenters and craggy farmers, and the love was reciprocated. He was never happier than when hearing the sound of hammers. One of his friends was my boyhood pal, Gerry Whitcomb, in later years a farmer and Selectman in Richmond, New Hampshire, where Alec bought a remote farm to which he retreated to paint undisturbed. Alec found in Gerry not only a friend, but the model he needed, for Gerry's rugged countenance permitted no prettiness of technique or weak-

ness of characterization—faults that Alec believed were his weak points. One of his best pictures is the *Embattled Farmer;* Gerry is seated in the James' kitchen in a woolen undershirt and with troubled brow, punching at his old typewriter.

Shortly before his death, Eric Gugler designed Alec James a handsome studio behind his house in Dublin. Cathedral high, built of weathered barn boards, it has two great windows, one of them almost reaching to the east gable, and the beautifully proportioned north light framing a walled garden of apple trees and grape arbors. Alec did not live to enjoy his monumental dream for long, but each morning he woke to the joyful sound of work in progress. The carpenters adored him and when the studio was finished, they presented him with a handsome brass lock for one of its doors. Engraved on the surface of the lock are the names of all the men who worked there.

Before Alec James' death both he and George Brush figured in a mural I painted during the war for the State House in Concord, New Hampshire. The commission came in 1942 to decorate four panels in the Senate Chamber; the spaces to be filled were vertical and enclosed by round arches above. In choosing the subjects, I endeavored to combine New Hampshire's contributions to history with portraits of men associated with them. The first panel depicted Eleazar Wheelock greeting Governor John Wentworth at Dartmouth's first commencement in 1771; in another was General John Stark departing for the battle of Bennington, 1775; and there was Daniel Webster, as a boy in Salisbury, reading the Constitution. But I enjoyed most of all the panel of "art and science." My conception was to feature Abbott Thayer in his role as pioneer naturalist as well as artist, and I painted him seated in his studio explaining his theory of Protective Coloration to his friends, Brush and Daniel Chester French, and his pupils—Alec James and myself.

One of the fates of aging artists is committees, and after the war, especially, I came in for my share of them, with varied satisfactions and disappointments. New friendships

were among the rewards, and the opportunity to meet younger men and women and keep abreast of new developments in contemporary art.

When the war ended in 1945 I began working with Eric Gugler to liberalize the curriculum of the American Academy in Rome which had not altered for upwards of fifty years. The conditions under which the students went to Rome were rigid and confining, as I had found when I was a student. For the past few years the talents of the men applying for scholarships had been mediocre, and Gugler and I believed that the hoary formulas for residence and work had much to do with it.

We drew up a new curriculum in which men were appointed for one year, instead of three, and reappointed if mutually desired. There were no restrictions on travel and residence. The men could work as they pleased, and might sell their work. Married men could bring their families, and the scholarships were made eligible to women. The Board of Trustees approved the reforms, and we held a series of dinner meetings for the various categories of artists and classical students among the alumni of the Academy. They greeted the changes with whoops of joy.

One of my most pleasant assignments was assisting Stephen Clark to hang the pictures at the Century Club when he was chairman of the Gallery Committee. Clark was a connoisseur of French and American paintings, a truly eminent collector. When he asked for the loan of a choice picture for the Century Gallery, museums, private collectors or dealers would not refuse him. On hanging days early in the afternoon, Eugene Speicher and I arranged the pictures according to our taste. Stephen Clark appeared at four, and with a few swift and brilliant suggestions upset our scheme of arrangement—always for the better. Clark's house was filled with rarest pictures and at dinner, one might sit under a famous Renoir, a Corot or a Cézanne.

In 1948 Paul Manship became president of the Academy of Arts and Letters and appointed me chairman of the Art Committee. The work was challenging, for Childe Hassam, the late American impressionist, had bequeathed to the

Academy about four hundred of his paintings, oils, water-
colors, etchings and pastels. The Academy was to sell them
as it could, and use the accumulated income for purchase
of work by living American and Canadian artists. The pic-
tures we bought were presented to small museums in
Canada and the United States. From tiny beginnings our
income reached thirteen or fourteen thousand dollars.

The painters Eugene Speicher, Gifford Beal and Leon Kroll
were on the committee with me. We would meet for lunch
at some comfortable restaurant like "Maria's" in the east
fifties, and afterwards spend the afternoon in the galleries,
selecting the pictures which were eventually bought and
given to the museums. We tried for a tender balance be-
tween traditional and nonobjective paintings.

In the course of our labors, we discovered two unused
lumber rooms in the basement of the Academy, and it
dawned on us that they would make dandy storage space.
We cleared the junk out, cleaned up the basement, and in-
stalled steel sliding racks ample enough for those nearly-
four-hundred Hassams and the other pictures owned by
the Academy. The Art Committee, of which I was chairman
for twelve years, would scarcely have been able to function
had it not been for the incomparable Miss Felicia Geffen,
who did the drudgery of correspondence and whose tact,
taste and judgment rescued us from many pitfalls.

In the midst of these happenings came an eventful turn
in my domestic life. In 1952 Paul Manship found it neces-
sary to sell the houses on 72nd Street, and after almost
thirty years we packed up and scattered to different roosts
—the Manships downtown to 17th Street just off Fifth
Avenue and me to a small spartment on East 66th Street,
next to the one where Charles Platt had once lived. The
last two commissions painted at my 72nd Street studio
were *Day of Decision,* a large mural of the Declaration of In-
dependence for the John Hancock Building in Boston (in
1949), and an altar decoration for the American Cemetery
in Florence, finished just before I moved.

My removal left the Octomanic Society bereft and
prompted this lament from Larry White:

Barry in a careless manner
Up and sold his grand pianner.
So the Octos could not find
A place to play of any kind.

The sale of the "grand pianner" was neither willful nor careless; both the baby Steinway and the concert grand had to be removed. My new apartment was too small for even one pianner. After an uneasy winter, the Octos were rescued by lovely, warmhearted Polly Howard, who invited us to use the pianos in her large drawing room. There, beneath a portrait of her father Walter Damrosch, who regarded us with a kindly but skeptical gaze, our hearty musical evenings continued.

1952 was the year James Earle Fraser died, seventy-six years old. Jimmy's death was the end of a friendship that began long ago in Saint-Gaudens studio in Cornish, and for the country it was the loss of one of our finest sculptors. That year was also memorable because I decided to step down from the board of the Academy in Rome; twenty-two years in the Roman vineyards was time enough, and having —with Gugler—called for new initiatives and young faces, what better example could I set? Besides, there was a fresh challenge waiting.

A fellow trustee of the Academy in Rome was Douglas Moore, a composer and chairman of the music department at Columbia. Would I object, Moore asked me one day, to serving on the art committee of the Guggenheim Museum? He may have wondered whether it would be a mixture of oil and water; an old-school painter and an institution devoted to the *avant-garde.* Somewhat apprehensively I accepted.

The new director of the Guggenheim that year was James Johnson Sweeney, but our divergent tastes proved no impediment and we got along splendidly right from the start. Sweeney showed me the Guggenheim collection as he had inherited it. It was then quartered in a Fifth Avenue house with a rococo interior where fine things hung next to ridiculous things, and paintings were up to the ceiling and nailed to the floor.

The next time I saw the museum all was changed. The rococco panelling had disappeared under wallboard, painted a dazzling white; the clumsy gilt frames had gone from the paintings and their edges were bound with a delicate narrow white band of masking tape. This was Sweeney's ingenious device to make frames superfluous. He seldom showed more than thirty or forty paintings at a time, and the generous spacing between them set them off to perfection. His taste in hanging was impeccable, just the right accent here, the lack of it there, and the height and spacing of the paintings were a geometric joy. His method for determining the relative height of paintings was simple and he taught me its secret, but of course I could not acquire his genius for violating the rule in just the right places. However, it gave me a new perspective on the problems of hanging exhibitions at the Century and the Academy of Arts and Letters.

Besides giving me technical help, James taught me to appreciate the work of Calder, Leger, Juan Gris, Braque and Solange, but he never convinced me of the beauty of Mondrian's dry checker-boards. Paul Manship and Eric Gugler looked askance at this broadening of my tastes.

James and Laura Sweeney lived in a penthouse on East End Avenue with a sweeping view of the city and the East River; they were personable, buoyant, always ready for fun, and I spent many delightful evenings with them. The reception and dining rooms were sparsely furnished, painted "Sweeney White" with a few good pictures on the walls including an exquisite Picasso abstract. Behind these rooms was a large library as cluttered and comfortable as an old shoe.

Among the qualities I admired in Sweeney were courage, perseverance and imaginative resource. In Frank Lloyd Wright's new museum he strove doggedly to better the defects of lighting and arrangement which the architect had bequeathed him. After he resigned as director of the Guggenheim he went to the Museum at Houston, Texas. On a trip to Mexico he discovered and excavated a colossal archaic head, half buried in a swamp. Disregarding the

hostility of the natives, he built roads, imported tractors, and with the help of the Mexican Navy, got the mammoth thing to Houston and set it up in the grounds of the Museum on temporary loan from the Mexican government.

During these years, two of my committees often took me back to New Hampshire: Saint-Gaudens' old place at Cornish had become a museum under the aegis of the state, and I was elected one of the trustees. In later years the Federal Government took over, and Aspet became a National Historic Site. The MacDowell Colony in Peterborough, New Hampshire, had been founded early in the century by the gentle and indomitable Mrs. Edward MacDowell, widow of the composer, as a sanctuary for aspiring artists. Serving on the board was a rewarding job. Composers, painters, sculptors and writers—many of them young and impecunious—were given grants to come to the Colony to work uninterrupted for anywhere from a month to three months at a time. The roster of their "alumni" was dotted with distinguished names in every field of the arts.

Activities on my multifarious committees drew to a close after a heart attack in 1960; high time, no doubt, as I was well beyond the allotted three-score-and-ten. I gave up the chairmanship of the Art Committee at the Academy, withdrew from active work at the Century Club, and bid a fond farewell to the MacDowell Association. There had been too much committee work; I was deaf, and peevish when I could not have my own way. I tried at times to resign from the board of the Saint-Gaudens Museum, but I was the last trustee who knew Saint-Gaudens and Aspet in the old days, and trustees retained me as a kind of sacred cow.

XVII

Afternoon of a Native Son

The lure of the Bounty drew me back to New Hampshire every year, and often I remained in Keene from May until the middle of October. I was at home among the familiar landmarks of boyhood and the welcoming fold of the Faulkner clan. There was the attraction of hospitable and stimulating friends, old and new, dotted about the region. And as a venerable native son, I found myself in the flattering position of being asked for advice by various civic committees about problems and schemes for the future of the town.

My studio at the Bounty was not idle. Even before the Second World War, and in later years as well, I was awarded some interesting commissions for murals from my native state. Beside the State House panels, there were three from the citizens of Keene, and I was honored and touched by these marks of their regard. I have mentioned two of the murals in the opening chapter: the first, in 1938, for the Elliott Community Hospital, was commissioned by public subscription and depicted Central Square as I remembered it from boyhood. Another, showing the advent of the Cheshire Railroad was painted for the Cheshire County Savings Bank and completed in 1955 with the help of Cliff Young, a talented painter, who had been my assistant on the National Archives decorations.

The other home-town commission came from the Keene National Bank: to fill three large panels on the end wall of

the high-ceilinged main banking room. Wallace Mason,
president of the bank, a warm friend of my father's, and one
of Keene's finest and most respected men, asked me to un-
dertake the job in 1950. (Before finishing the murals, I made
a portrait drawing of Wallace, whose features reminded me
of Sir Walter Scott.) I chose as the subject of my panels,
Men of Monadnock: Ralph Waldo Emerson, Henry Thoreau,
and Abbott Thayer; all three men knew the mountain well
and had celebrated its grandeur. I pictured Emerson in con-
templation resting on a rock with a squirrel at his feet; a
young Thoreau striding forward, a porcupine beside him;
Thayer at his easel, his attention distracted from his paint-
ing by a block of birds. The summit of the mountain gave
the figures a common background.

The tradition of Monadnock and its countryside as a
haven for artists, beginning in the nineteenth century, was
kept alive in the years after Thayer and Brush: younger
painters like Alec James came to the region; spiritual descen-
dents of the earlier Dublin painters and the "Pennsylvania
colony" in Nelson took root; the MacDowell Colony flour-
ished, and some of its artists found niches and stayed. I got
to know some of these younger men during the early years
of World War II, when we decided to put on an exhibition
in Keene for Cheshire County artists. The idea sparked
when my brother Philip, who was head of the Red Cross,
appealed to Ellen Faulkner and me to suggest a money-
raising scheme for the new ambulance they needed. We
hunted about, found an empty store at the head of Central
Square, freshly painted it white and installed good lighting.
Our little gallery opened with an admission charge of fifty
cents, a good crowd of people, and generous representation
of regional artists, who gave paintings, drawings and
sketches. From Dublin there was Alexander James, Richard
S. Meryman (also a one-time pupil of Thayer), Beatrix
Sagendorph and Gouri Ivanov-Rinov; John de Martelly,
Albert Quigley and Janet Tolman were among those from
Nelson; Everett Warner, myself and many others. One lady
walked in with an enormous Hudson River School land-
scape—not precisely in the contemporary mode—but we

sold it to the manager of a local hotel for six hundred dollars. The sale of drawings and small pictures was brisk, and when the final day came we had cleared upward of three thousand dollars. So—with an assist from the Kingsbury Foundation—the Red Cross got its ambulance. Thereafter highly successful annual summer exhibitions of regional artists, organized by Gouri Ivanov-Rinov and others, continued at nearby Marlborough during the post-war years.

A heart attack in the fall of 1960 laid me low for a time, and it became apparent that I would no longer be scurrying up stepladders to paint murals. But a new vocation stood me in good stead. For some years I had been compiling and writing the stories of painters and sculptors whom I had known in my youth, as well as the lives of earlier artists of the Connecticut River Valley. As a consequence, Wallace Mason, president of the Keene National Bank, commissioned a series of historical talks over WKNE, one of our local radio stations. I also found myself on the lecture platform. Corinna Smith—Mrs. Joseph Lindon Smith—asked me to speak on several occasions at the Dublin Lake Club, sanctuary of the summer colony, and these talks were followed by others in Keene and elsewhere. It was Corinna Smith (I have spoken of her elsewhere as a young woman in Dublin) who gave me my first incentive for writing. In the long interval since our youth, she had become an author herself and matriarch of the Dublin summer colony; her home at "Loon Point" was a magnet for interesting people from all over the globe. Corinna was a woman of keen mind, ready wit and unflagging energy, and she encouraged my fledgling writing efforts with sympathy and frank criticism.

Frederika James, widow of Alec James, enlisted me to give two talks at the Dublin Women's Club. The "gate" was respectable and the funds were given to the Garden Club to landscape the building, formerly a church—and the very place where we had stood outside in the snow at Alec's funeral. One astonishing and rewarding result of the lectures was my election as an honorary member of the Dublin Garden Club. "Freddie" James, a gardener *par excellence* and

a charming and gifted woman, gave her energy and imagination to the creation of an intimate and beautiful walled garden at her brick house in Dublin. She has remained unfailingly helpful and interested in my own efforts to improve the garden at the Bounty.

It was in the walled garden and orchard at the James studio that I first remember Peggy Colony and Rosamond Putnam, among the most attractive of my younger friends. The occasion was an afternoon Italian fiesta, an imaginative fund raising affair given in the early 'fifties by Frederika James. Rosamond and Peggy, sisters and descendants of the Booth family of theatrical fame, first came to Keene to study with their aunt Beatrice Booth Colony, who with her husband Alfred, owned the Keene Summer Theatre. In a short time they had both married young men from Keene, David Putnam and John Colony, and in the years since then, the sisters and their close friend Laney House—the "Three Graces" I call them—have enriched the life of Keene and its environs by their energy, intelligence and good will. During our first encounter at the James fiesta, we were put in charge of the Wishing Well in a somewhat remote corner of the grounds. In the beginning we did little business, but the beauty of the young women, Rosamond dark and Peggy fair, soon caught the eyes of the bucks, young and old; and they crowded round and wished the well to its bottom!

The Faulkners of Keene are a formidable tribe; Charles Faulkner and my grandfather Francis were brothers. The Charles Faulkners were a sturdier breed than my own branch of the family in that generation, for my father's brothers and sisters died at an early age. Father's cousin, Dr. Herbert Faulkner, who had urged us to buy "Bounty" and was our neighbor on the West Hill, fathered two sons and five daughters, all of whom married except my cousin Ellen. At a family gathering in 1962 I counted at least sixty of his children, grandchildren and great-grandchildren. Our branch of the family righted the balance somewhat in the next generation, for my youngest sister Dora Mowbray had three children, and Philip had a flock of five, all of them now grown and with youngsters of their own.

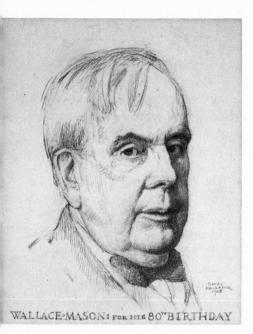

WALLACE·MASON: FOR HIS 80ᵗᴴ BIRTHDAY

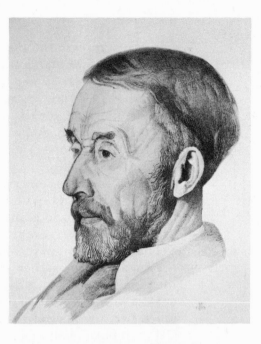

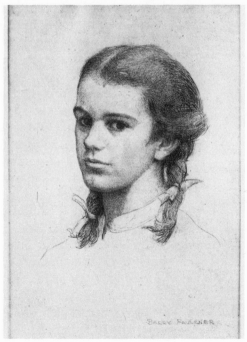

Three drawings by Barry Faulkner. Above: Wallace Mason, president of the Keene National Bank; Above Rgt, Dr. Herbert Faulkner of Keene; Right: Dr. Faulkner's grand-daughter, Ellen Hayward Roentsch

In the summers the Bounty overflowed with nieces and
nephews. Philip's handsome and gifted brood—Ann, Fran-
cis, Philip, Jr., Martha and Jocelyn—loved the place and were
often there. The Mowbrays usually spent August with us,
a hectic interlude, for their birthdays—all five of them—fell
in the same month, and when the children were young they
insisted on everyone celebrating separately. So August was
all cake and candles.

When I bought a new Plymouth I gave my old Ford road-
ster to Philip's boys, who named it "Pluto," painted it blood
red, and had a glorious and no doubt hair-raising time in it.
I saw them grow to manhood, and both take their places in
Keene, Francis a lawyer, and Philip, Jr., a successful busi-
nessman and the father of five sturdy boys. Martha was
the comeliest of the girls, and Ann and Jocelyn both en-
dowed with musical talent. I knew Jocelyn, "Pinky" as we
called her, the best of the children. She was a round little
girl with flaxen hair and a beautiful rosy complexion. When
she grew older, I painted her portrait, and we played duets
together on her frequent visits to the Bounty. Later when
she came to New York to study music, she was constantly
at my studio and often lent her talents to the Octos for an
evening.

Philip was a remarkable father to his children. He en-
couraged the backward, sympathized and controlled the
wayward, scolded and laughed with them. Philip and I had
our ups and downs, as many brothers do, but on the whole
it was a warm and genial relationship. We both loved gos-
sip, and he retailed many juicy bits of recent scandals and
old rascalities. He died in 1959, to the end a gallant, coura-
geous man, much valued and looked up to in the community.

Not far from the Bounty, high up on West Hill, Dr. Her-
bert Faulkner had built a rustic camp in a grove of rock
maples; in the distance, Keene, the Ashuelot Valley and
Monadnock lay at his feet. Here, on Sundays, holidays and
anniversaries an army of Faulkners gathered for family
picnics, over which the good doctor presided with genial
simplicity. Cousin Herbert was the foremost physician in
Keene, the successor and spiritual descendant of Dr. George

Twitchell, famous in a previous era. He was a handsome, slight, active man, with a well-trimmed beard, a pleasant voice and a kindly eye. His sons and daughters all loved the place, as did their husbands and wives. At these reunions, while waiting for the crackle of the golden piglet sizzling in the outdoor fireplace, they sipped martinis, exchanged family gossip and scrutinized the latest additions to the tribe. These reunions kept the family closely knit, and they continued after Cousin Herbert's death.

The garden at the Bounty is on a small raised terrace to the west of the colonnade, below an abrupt little hill crowned by a fine young pine tree. Before the war, Katharine and Lucy Smith, daughter of our old friend Margaret Smith, had laid out the garden with skill. They planted the slope behind the retaining wall with Japanese arborvitae, wild azaleas and flowering shrubs. Wild columbine seeded itself everywhere. And below was a riot of pink and white phlox, foxgloves, English larkspur, blue globe thistle, hollyhocks, milady's bedstraw, and other pretty things. After Katharine's death it seemed shameful that the love and care she had lavished on it should go for nothing, so with the help of Wesley Olmstead, my friend and right arm, we kept it going in spite of woodchucks and porcupines. Each year I planned a new project: a wall here; a flowering hawthorne there; and hedges of privet and hemlock everywhere.

The garden and the studio at the Bounty were the scenes of gatherings, less populous than at Cousin Herbert's perhaps, but no less joyous. My two nephews, both inveterate cameramen, presented me not long ago with an album of photographs taken over the years of my parties. Many of them are only dimly remembered, but the assembled pictures leave the impression of unflagging and relentless entertainments. Not true, of course, for in the matter of hospitality, I think I got more than I gave. I have mentioned elsewhere the magic evening to celebrate the opening of the studio. Another image I recall vividly was Martha's wedding to Douglas Jones. Philip wanted the wedding in the studio. So among others I summoned the Guglers and

William and Margaret Platt, and in the presence of a hushed assemblage Martha and Doug were married before the big round-headed window the lovely apple tree framed behind them, and the room gaily decked with wreaths and garlands.

There were more intimate entertainments for visiting artist friends. Gifford Beal and his wife Maude would come up from Rockport to stay for a week or more twice a summer. Beal liked the change from the seacoast to our hills, and he painted two prize winning pictures in the locale: one of Dublin Lake and Monadnock, the other of haymakers in the big field below the Bounty. He also painted several sketches of the house and the garden and another of the proprietor, three of which I am the happy owner. We sketched by the river and other places that took our fancy and had a serene and contented time together. Paul and Isabel Manship rarely came to Keene, for the humid damp of the valley brought on his asthma, but there were visits from Leon Kroll and his wife Viette. The Krolls seldom stayed away from Folly Cove for more than a single night, for Leon would not absent himself longer from the delectable models in his garden.

The Children's Party was, in its way, the most charming I ever remember giving at the Bounty. The numerous offspring of John and Peggy Colony, David and Rosamond Putnam, and the Thomas Laceys were there, and others whose names I do not recall. The parents came in the bloom of early married life. For entertainment I had a magician, a boy of thirteen, who did his stunts most adeptly; then there was a big covered basket of little presents with bright ribbons leading out of it, with the children's names attached to them, ready for them to pull. At suppertime the children lay on the wide lawn eating their ice cream and cake. The day was peerless, and the tender young things in their pretty clothes, under the apple trees in the dappled afternoon sunshine, made a picture I shall never forget.

"Cheers!" Barry Faulkner at the Bounty

Barry Faulkner: An Appreciation

*Barry Faulkner died in Keene, New Hampshire on October 27, 1966. In the following year, on the occasion of two memorial exhibitions of his work—at the Saint-Gaudens studio in Cornish and the Thorne Art Gallery in Keene—the late Mrs. Alexander James wrote this appreciation of him:**

A stranger, sitting pleasantly next to one Barry Faulkner, might never be aware that he was, in our time, of the breed of the famous Sir Horace Walpole, Eighteenth Century poet and connoisseur of the gentle arts, who attracted the talented and witty men of the day to his almost legendary "Strawberry Hill."

Because of Barry's modesty and his refusal to take himself seriously, most of us had no idea of the immensity of his preparations for his murals, of the grace of many unframed drawings found in a closet, of his wide and discriminating reading, always a book at his side and in his New York apartment, a symphony, perhaps, on his piano.

He was the second piano of a lively group who made music once a week at the house of a Mrs. Lockwood on 84th Street. In the early days, she not only contributed her pianos but a lovely musical daughter as well. They called themselves the "Octos," for there were usually eight hands,

*Reprinted, courtesy of the *WKNE Listener's Guide*.

and Barry described them in a charming tribute to Lawrence Grant White, the architect, "We Octomaniacs owe our existence and its attendant pleasures to the enthusiasm and energy of Larry, our instigator and founding father." The attendant pleasures were Luccullean feasts followed by poems, charades and high jinks!

Barry loved beauty and gaiety in all its forms; and his house, studio and garden in Keene, named "Mary's Bounty," after an Aunt whose will made all this building possible, was a reflection of himself, Eric Gugler, its architect, and Paul Manship, the sculptor. Both dear friends! To the gala housewarming of the "Bounty" those three must have brought the perfection of detail which would make that evening, and every other such evening, unforgettable.

Barry's friends—all his wonderful friends and Barry's generosity! He shared his friends. He wanted them to know each other, and to enjoy each other, a selfless virtue, for he sat back and watched them enrich each other's lives.

He did, to balance the picture, have plenty of vinegar in his make-up, and refused to put up with whomsoever and whatsoever he did not like. In the hospital, when he was very ill, I was allowed to see him for a few minutes. He was fussing about the bed lamp.

"I can't read in this light."

"Perhaps they don't want you to read."

"I can always read," he snapped back, and then he greeted me.

—Frederika James

Chronology

1881 Barry Faulkner born, July 12, Keene, New Hampshire

1897 First studies with Thayer, summer; enters Phillips Exeter Academy, fall

1899 Enters Harvard College

1900 Leaves Harvard; summer with Saint-Gaudens

1901 First trip to Italy, with Thayer

1902-06 New York: Art Students League; studies at Chase School; illustrates for "Century"

1907 Wins Rome Prize Fellowship, American Academy in Rome

1908 Studies with Brush in Florence

1910 Returns from Italy; completes first mural, *Famous Men* for Mrs. E. H. Harriman, Arden, N.Y.

1912 Completes *Famous Women* for Mrs. Harriman

1913 Medal, Architectural League of N.Y. for *Famous Women*

1915 Mural, *The Tempest,* for Edwin Holter, Mt. Kisco, N.Y.

1916 Murals, *History of New York*, Washington Irving High
 School

1917-18 U.S. Army, 40th Engineers, AEF, France. Enlisted as pri-
 vate, discharged as 1st Lieutenant

1919-21 Completes last 2 panels for Washington Irving High
 School; Map of Belleau Wood, Marine Hq., Quantico,
 Va.; Sea-Charts of the World, Cunard Building, N.Y.;
 Murals for Meredith Hare, Huntington, L. I. and R. H.
 Dana, New York

1922 *Dramatic Music* and 3 other murals for Eastman Theatre,
 Rochester, New York

1923-24 American Academy in Rome war memorial in collabora-
 tion with Gugler and Manship

1925 Moves to 319 East 72nd Street

1925-29 Decorations for "Elmwood", Cambridge, Mass.; Ceiling
 mosaic, Metropolitan Life Insurance Co., Ottawa, Canada;
 Two maps in oil, University of Illinois Library, Urbana,
 Illinois; Six grisaille murals of New England Landscape,
 Phillips Andover Academy, Andover, Mass.

1929 Exhibition of watercolors and sketches, Fifty-Sixth Street
 Gallery, N.Y.

1930 Elected trustee, American Academy in Rome; Mosaic
 interior, U.S. Cemetery, Thiaucourt, France; *Peace*, mo-
 saic altar, U.S. Cemetery, Suresnes, France.

1931 Ceiling mural, Bushnell Memorial Auditorium, Hartford,
 Conn.; Elected academician, National Academy of Design

1932 *Intelligence Awakening Mankind*, 80 ft. mosaic in the west
 entrance of the RCA Building, Rockefeller Center

1934-36 Two large murals, *The Constitution* and the *Declaration of
 Independence*, National Archives Building, Washington,
 D.C.

1936 Buys the "Bounty" in Keene, N.H. and builds studio

1937-38 Three historical murals, State Capitol, Salem, Oregon

1938-43 *Central Square,* mural for Elliot Community Hospital, N.H.

1942 Four historical panels, Senate Chamber, State Capitol, Concord, N.H.

1943 Death of Katharine Faulkner

1942-44 Triptych Committee, U.S. Army and Navy chapels

1949 *Day of Decision,* mural, John Hancock Building, Boston

1950 *Men of Monadnock,* 3 murals for Keene National Bank, Keene, N.H.

1951 Altar decoration, U.S. Cemetery, Florence, Italy

1952 Moves to 137 East 66th Street

1955 *Advent of the Railroad, 1848,* mural, Cheshire County Savings Bank, Keene, N.H.

1961 Medal for distinguished contribution, American Academy in Rome

1965 Moves permanently to Keene

1966 Death of Barry Faulkner, Oct. 27, Keene, N.H.

1967 Memorial exhibitions, Saint-Gaudens studio, Cornish, and Thorne Art Gallery, Keene, N.H.

Index

THIS BOOK was set in 11 point Andover (Palatino) type at Bayfield, Providence, Rhode Island. Printed by the Murray Printing Company, Forge Village, Mass. and bound at the Colonial Press, Inc., Clinton, Mass. Color plates printed by Sim's Press, Peterborough, New Hampshire.